a gallery of Masterpieces

from Giotto
to Picasso

108 reproductions
selected & introduced
by Keith Roberts

Phaidon

Footnotes would be out of place in a book of this character. However, the author would like to acknowledge, in a general kind of way, the many unspecified sources from which information has been taken. The author and publishers are grateful to all museum authorities and private owners who have given permission for works in their possession to be reproduced. Plates 85, 86 and 87 are © by SPADEM Paris 1974 and Plate 93 © by ADAGP Paris 1974. Photographs have been supplied from the following sources: Scala, Florence 1, 3, 8; Farbaufnahme Gerhard Reinhold, Leipzig-Mölkau 53; Bulloz, Paris 57; Giraudon, Paris 64, 68, 80.

Phaidon Press Limited, 5 Cromwell Place, London SW7 2JL

Distributed in the United States of America
by Praeger Publishers, Inc., 111 Fourth Avenue, New York, N.Y. 10003

First published 1974
© 1974 by Phaidon Press Limited
All rights reserved

ISBN 0 7148 1626 4
Library of Congress Catalog Card Number: 73-21455

Printed in Great Britain by Severn Valley Press Ltd

A Gallery of Masterpieces

The aim of this album is to present a group of European and American paintings, drawings, and graphic works avowedly popular in character. But what, the indignant reader may ask, looking in vain for old favourites, makes a work of art popular? What indeed? What are the criteria? Certainly not those that sensitive critics sometimes like to imagine—their own: there are many great artists, from Rogier van der Weyden to Delacroix, who will probably never be really popular, just as there are third-rate pictures, reproduced everywhere, which are outside the canon of critical taste altogether.

Dozens of works were considered for the selection that follows, only to be rejected because they were thought to be not quite appropriate. As the anthology took shape it became clear that two of the main criteria were familiarity and association. The '*Mona Lisa*' (Plate 9), the '*Laughing Cavalier*' (Plate 29) or *The Haywain* (Plate 56) are popular partly because they are already well known. Popular taste re-enforces itself.

Association is a much more important factor in the enjoyment of art than critics care to imagine or wish to admit. The critic may be well aware of the 'human' elements in a picture or a play; but he may feel it his duty to write about all the technical and stylistic elements that transform the basic morsel of ordinary experience into art and therefore, in the crudest sense, separate it from life. The critic is often less concerned with the beauty of the roses that grow in the garden than in how they are painted on one occasion by a single artist.

The layman is not usually worried about the element of 'style' in the arts—though it can be a different matter when it comes to cricket, football, or jazz. He is often more involved in all the features that still seem directly to link the 'work of art' with life: naturalistic detail, recognizable places and things, beauty of form and obvious skill. The appeal of Dürer's *Hare* (Plate 10) surely— and rightly— depends on a combination of the animal's charm and the painter's prodigious technique. Just as Guérin's enchanting portrait of his daughter (Plate 49) or Picasso's *Child with a Dove* (Plate 85) exert a spell that it is quite unnecessary to analyse.

Sometimes, of course, a painter or sculptor manages to combine the highest degree of artistry, acceptable to the most fastidious connoisseur, with the maximum human impact. When this happens, the work of art, be it Botticelli's *Birth of Venus* (Plate 6), Rembrandt's *Self-Portrait* (Plate 24) or Vermeer's *Painter in his Studio* (Plate 25), achieves a universal appeal. Perhaps the supreme example, immediately comprehensible and recognizably sublime, is Michelangelo's *Creation of Adam* (Plate 7).

Popular taste naturally changes from age to age. In 1869 there appeared a not dissimilar album, entitled *The World's Pictures*, and it was confined to reproductions of fifteen famous religious paintings, ten of them Italian works of the sixteenth century (with three by Raphael and three by Correggio), as well as examples by the now less popular artists, Domenichino, Murillo and Annibale Carracci. What is striking about the selection is the way it reflects the established taste of the time, both socially and aesthetically. It is the high-minded taste of the wealthy connoisseur; and it had hardly changed since 1769. The pictures themselves also imply a confidence in traditional artistic values, belief in orthodox Christianity and a knowledge of the Bible.

If there has been one major shift in popular taste it has been away from the kind of art that assumes familiarity with a literary source. This is one of the underlying reasons for the immense current enthusiasm for the French Impressionists and Post-Impressionists. A racing scene by Degas (Plate 68), Monet's *Terrace* (Plate 72) or Manet's *Bar at the Folies-Bergère* (Plate 81) demand no background knowledge for their appreciation. Theirs is an art without an iconography.

This trend, however, does more than just mirror a decline in religious teaching and a narrowing of educational assumptions; it is more positive than that. The old demand that a picture must tell a story is very largely satisfied by, quite literally, moving pictures in the form of cinema and television. People are happier than ever before to accept from a painting what critics of the nineteenth century would have felt was a good deal less but which can actually be a great deal more: the artist's ability to please, charm, intrigue and affect the spectator by means of line and colour that are only loosely connected with the facts of ordinary vision.

Impressionist pictures fall into the category of 'attraction by association'. And their point is still not only obvious but, for many people, entirely valid. Although they laid great stress on painting the visual facts of real life, impartially, the Impressionists tended to concentrate on scenes with a high pleasure content. Bars with pretty barmaids (Plate 81), the seaside in summer with the flags flying (Plate 72), even a simple vase of spring flowers (Plate 77), coincide with the kind of things that most of us enjoy.

The Impressionist world is still our world—or is it? Is it not our world subtly enhanced, without our quite realizing it, by affectionate artistry and the passage of time? Wish-fulfilment, in fact, plays a very important part in our taste; and it is the perfect fifth columnist, operating best when we are least aware of it. Nostalgia is merely wish-fulfilment in the past tense. Impressionism, the perfect democratic art form, offers a wonderful escape route from the drabness of everyday existence that we can all still believe in. So does Constable in pictures like *The Haywain* (Plate 56), a subject which in Britain apparently outsells all other large colour prints. With its loving evocation of a rural existence, it performs a comparable function, in painting, to the Western in the cinema and on television. Their pace may be different; but both have become popular symbols of escape from the wearying and monotonous complexity of modern city life.

All of us have cherished recollections of childhood, when the summers were hotter, the days longer, and when the snow in winter was always deep and crisp and dazzlingly white. Works of art, partly because they belong to the past, can sometimes have the sharp intensity of a childhood memory; and I suspect that this is part of their appeal to us. Bruegel's *Hunters in the Snow* (Plate 20) has few rationally pleasing associations at all (imagine having to climb all the way back up that hill); but it does have just that air of enclosed intensity, the feeling of an adventure lying ahead, that recaptures a quality of early memories.

One of the most interesting features of the modern shops that sell large colour reproductions is the wide variety of choice, reflecting modern breadth of taste and, in particular, a healthy absence of prudishness. The average Victorian thought Bruegel was vulgar and would certainly have labelled Bosch's '*Garden of Earthly Delights*' (Plate 11) and Bronzino's *Allegory* (Plate 13) indecent. The Bosch, which *looks* completely irrational, might seem at first to contradict what has so far been suggested about popular taste; it is not naturalistic, it is not pretty, and it is difficult to understand. But there is a key: the sub-conscious. People may look upon it with alarm or merely be amused by it; but whether we like it or not, psychiatry has become part of the currency of modern thought. And the dream, the irrational idea, often so cumbersome in words, is ideally suited to the visual arts. The technical tricks of the cinema, where dreams can be suggested with great virtuosity, and even ten-minute cartoons in which mice, dogs, cats and birds are momentarily crushed into surrealistic shapes, have conditioned us not merely to accept but actually to enjoy the irrational in art, and to make with ease the necessary connection between two dissimilar ideas that underpins a work like Picasso's *Three Musicians* (Plate 87). The popularity of Dali hardly needs comment.

There must be a great many of us who enjoy looking at the paintings of Bosch and Bruegel in books and colour prints but have never seen the pictures themselves. In any consideration of popular taste, allowance must always be made for the role played by repro-

ductions in disseminating pictorial images. Before the invention of photography, lovers of art who could not afford to buy the originals had to be content with various types of engraving. Although these could be coloured, at first by hand and later mechanically, they were usually black and white and were at their most attractive when the painting or design reproduced was conceived in terms of clear outline and carefully observed detail, as in the case of Dürer's *St Eustace* (Plate 23) or Munch's *The Scream* (Plate 70). It would have been virtually impossible to do justice to the merits of a very free painting by Turner in 1835. But as the photographic processes developed, initially in black and white and then in colour, so the range of what could be reproduced widened. The great popularity of the Impressionists, the Post-Impressionists and many later artists cannot be defined only in terms of what people respond to in exhibitions and museums; it must also be related to the possibilities of colour reproduction. Which of us has not bought a postcard of a work unknown to us in the original merely because we have been attracted by what was printed on a small piece of cardboard?

Unfortunately public love can swiftly lead to public exploitation, in the ordinary printed media and even on biscuit tins, trays and chocolate boxes. But images can take a terrible battering and yet somehow survive; and it is the much used, much abused image, at once vulnerable and banal, that has been a potent source of inspiration to Andy Warhol. The face of the young and still confident Marilyn Monroe, in Warhol's silk-screen print (Plate 96), looks as if it were on the point of dissolving in the very constituents of its own repetitive familiarity, the printer's actual techniques caught in the act of devouring what they feed on. A disturbing symbol, in our age of mass production and instant mass communication, of what real popularity in the visual arts can lead to.

Giotto (1266?-1337)

1 The Pietà

Fresco. About 1303–5. Padua, Arena Chapel.

One of a series of frescoes illustrating the life of Christ, painted by Giotto on the walls of a small family chapel built by the wealthy Enrico Scrovegni next to his palace in Padua. The *pietà*, a familiar theme in European painting, shows the lamentations over the body of the dead Christ after he had been taken down from the Cross. The fresco's great impact depends partly on the simplified setting and on the figures, whose feelings are given a touchingly direct visual expression, and partly on the variety of the response to the tragedy. The Virgin Mary, who cradles the head of her Son in her lap, shows a gentle sorrow, in contrast to St John the Evangelist, arms outstretched in passionate grief, and the dignified figures of Nicodemus and Joseph of Arimathea on the right. The tragic mood is echoed by the lamenting angels above.

Artist Unknown

2 Richard II presented to the Virgin and Child by his Patron Saints ('The Wilton Diptych')

Two panels, each 18 × 11½ in. About 1395 or later. London, National Gallery.

A diptych is a painting on two hinged panels, which can be closed like a book and easily transported without damaging the surfaces of the picture. This one, formerly at Wilton House, near Salisbury, shows Richard II of England being presented to the Virgin and Child by his patron saints, St John the Baptist (with a lamb), St Edward the Confessor (with a ring) and St Edmund, King and Martyr (with an arrow). Richard's hands are raised, not in prayer, but in hopeful expectation of the Child's blessing. The image of the King (who was born in 1367 and died in 1400) should not be regarded as a portrait in the modern sense. As the gold background itself implies, the nature of the image is essentially symbolic and embodies a flattering view of royal piety. Little is known about when the diptych was painted or, indeed, who painted it; but it may have been produced in connection with a crusade.

Fra Angelico (c.1387?-1455)

3 The Annunciation

Fresco. About 1435–45. Florence, Museum of San Marco.

Christianity has been so pervasive an influence in many people's lives that both believer and non-believer are apt to forget that no reliable evidence exists as to what Jesus Christ, his family and disciples actually looked like. And so, in past centuries—when the feeling for historical evidence was in any case less highly developed —biblical pictures often reflected the artistic preoccupations of the time and place in which they were created. Guido di Pietro (known as Fra Angelico) was a Dominican friar as well as a painter; and his most famous achievement was the series of some fifty frescoes with which he decorated the Dominican friary of San Marco in Florence. Many of them are in the individual cells and were intended as aids to religious contemplation. *The Annunciation* is one of the most beautiful; but even here, in a sacred scene, the fifteenth-century Italian interest in a revival of classical forms employed in ancient, pagan Rome is evident in the delicate architecture.

Jan van Eyck (c.1390?-1441)

4 The Arnolfini Marriage

Panel, 32¼ × 23½ in. Signed and dated 1434. London, National Gallery.

This picture occupies an important place in the history of European painting. Nothing comparable survives; and without it, a whole dimension of Jan van Eyck's art would be lost to us. The accurate observation of detail, the sense of space and the rendering of light look forward to the art of seventeenth-century Holland (see Plate 25). Both the identification of the couple and the precise meaning of the scene are in some doubt; but the painting probably represents Giovanni Arnolfini and his wife, Giovanna Cenami, both members of Italian merchant families living in northern Europe. And it is likely to have been a marriage picture. In this case, the elaborate Latin inscription (meaning 'Jan van Eyck was

here') and the artist's own figure, reflected in the mirror, imply that he had been a witness. Some of the details, while depicted naturalistically, would also have had a symbolic meaning. The statuette surmounting the back of the chair next to the bed shows St Margaret, the patron saint of childbirth; the single candle (burning in the middle of the day) symbolizes the all-seeing Christ; the fruit on the window-sill represents the Innocence before the Fall; while the griffon terrier is a symbol of fidelity. The lady's stance relates to the fashions of the period, and is not an allusion to pregnancy.

Piero della Francesca (1410/20-92)

5 The Baptism of Christ

Panel: 66 × 45¾ in. About 1450–5. London, National Gallery.

Like Fra Angelico's *Annunciation* (Plate 3), this picture reveals as much about the artist's interests as it does about Christ's baptism by St John the Baptist in the River Jordan, which Piero has imagined as being just outside his native town of Borgo San Sepolcro. The walls and towers are visible to the left of Christ; in the distance are the Tuscan hills. *The Baptism* was painted for one of the town churches; and for the congregation the meaning of the scene must have been immeasurably strengthened by the familiarity of the setting. The treatment of Christ's figure expresses the Renaissance concern with the ideal body as a symbol of the Perfect Man, a theory developed to its supreme conclusion by Michelangelo.

Sandro Botticelli (c.1445-1510)

6 The Birth of Venus

Tempera on linen, 70 × 111½ in. Probably about 1485–90. Florence, Uffizi.

Venus, the goddess of love in classical mythology, stands on a seashell, which is being blown towards the shore by two zephyrs, personifications of the winds. On the right, a nymph hurries forward to offer her a cloak. The painting came from the villa of Lorenzo di Pierfrancesco de' Medici, and may have been painted for the owner when he was a young man, as an allegory of the importance of the more tender human values, which in fifteenth-century Florence were often symbolized by the figure of Venus. The universal admiration for Botticelli's exquisite painting is surely based on the beautiful drawing of the figures, their lightness and grace, and on the gentleness of Venus herself. If she were more obviously sensual, as her mythological role would permit, she would probably be less popular. As it is, she seems almost as chaste as one of Botticelli's wistful Madonnas. It is rather interesting to compare her with Rubens's fleshier, more carnal Venus, in the centre of *The Judgement of Paris* (Plate 15).

Michelangelo (1475-1564)

7 The Creation of Adam

Fresco. 1511. Vatican (Rome), Sistine Chapel.

This is the most famous and popular of the scenes on the Sistine Chapel ceiling, which measures approximately 44 by 130 feet, contains some 300 figures and took four years to paint (1508–12). Like Giotto (see Plate 1), Michelangelo relied on the figures and gestures to carry the meaning and emotional weight of the stories. He has always been so highly praised for the heroic and sublime character of his imagery that it is easy to forget that he was also— quite simply—a skilled professional artist. What is sublime is also effective, like the two fingers that almost touch—a master-stroke of pictorial invention. Michelangelo also realized that since the fresco was about sixty-five feet above the floor only relatively simple effects could be properly seen by the spectator below. Ornament and detail are reduced to a minimum; and a comparison with the preparatory drawing (Plate 18) shows how the outlines of Adam's body and the pattern of light and shade across the torso have been simplified in the fresco.

Raphael (1483-1520)

8 Madonna della Sedia

Panel, diameter 28in. About 1513–14. Florence, Palazzo Pitti.

The *Madonna della Sedia* ('Madonna of the Chair') is probably now the most celebrated of Raphael's Madonnas, having taken the

place of the *Sistine Madonna*, which since the Second World War has been relatively inaccessible in East Germany. It shows the Virgin Mary comforting the Child, watched by the adoring infant St John. The arrangement of the figures within the circle is extremely ingenious: there is variety in the angles of the heads and in the contrasted poses of the Mother and Child, but it is a variety subordinate to an overall harmony. Note, too, how the upright post of the chair establishes a strong vertical accent, which helps to stabilize the composition. But as well as compositional skills and a beautiful technique, Raphael also possessed, to a supreme degree, the ability to idealize a subject without losing sight of its humanity. He was a master of those delicate areas of feeling where human sentiment and religious reverence begin to merge and become almost indistinguishable.

Leonardo da Vinci (1452-1519)
9 Portrait of an Unknown Lady (The 'Mona Lisa')

Panel, 30¼ × 20⅞ in. About 1506–13. Paris, Louvre.

Although this is probably the most famous picture in the world, even familiar to many who have not seen the original, surprisingly little is known about it. The name of the sitter is not reliably documented; and the date is far from certain. The lady is seated in a chair in front of a window. The panel has been slightly cut, to left and right, so that only the bases of the columns at the sides are now visible. The landscape behind her, a strange mountainous world that recurs in other works by Leonardo, suggests that this is not simply the portrait of a young woman who happened to be sitting by a casement at home. And while the portrait may have been based on an individual likeness, the image as we now see it is much closer to Leonardo's feminine ideal, with the gentle but mysterious smile, to be seen in various religious pictures by him. The composition of the portrait is very impressive—look at the simple, easy yet perfectly balanced pose of the body and arms and the lovely arrangement of the hands; but it is the expression on the face and, in particular, the smile which continues to intrigue visitors who cluster round the heavily protected original in the Louvre. What can she be thinking about? The answer could be—nothing at all. Leonardo may simply have had in mind a face, a visible expression, that would symbolize the invisible qualities of the human mind, the fugitive, constantly changing nature of thoughts and feelings. And if that was Leonardo's aim, he succeeded. The lady may be unknown, and what she is thinking about indecipherable, but there is certainly no other portrait that evokes so strongly the fascinating but ultimately mysterious power of the human personality.

Albrecht Dürer (1471-1528)
10 Study of a Hare

Watercolour and body-colour, 9⅞ × 9 in. Signed and dated 1502. Vienna, Albertina.

One of the most famous of all Dürer's works, this study of a hare shows his extraordinary powers of observation and meticulous technique, unparalleled in northern Europe since the days of Van Eyck (compare, for example, the terrier in the Arnolfini marriage picture, Plate 4). Dürer was among the most versatile of Renaissance artists, being active as painter, draughtsman and engraver (Plate 23). He was perhaps the first to achieve a European reputation as a print-maker.

Hieronymus Bosch (c.1450-1516)
11 'The Garden of Earthly Delights'

Panel, 88 × 78 in. Madrid, Prado.

The central panel from a triptych (a main subject with separate, usually hinged, scenes on either side). Bosch is a mysterious artist, about whom we have very little information. The left wing of this triptych shows Paradise with Adam and Eve; the right wing, Hell. The central scene, reproduced here, depicts the life of the senses and, in particular, Lust. Sex, in the Middle Ages, was looked upon with a great deal of anxiety; in theological terms—the basis for Bosch's altarpiece—it was seen as an element in the Fall from Grace (shown on the left wing) that might, indeed probably would, lead straight to Hell (shown on the right wing). The modern spectator, more relaxed about sex, probably less

worried about religious issues, and familiar with the Surrealism of Dali (see Plate 93), is in a good position to enjoy Bosch's painting to the full; but he may also underestimate the seriousness of its original purpose.

El Greco (1541?-1614)
12 View of Toledo

Canvas, 47⅝ × 43 in. Signed; about 1595–1600. New York, Metropolitan Museum of Art.

Domenikos Theotocopoulos, known as El Greco ('The Greek'), was born in Crete, but migrated to Venice, where he seems to have trained in the studio of the aged Titian; he eventually settled in Toledo in Spain. His very strange and beautiful style, with its elongated forms and flickering brush strokes, represents a fusion of the Byzantine art of his native Crete, Italian Mannerist elements and the broad Venetian approach to colour and handling. It is only in this century that El Greco's visionary art has come to be fully appreciated again. This famous *View of Toledo* is one of the only two landscapes by him to have survived.

Bronzino (1503-72)
13 An Allegory

Panel, 57½ × 45¾ in. About 1545–6. London, National Gallery.

Bronzino was Court Painter to Cosimo I de' Medici, the Grand Duke of Tuscany. He is best known for his portraits, which, like this *Allegory*, are painted with an icy precision and control. He also painted religious subjects. *An Allegory* is probably the most famous, and perhaps the most distinguished, of his works other than portraits. The precise meaning of the subject is unknown, but it is generally agreed that the picture illustrates the perils of a love that is exclusively sensual. In the foreground, Venus, the goddess of love, kisses Cupid. The naked *putto* on the right, who is about to throw rose petals at the couple, symbolizes Pleasure. In the background to the left Jealousy tears her hair. The mysterious creature behind Pleasure, with the face of a girl, the hindquarters of an animal and a tail that ends in a scorpion's sting, is about to present Venus with a honeycomb. The contrast between the gift of the honeycomb and the sting indicates that she symbolizes Deceit. Sensual love thus leads to Jealousy and Deceit and, however secret, is ultimately revealed by Time (the bald man at the top with the wings and the hourglass) and Truth (upper left), who is evidently pulling away the curtain from the other figures. It is interesting to compare this moral allegory with the painting by Bosch (Plate 11).

Titian (c.1485?-1576)
14 Diana and Actaeon

Canvas, 74 × 80 in. About 1556–9. Edinburgh, National Gallery of Scotland (on loan from the Duke of Sutherland).

This painting illustrates a famous classical legend, related in detail by Ovid. While out hunting in the Boeotian woods, the huntsman Actaeon suddenly and unexpectedly came upon the goddess Diana and her attendant nymphs while they were bathing in their sacred spring. Furious at this embarrassing intrusion by a mere mortal, Diana sprinkled Actaeon's head with water, crying 'Now tell that you have seen me naked—providing you are able to tell!' The unfortunate youth was then turned into a stag and torn to pieces by his own hounds—the subject of another superb painting by Titian recently acquired by the National Gallery in London. Actaeon's subsequent fate is alluded to here in the stag's head on the pillar. Classical themes, given the stamp of intellectual respectability by virtue of their origins in Greek and Latin literature, often provided important patrons like King Philip II of Spain (for whom the *Diana and Actaeon* was painted) with a justification for hanging paintings of the nude in their palaces in spite of the very strict Catholicism that they both obeyed and promoted.

Sir Peter Paul Rubens (1577-1640)
15 The Judgement of Paris

Panel, 57 × 76¼ in. About 1632–5. London, National Gallery.

According to the classical legend, three goddesses, Juno, Minerva and Venus, quarrelled about which of them should be awarded the apple

as the most beautiful. The three rivals agreed to accept the judgement of Paris, who was really the son of Priam, King of Troy, but had been brought up on Mount Ida as a simple herdsman. Each of the goddesses tried to bribe Paris, Minerva by promising wisdom, Juno power and Venus the most beautiful woman in the world. Paris awarded the apple to Venus and was himself later rewarded with Helen of Troy. Rubens has chosen to show the moment when Paris offers the apple to Venus, who stands between Minerva (with her attributes, owl, helmet, shield and spear) and Juno, whose peacock glares at the dog. The setting has been turned into a Flemish landscape; and the goddesses embody reminiscences of Rubens's second wife, Hélène Fourment, whom he had married in 1630, when she was sixteen. The figure behind Paris is Mercury, the messenger of the gods. Note how the silhouettes of the three goddesses are enlarged, visually, by a clever deployment of drapery and accessories. This ensures that the background does not assume an undue prominence.

Marcus Gheeraerts the Younger (c.1561-1635)
16 Queen Elizabeth I

Canvas, 93 × 59 in. About 1592. London, National Portrait Gallery.

In 1592, one of Elizabeth's courtiers, Sir Henry Lee, received the Queen at Ditchley, his Oxfordshire home; this portrait was almost certainly painted to commemorate the occasion. The Queen stands on a map of England and her feet rest on the Oxford area. Like many people accustomed to great power, Elizabeth had a sharp appetite for flattery. Although she was 59 in 1592, the face shows few signs of age, Gheeraerts having faithfully followed a royal injunction against showing her features in any kind of shadow, which suggests wrinkles. This, then, is not quite the woman whom you might have seen sweeping through the candle-lit rooms of old Whitehall Palace. The portrait is not only a record of vanity; it is also a calculated image of power. In the top left-hand corner there is a bright light symbolizing the sun. The visual implication is that the Queen of England, in her splendid clothes studded with jewels, outshines even 'The prince of light', the opening phrase of the explanatory poem on the right. Bad physics, perhaps, but good propaganda.

Sir Anthony Van Dyck (1599-1641)
17 Henrietta Maria, Queen of Charles I

Canvas, 41½ × 33¼ in. 1636-7. New York, Private Collection.

King Charles I (1600–49), unlike Queen Elizabeth, who was not especially interested in the visual arts, was the greatest royal patron and collector Britain has ever known. As a child he would have been familiar with the flat, decorative and often extravagant Elizabethan style, of which Plate 16 reproduces a fine example. But when he grew up, he came to know, and love, the best Italian Renaissance art, particularly the works of Titian that he collected in impressive numbers. (He would have received the *Diana and Actaeon* (Plate 14) as a wedding present had he gone through with the Spanish marriage in 1623.) And he looked for contemporary artists who could embody in their pictures both the ease and fluency and the dignified yet realistic air of the best Continental art, past and present. Van Dyck, who settled in England in 1632 and was given a knighthood the same year, was an almost perfect answer to Charles's prayers. With every sympathy for what was refined and elegant, and with a sensitive yet lively technique partly modelled on a close study of Titian's work, Van Dyck was able to give his portraits an air of aristocratic distinction, ideally suited to the needs of the King and his court. This beautiful painting of Charles's Queen, the French-born Henrietta Maria, has a grace and suggestion of gentle good breeding that make the *Queen Elizabeth* (Plate 16) seem, by contrast, absurd and overstrained. Indeed, we would probably be quite prepared to believe that this is how Henrietta Maria actually looked were it not for the alternative evidence. Sophia of Bavaria, for example, saw her in Holland in 1641 and wrote: 'Van Dyck's handsome portraits had given me so fine an idea of the beauty of all English ladies, that I was surprised to find that the Queen, who looked so fine in painting, was a small woman raised up on her chair, with long skinny arms and teeth like defence works projecting from her mouth . . .' An unkind comment; but an implicit tribute to the propaganda value of Van Dyck's work. The picture is almost certainly the canvas documented as in progress in December 1636. The Princess Anne, the couple's third daughter, was born on 17 March 1637; and the cradling gesture of the Queen's hands probably refers to her pregnancy.

Michelangelo (1475-1564)
18 (top) Study for 'The Creation of Adam'

Red chalk, 7½ × 10¼ in. About 1510–11. London, British Museum.

(bottom) Male Torso

Black chalk, 7¾ × 11 in. About 1504. Vienna, Albertina.

Michelangelo's mastery of the male nude, in both painting and sculpture, depended on profound and prolonged anatomical observation, recorded in a matchless series of drawings. The upper drawing is a study for the reclining figure of Adam (Plate 7); the general pose was established from the start but Michelangelo corrected the outline of Adam's left thigh and made two separate studies on the same sheet for the right hand. The lower drawing is a preparatory study for one of the figures in a lost fresco, which showed a group of soldiers surprised while bathing.

Raphael (1483-1520)
19 Studies for 'The Transfiguration'

Black chalk, 19⅝ × 14¼ in. 1517–19. Oxford, Ashmolean Museum.

In preparation for a painting, and especially if the composition was elaborate and involved a number of figures, it was common practice in the past for artists to make drawings, to ensure accuracy of detail, for example, or to clarify the grouping of the figures. This is a study of the heads and hands of St Peter and St John (left) in the famous picture, now in the Vatican, commissioned in 1517 but still unfinished when Raphael died in 1520.

Pieter Bruegel the Elder (c.1525-69)
20 The Hunters in the Snow (January)

Panel, 46 × 63¾ in. Signed and dated 1565. Vienna, Kunsthistorisches Museum.

The Hunters in the Snow, one of a series of pictures which symbolize the months of the year, represents January. It is not a view of a particular place in winter but a scene with all the elements appropriate to a snowy landscape. The mountains of Switzerland, which Bruegel had seen and drawn on a journey to and from Italy, are combined with the flat scenery of his native Netherlands. With its hunters, skaters, busy peasants and exciting sense of distance, it is a wonderful painting to explore. But equally important is the way in which the artist has managed to include many precisely observed details without undermining his powers of pictorial simplification. Look, for instance, at the way the hunters' feet sink into the soft snow as they trudge over the hill. The hunters, the dogs with their curling tails and the trees with their network of snow-lined branches, have the visual impact of a poster. It is a painting to look at and to look into, so perfectly does it combine pattern and detail.

Aelbert Cuyp (1620-91)
21 River Landscape with Horseman and Peasants

Canvas, 49 × 96¼ in. Late 1650s. Cardiff, National Museum of Wales (on loan from the Marquess of Bute).

One of the main aims of landscape painters in the past was to show the variety of nature; and they evolved elaborate compositional schemes so as to be able to include a great deal of information in a picture without upsetting the harmony of the design as a whole. There are plenty of well-managed contrasts in this scene by Cuyp: there is the contrast between the spacious distance on the left and the more enclosed right half of the design; between the carefully described brambles in the foreground and the faraway milky horizon; and between the partly shaded areas in the front of the picture and the sunlit town beyond the river. The harmonious beauty of Cuyp's landscape in part depends on the skilfully worked out composition; but it also relies on the pervasive golden light. This type of sun-drenched landscape was chiefly developed by the influential artist Claude Lorraine (see Plate 31), whose landscape's often include incidents from the Bible and classical literature; but Cuyp rarely introduces literary subjects. The heroes and heroines of his idealized Holland are usually the herdsmen and shepherdesses—even the cattle—of a rural economy. If there is drama, it is on a small scale, like the hunter in the

River Landscape who crouches behind the bushes, aiming his gun at the ducks in the water.

Hans Holbein the Younger (1497/8-1543)
22 Sir John Godsalve

Pen and ink, chalk and watercolour, $14\frac{1}{2} \times 11\frac{5}{8}$ in. About 1532? Windsor Castle, Royal Library.

Holbein, who was born in Germany, spent the last eleven years of his life in England, partly as a Court Painter to Henry VIII; and his paintings and drawings are an invaluable record of the appearance of the King and his courtiers. Holbein had a sharp and objective eye for a likeness, and, like Velázquez (see Plate 28), seems to have been undeterred by the rank or power of his sitters. He combined an acute feeling for the outline and solidity of the figure as a whole with an attention to detail as patient and accurate as a watchmaker: look, for example, at the stubble on the chin or the lower lashes of the right eye. No other portraitist, with the possible exception of Ingres (see Plate 48), has ever been able to combine these two artistic qualities quite so well. Godsalve held various Court appointments under Henry VIII and Edward VI, and died in 1556.

Albrecht Dürer (1471-1528)
23 The Vision of St Eustace

Engraving, $14 \times 10\frac{1}{4}$ in. About 1501. London, British Museum.

This extraordinary print, with its lavish amount of detail, illustrates the legend of a Roman soldier of noble birth who, while out hunting, came upon a stag with a crucifix between its antlers. The stag addressed him in the name of Christ. The soldier, deeply moved by the miracle, became a Christian and died for his faith. He became known as St Eustace. Dürer has not attempted to set the scene in Roman times; the hill in the background is covered with medieval buildings and Eustace himself is dressed in late fifteenth-century costume.

Rembrandt (1606-69)
24 Self-Portrait

Canvas, 45×37 in. Painted about 1662-3. London, Kenwood House, Iveagh Bequest.

No other artist has left us so compelling and honest a record of his own features as Rembrandt; and of the fifty or so painted self-portraits that survive this is perhaps the grandest, informal in character yet heroic in mood. The clothes, palette and brushes are depicted in only the most general terms but they are completely convincing because of the vivid treatment of the head. In comparison with Plate 4 or Plate 13, the strokes of paint are applied loosely and openly; Rembrandt's technique is revealed for all to see. The extraordinarily hypnotic quality of the finest paintings in a broadly handled style—of which this self-portrait and Velázquez's *Juan de Pareja* (Plate 28) are supreme examples—lies partly in the way that maximum pictorial conviction seems to be combined with the minimum technical pretence. It is a form of conjuring raised to the level of great poetry. Rembrandt, in his working clothes, stands in front of a large canvas, an edge of which is visible on the upper right-hand side of the picture.

Jan Vermeer (1632-75)
25 A Painter in his Studio

Canvas, $51\frac{1}{4} \times 43\frac{1}{4}$ in. Signed; about 1665-6. Vienna, Kunsthistorisches Museum.

This famous work, looted by Hitler for his private collection, shows an artist (not necessarily Vermeer himself) painting a picture that probably represents Clio, the muse of history. What distinguishes Vermeer's interiors from those painted by his contemporaries are his extremely subtle sense of design and his astonishingly accurate observation of light. In this picture, every element—from the curtain on the left and the beams in the ceiling to the placing of the figures and the pattern of the floor—contributes to the harmony of the composition. Look at the way the light strikes the map of the Netherlands, showing up every wrinkle, and how it brings out the metallic sheen of the chandelier. No detail was too insignificant for Vermeer, who was just as concerned with how the woven threads in

the curtain and the gleaming studs on the chairs reacted to the all-embracing light.

Guercino (1591-1666)
26 A Theatrical Performance in the Open Air

Pen and brown ink, with wash, $14\frac{1}{4} \times 18\frac{1}{4}$ in. London, British Museum.

Apart from their intrinsic beauty, drawings can also reveal aspects of an artistic personality that are neither so easily discernible nor, in the past, even possible in the more formal medium of oil painting. Most of Guercino's easel pictures are of traditional religious and mythological subjects; but this charming study, probably made before 1621 (and thus within a few years of Shakespeare's last plays), throws an interesting light on seventeenth-century life. It may be related to a theatre built by Barstolomeo Fabri at Cento, Guercino's birthplace, near Bologna. The artist is known to have painted scenery for this theatre.

Rembrandt (1606-69)
27 (*left*) Young Woman at her Toilet

Pen and wash, $9\frac{3}{8} \times 7\frac{1}{4}$ in. About 1632-4. Vienna, Albertina.

(*right*) Sleeping Girl

Brush and wash, $9\frac{5}{8} \times 8$ in. About 1655-60. London, British Museum.

In addition to his mastery in painting and etching, Rembrandt was also one of the greatest of European draughtsmen. He used drawing to extend his imaginative powers, depicting episodes from the Bible in more or less contemporary terms, to sharpen his powers of observation and also to record what pleased and moved him—surely the case with these two tender studies of domestic life. The *Sleeping Girl*, one of the most celebrated of his 1,400 surviving drawings, may represent Hendrickje Stoffels, with whom he lived some years after the death of his wife, Saskia.

Diego Velázquez (1599-1660)
28 Juan de Pareja

Canvas, $32\frac{1}{4} \times 27\frac{1}{2}$ in. 1649-50. New York, Metropolitan Museum of Art.

Like Holbein and Van Dyck, Velázquez worked as a Court Painter, to Philip IV of Spain. And the really remarkable feature of his career is that the demands of royal patronage in no way corrupted the objectivity of his artistic vision. He could record the King's face as it grew older and sadder, so that in the last portraits it is scarcely distinguishable from that of a minor court official resigned to waiting for his pension, just as he could record the innate dignity of the mulatto, Juan de Pareja, who was his studio assistant. Look at the proud carriage of the head and the steady, unwavering expression in the eyes. This painting has the dubious distinction of being, to date, the most expensive work of art ever sold at auction: on 27 November 1970 it fetched £2,310,000 at a sale in London.

Frans Hals (*c.*1580-1666)
29 Portrait of a Young Man ('The Laughing Cavalier')

Canvas, $33\frac{5}{8} \times 27\frac{1}{4}$ in. Dated 1624. London, Wallace Collection.

All that we know about the sitter in this famous portrait is what the inscription tells us: that he was 26 years of age in 1624. The familiar title was not given to the picture until the second half of the nineteenth century; and it is not quite correct. The young man is smiling rather than laughing. And once again, as in the case of the '*Mona Lisa*' (Plate 9), the expression has more to do with the artistic preoccupations—and in particular Hals's interest in lively, fleeting effects—than with the actual character of the sitter. The supreme popularity of '*The Laughing Cavalier*' partly depends on the brilliant painting of the clothes, especially the treatment of the embroidered sleeves, but mainly on the look on the young man's face, jaunty, confident and with just a touch of provocation. After Rembrandt, Hals was the greatest Dutch portrait painter of the seventeenth century.

Sir Peter Paul Rubens (1577-1640)

30 (*top*) **Farmyard Scene**

Black and red chalk, 10 × 16½ in. About 1615–17. Chatsworth (Derbyshire), Trustees of the Chatsworth Settlement.

(*bottom*) **A Bullock**

Black and red chalk, 11⅛ × 17⅛ in. About 1618. Vienna, Albertina.

Rubens was one of the most versatile of the great seventeenth-century masters. Although he devoted most of his time to commissions for religious, mythological (Plate 15) and allegorical works, he also found time to become one of the finest landscape painters of the age. The many details in his big landscapes were frequently based on independent drawings like the two reproduced here.

Claude Lorraine (1600-82)

31 (*top*) **Seaport at Sunset**

Pen and wash brown, 5¼ × 8 in. About 1635–40. Chantilly, Musée Condé.

(*bottom*) **View from Monte Mario (?)**

Brown wash, 7¼ × 10½ in. About 1640. London, British Museum.

Claude Gellée (known in England as Claude Lorraine, or simply Claude) was a French painter, born in Lorraine, although he spent most of his life in Rome. He was the first great artist to achieve European fame exclusively as a landscape painter; kings and popes were among his clientele. His pictures, like Rubens's landscapes, tend to be elaborate, and he made many preparatory drawings for them. The *Seaport at Sunset* is a compositional study; the grid lines helped Claude to achieve the right balance and perspective for the design. A most delicate observation of light is one of the glories of his art; and he made endless studies of atmosphere, space and distance. The second of the two studies illustrated here probably shows the view from Monte Mario, near Rome, with the Tiber and the Tiburtine hills.

Antoine Watteau (1684-1721)

32 Spring

Canvas, 46⅞ × 38½ in. About 1715–16? Formerly England, Private Collection; destroyed by fire 1966.

33 (*top*) **Study for Flora in 'Spring'**

Crayon, 12⅝ × 10⅝ in. Paris, Louvre.

(*bottom*) **Studies of Nine Heads**

Crayon, 10⅝ × 16½ in. Palais des Beaux-Arts de la Ville de Paris.

Spring, tragically destroyed by fire a few years ago, was one of a set of four oval canvases, representing the Seasons, painted by Watteau for the dining-room of his friend and patron, the wealthy Parisian collector, Pierre Crozat. The treatment is of course symbolic—as it is in the most famous painting of the subject, Botticelli's *Primavera* in Florence. Flora, the goddess of flowers, is about to receive a floral crown from Zephyrus, who in Greek mythology personifies the West Wind (see also Plate 6). *Spring* is not a typical Watteau painting; he usually preferred compositions with a number of small figures shown in a defined, often woodland, setting. But common to all his work was the role played by preparatory drawings. Watteau was a brilliant draughtsman, to whom a delicate study of the female nude came as easily as the exquisitely incisive observation of individual heads. In Plate 33 (*bottom*) seven of the studies are of the same woman, seen from different angles. Watteau kept many of his drawings together in albums, for future reference, and the same figure often occurs in more than one painting.

Jean-Baptiste Siméon Chardin (1699-1779)

34 The Kitchen Maid

Canvas, 18¼ × 14¾ in. Signed and dated 1738. Washington, D.C., National Gallery of Art (Kress Collection).

In scenes of this type, Chardin was following in the seventeenth-century Dutch tradition (see Plate 25); but he usually made his compositions simpler. This enabled him to give full and careful value to each object depicted. Look at the way the various utensils are painted. Chardin also paid great attention to the overall surface of his pictures; and no other French painter, not even Watteau, can rival him for the beauty and delicacy of his textures. His sense of colour is one of the glories of French painting; and his palette is curious, soft and cool, but not cold. Both the quality and the unity of his colours were achieved by mixing white with his pigments. *The Kitchen Maid* was shown at the Paris *Salon* of 1739.

Jean Honoré Fragonard (1732-1806)

35 The Swing

Canvas, 32 × 25½ in. Probably 1768 or 1769. London, Wallace Collection.

The Swing shows how a smutty schoolboy joke can be turned into a work of art—indeed, the artist's masterpiece—by imagination, skill and taste. The idea for the picture was apparently given to Fragonard by his client, the Baron de St Julien, and the girl so carelessly displaying her charms was his mistress. The fairy-tale setting robs the scene of much of its indelicacy and the exquisite painting of the foliage and the girl's dress adds attendant notes of poetry. On the left there is a statue of Cupid, a finger to his lips; it is copied from an actual statue, carved some eleven years earlier by Falconet for Madame de Pompadour (see Plate 42).

William Hogarth (1697-1764)

36 (*top*) **Strolling Actresses Dressing in a Barn**

Engraving, 17 × 21¼ in. 1738.

(*bottom*) **Canvassing for Votes**

Engraving, 17 × 21¼ in. 1757.

Hogarth's European fame in the eighteenth century depended not on his paintings, which were known to relatively few people, but on his widely disseminated prints. Plate 36 (*bottom*) belongs to a set of four prints that show in rumbustious detail the hazards of Georgian democracy. Plate 36 (*top*) is one of his most enchanting compositions; and it suggests that in another incarnation Hogarth might have been a great comedian in silent films. The little boy dressed as Cupid who has gone up the ladder to hang out the stockings to dry on the stage clouds is pure Charlie Chaplin. The print also had a more serious intention, as a reminder of the strict theatrical censorship imposed in the previous year (1737) by the Prime Minister, Sir Robert Walpole, to muzzle Opposition playwrights like Fielding. In London, theatre was limited to the two licensed houses, Covent Garden and Drury Lane, and outside the capital it had virtually ceased to exist. The playbills visible in the engraving indicate that this was to be the provincial company's last performance prior to the act's coming into force.

G. D. Tiepolo (1727-1804)

37 (*top*) **Punchinello as a Tailor's Assistant**

Pen and wash, 11½ × 16¼ in. New York, Metropolitan Museum of Art (Robert Lehman Collection).

(*bottom*) **At the Milliner's**

Pen and wash, 12¾ × 16¾ in. Probably 1791. Boston, Museum of Fine Arts.

Giovanni Domenico was the son and principal assistant of the better-known Giovanni Battista Tiepolo (1696-1770). Although, like his father, he painted religious and mythological subjects, he is chiefly remembered for his fanciful scenes of contemporary life. Plate 37 (*top*) belongs to a series of over a hundred drawings of episodes from the life of Punchinello, one of the members of the *commedia dell'arte* (a group of traditional pantomime characters often impersonated by a company of strolling players). Punchinello was anglicized as Punch.

Antonio Canaletto (1697-1768)

38 Venice: A Regatta on the Grand Canal

Canvas, 48 × 72 in. About 1740. London, National Gallery.

An illustration of the annual regatta, held during the Carnival; some of the spectators wear the *bauta*, a domino of white mask and black cape that could only be worn at carnival times. The regatta

had been an established institution in Venice since at least 1315 and by the eighteenth century was one of a whole series of events that made the city the great pleasure resort of Europe. Canaletto was well aware of the tourist trade and painted many of his pictures for wealthy visitors. When the War of the Austrian Succession led to a decline in the number of tourists, he followed his best clients to England, where he stayed, on and off, from 1746 to about 1756. The charm of Canaletto's best Venetian pictures depends partly on the subject but, to an even greater extent, on the light, buoyant way they are painted. In the picture reproduced here the curly ornaments on the boats, the ripples on the water and the crowds which line the canal, are conjured up in deliciously deft flourishes of pigment.

George Stubbs (1724-1806)
39 Mares by an Oak Tree

Canvas, 39 × 74 in. 1764–5. Ascott, Wing, The National Trust (Rothschild Collection).

Stubbs was perhaps the finest of all painters of the horse, and certainly one of the masters of British painting. He combined an acute knowledge of equine anatomy, based on careful dissection, with a very subtle eye for pictorial composition and colour relationships. In this picture, one of a series showing mares and foals that he produced in the 1760s, the five animals are spaced across the canvas in such a way that they form a harmonious frieze without impairing the value and interest of the individual studies. The landscape setting is painted with particular delicacy.

Giovanni Battista Piranesi (1720-78)
40 Fantastic Prison Scene

Etching, 16 × 21¼ in. 1745–61.

Piranesi was born near Venice, but moved to Rome as a young man, where he produced a famous series of etched views of his adopted city. But his greatest achievement was his *Carceri d'Invenzione*, a series of fantastic prison scenes, where the workings of his strange imagination are evident in the weird interiors filled with towers, drawbridges, staircases, ropes and various instruments of torture.

Jacques Louis David (1748-1825)
41 The Oath of the Tennis Court

Pen and ink and wash, 25⅝ × 41¾ in. Signed and dated 1791. Paris, Louvre (deposited in the Musée de Versailles).

David was the most important French painter in the last quarter of the eighteenth century. A man of action as well as an artist, he was involved in the French Revolution, his fidelity to Robespierre gaining him two periods in prison. Afterwards he became Napoleon's official First Painter. This drawing, the main record that we have of a vast painting that he planned but never realized, shows a key event in the early history of the Revolution: the moment when the Deputies of the Third Estate swore, on 20 June 1789, 'never to separate but to meet together wherever circumstances demand until the Constitution of the Kingdom has been established and confirmed on a solid basis'. The tennis court in the Palace of Versailles was used as a meeting place because the deputies had been refused admission to more suitable premises.

François Boucher (1703-70)
42 The Marquise de Pompadour

Canvas, 79 × 62 in. Dated 1756. Munich, Alte Pinakothek, Bayerische Hypotheken- und Wechsel-Bank Collection.

In the portraits by Velázquez (Plate 28) and Hals (Plate 29) reproduced in this album the sitters are isolated against a plain background; everything depends on the treatment of the heads. Boucher shows Louis XV's most celebrated mistress, Jeanne Antoine Poisson (1721–64), created Marquise de Pompadour, in a setting appropriate both to her domestic role and to her patronage of the arts; and it is the brilliant rendering of the cabinet reflected in the mirror, the little table at the side of the *chaise-longue* and the lavishly trimmed dress, as much as the painting of her actual face, that accounts for the charm and assurance of the portrait. At her feet lie a portfolio of drawings, music scores and an

engraver's burin, all symbolic of her interest in the arts. Her personal seal lies on the side table. The portrait was shown at the Paris *Salon* in 1757.

Thomas Gainsborough (1727-88)
43 Jonathan Buttall ('The Blue Boy')

Canvas, 70 × 48 in. Probably 1769–70. San Marino, California, Henry E. Huntington Library and Art Gallery.

The authority and elegance of Van Dyck's style (see Plate 17) had a profound influence on British portrait painting. Gainsborough actually kept a 'Van Dyck costume' in his studio; and he used it in this picture of the teenage Jonathan Buttall, who, in spite of appearances, followed his father's trade of ironmongery in Greek Street, Soho. Probably shown at the Royal Academy in London in 1770, 'The Blue Boy' may not have been a formally commissioned portrait but a kind of homage to Van Dyck, whose paintings Gainsborough admired and copied. The wild landscape, a slightly odd setting in which to find so beautifully dressed a figure, is a reminder of Gainsborough's abiding love of nature and mastery of landscape painting.

Francisco Goya (1746-1828)
44 The Colossus

Mezzotint, 11¼ × 8¼ in. About 1810–18. London, British Museum.

Goya began his career as a painter of relatively conventional religious pictures and portraits, and as a creator of charming tapestry designs. His life was changed, however, by a serious illness in 1792, which made him totally deaf, and later by the Napoleonic Wars, which left in Spain, as elsewhere, their trail of bloodshed, hatred and treachery. Goya's work matched the mood of the times in its evocation of bestiality (the *Disasters of War* prints) and its deep pessimism and sense of anxiety—perfectly reflected in *The Colossus*, the image of a giant sitting, it would seem, on the edge of the world and looking over his shoulder as if uncertain whether or not to destroy it.

Théodore Géricault (1791-1824)
45 (top) Four Views of a Guillotined Head

Black chalk, 8¼ × 11 in. About 1818–19. Paris, Private Collection.

(bottom) Entrance to the Adelphi Wharf, London

Lithograph, 10 × 12¼ in. 1821.

Géricault, whose work was greatly admired by his friend Delacroix, (Plate 51) had a short, brilliant and tragic career. He was the first great painter of the French Romantic movement and, again like Delacroix, often chose themes illustrating man and nature under stress. His masterpiece, the *Raft of the 'Medusa'*, in the Louvre, shows the exhausted survivors of a shipwreck at the moment when they first see the rescue ship. In preparation for this vast undertaking, Géricault made many studies, sometimes to get himself into the requisite mood. 'For several months', an early authority tells us, 'his studio was a kind of morgue. He kept cadavers there until they were half-decomposed, and insisted on working in this charnel house atmosphere . . .' The head shown here belonged to a thief; and Géricault apparently kept it on the roof of his Paris studio (appropriately in the Rue des Martyrs) for fifteen days. The lithograph below is one of a series made on a visit to London; and its mood, at once oppressive and slightly sinister, is characteristic of much of Géricault's imagery.

Francisco Goya (1746-1828)
46 'The Clothed Maja'

Canvas, 37½ × 74¾ in. About 1800–3(?). Madrid, Prado.

This painting and its naked counterpart (also in the Prado), are among Goya's most famous—and mysterious—works. Whom they represent and for whom they were painted remains unknown. It has been wittily suggested that the work reproduced here may have been painted as a kind of 'cover' for the naked version, which could then be enjoyed in privacy. But if this was so, it did not have the desired effect: on the basis of the two 'Majas', Goya was

denounced to the Inquisition in 1814 for painting obscenities. The intention of the pictures was presumably not unlike that of Ingres's 'Odalisque' (Plate 47); but the awkwardness of the pose, the absence of a setting, the instability of the design (as if the pillows and the lady are about to slide off the sofa) and the direct, slightly equivocal expression, strike that disturbing note so characteristic of even Goya's most optimistic mature works.

Jean-Auguste-Dominique Ingres (1780-1867)
47 The Odalisque with the Slave
Canvas, 28⅛ × 39⅜ in. Signed and dated 1839. Cambridge, Massachusetts, Fogg Art Museum.

48 The Stamaty Family
Pencil, 18½ × 14½ in. Signed and dated 1818. Paris, Louvre.

Ingres had an unusual and interesting artistic personality. He worshipped the paintings of Raphael (he knew, and was influenced by, the *Madonna della Sedia*, Plate 8); and he considered correct drawing and precision of outline to be among the most important elements in art. He was the apostle of orthodoxy and hated the nineteenth century—and painters like Courbet and Delacroix. But he was also a deeply sensual man, with a love of strong colours and rich textures and a passion for the beauty of the female body. In *The Odalisque* the sensuality of the reclining girl is enhanced by the unwavering precision with which every part of the scene, and not least her own voluptuous body, is carefully set down. The picture is, at one and the same time, wonderfully decorative and disturbingly erotic. Not all Ingres's paintings are so carnal; his ambitious and high-minded programme actually included rather more religious, historical and literary subjects. And in the early years, at least, his pictures did not always sell. To earn enough money for himself and his family, Ingres produced a large quantity of portrait drawings, many of them of visitors to Italy, where he lived for a number of years. *The Stamaty Family* shows the exquisitely precise outline that Ingres prized in drawing; but the clarity of line and detail is never dry and laboured.

Pierre-Narcisse, Baron Guérin (1774-1833)
49 The Artist's Daughter
Canvas, 18⅛ × 15 in. Boulogne-sur-Mer, Musée des Beaux-Arts.

This enchanting portrait shows one of the artist's two daughters. From its direct and simple style it would be hard to deduce that in his day Guérin was an admired painter of grand historical subjects in an elaborate classical idiom. In 1822, he won the coveted post of Director of the Académie de France in Rome. His work exerted an influence on many of the French Romantic artists, notably Géricault and Delacroix.

William Blake (1757-1827)
50 The Wise and Foolish Virgins
Watercolour, 16½ × 13½ in. About 1822(?). United States, Mr and Mrs Paul Mellon.

An illustration to Matthew 25: 1–13, this is one of Blake's most beautiful designs. The disarray among the Foolish Virgins is emphasized by their serene sisters, standing in a row, as graceful as the columns of a Greek temple. Blake's highly personal use of pictorial rhythm, to unify his designs and stress their poetic meaning, anticipates the art of Munch (see Plate 70), who apparently knew his work. Both artists repeated their favourite designs over the years. Six versions of *The Wise and Foolish Virgins* are known; the earliest dates from 1805.

Eugène Delacroix (1798-1863)
51 (top) Three Studies of Cats
Pencil, 9¾ × 15 in. Dated 1843. Paris, Louvre.

(bottom) Tiger Attacking a Wild Horse
Watercolour, 7 × 9¾ in. About 1825-8(?). Paris, Louvre.

Delacroix had one of the most complex and interesting personalities

of any nineteenth-century artist. He was something of a dandy, moving in the best Parisian society and numbering Chopin and George Sand among his friends; and he was well known for his intelligent and witty talk. His *Journal* still makes superb reading. He wrote in it, in 1824: 'I have no love for reasonable painting. There is in me an old leaven, some black depth which must be appeased.' The man who esteemed Mozart above all other composers was also excited by everything that was exotic and violent. Feeding time at the zoo, even a visit to the Natural History Museum in Paris induced in him a delicious but vaguely troubled longing; and these two drawings illustrate rather well his passion for animals, preferably wild and visualized under stress.

Joseph Mallord William Turner (1775-1851)
52 The 'Fighting Téméraire' tugged to her last berth to be broken up, 1838
Canvas, 35¾ × 48 in. London National Gallery.

Turner's passion for ships and the sea went back to his childhood, which was spent within easy reach of the Pool of London. And no other European painter has depicted the sea in all its moods quite so well. This famous picture was first shown at the Royal Academy in 1839 under the title shown above; it was intended as a work of sentiment, with something of the character of a requiem. The *Téméraire*, whose name was taken over from a French ship captured in 1759, was launched in 1798 and saw distinguished service at the Battle of Trafalgar in 1805, after which she was usually known as *The Fighting Téméraire*. Turner shows her with very light rigging because the main masts had been removed at Sheerness prior to the final journey to the breakers' yard at Rotherhithe; the shipbreaker had paid £5,530 for her. As in the case of Friedrich's *Stages of Life* (Plate 53), the sunset was intended, in part, to emphasize the theme of mortality.

Caspar David Friedrich (1774-1840)
53 The Stages of Life
Canvas, 28½ × 37 in. About 1835. Leipzig, Museum der Bildenden Künste.

Friedrich was the greatest German painter of the Romantic Movement. He was a deeply religious man, and many of his paintings should be seen as reveries, in landscape terms, about the inexorable journey from this life to the next. *The Stages of Life* was one of his last major works. The five ships correspond to the five figures on the shore. The largest boat, which has almost reached the shallows, is symbolically linked to the old man with his back to us, who is near death; this figure was probably based on the artist himself. The ships in the far distance are to be connected with the two children, who may be Friedrich's own. The beauty of the sunset emphasizes the mood of delicate melancholy.

François Bonvin (1817-87)
54 Interior with a Woman Putting a Fresh Candle into a Lantern
Black chalk, 16¼ × 12¼ in. Signed and dated 1864. Rotterdam, Museum Boymans-van Beuningen.

Bonvin is a charming but little-known artist; he drew and painted scenes from contemporary life—often set in the kitchen—in a style consciously influenced by seventeenth-century Dutch painting and French masters like Chardin. And in this tender drawing the careful attention paid to the still-life, the simple setting and the quiet seriousness of mood, have their parallels in Chardin's *Kitchen Maid* (Plate 34).

Gustave Courbet (1819-77)
55 Self-Portrait
Charcoal, 21¾ × 13⅛ in. Probably 1848-9. Cambridge, Massachusetts, Fogg Art Museum.

Courbet was a handsome, rather vain man, though without his vanity we would presumably have been denied one of the most interesting series of self-portraits in nineteenth-century art. He was the leader of the movement known as Realism, which in mid-nineteenth-century France stood for a greater degree of involve-

ment, in painting, in the life and aspirations of the ordinary man in reaction to the vogue for grand historical and literary subjects.

John Constable (1776-1837)
56 The Haywain

Canvas, 51¼ × 73 in. Signed and dated 1821. London, National Gallery.

This is now the most popular of all Constable's paintings, first shown to the public at the Royal Academy Summer Exhibition of 1821. Constable was born and bred in Suffolk, and although he later made his home in London he remained a countryman at heart. In the autumn of 1821, he wrote to his old friend, Archdeacon Fisher, about 'the sound of water escaping from Mill dams . . . Willows, Old rotten Banks, slimy posts, & brickwork. I love such things . . . Painting is but another word for feeling. I associate my ''careless boyhood'' to all that lies on the banks of the *Stour*. They made me a painter (& I am gratefull) . . .' Constable's main aim, as an artist, was to reconcile what he could see and love in nature with the traditions of pictorial design, going back to Rubens, Claude (Plate 31), Poussin and Ruisdael, that alone, he felt, could give his images the necessary pictorial weight and impression of permanence. In 1824 *The Haywain* was shown at the Paris *Salon*, where it was widely praised (Stendhal called it 'a mirror of nature'), and where it earned the painter a gold medal from the French King.

Jean-Baptiste-Camille Corot (1796-1875)
57 Florence from the Boboli Gardens

Canvas, 20⅛ × 29 in. About 1835–40. Paris, Louvre.

Like Vermeer (Plate 25), Corot had an uncannily accurate eye for exactly how forms look in sunlight, in his own case the forms of landscape. He paid three visits to Italy; and this beautiful picture was based on an oil study made in Florence in the summer of 1834. Corot's habit of painting out-of-doors, his obsession with light and his basic lack of interest in literary overtones made him an important precursor of the Impressionists.

Adolf von Menzel (1815-1905)
58 (top) Hands of a Woman Holding a Basket

Crayon, 5 × 8⅛ in. East Berlin, National-Galerie.

(bottom) Studies of a Worker Eating

Pencil, 10⅜ × 14½ in. East Berlin, National-Galerie.

Menzel was a highly skilled artist, who, in his earlier work, anticipated the sunlit naturalism of the Impressionists, but came to prefer grand historical subjects, especially those taken from the era of Frederick the Great. As these drawings show, he was a conventional draughtsman of great brilliance.

Honoré Daumier (1808-79)
59 (top) The First-Class Carriage

Watercolour, 8¼ × 11¾ in. 1864. Baltimore, Walters Art Gallery.

(bottom) The Third-Class Carriage

Watercolour, 8 × 11⅝ in. About 1864. Baltimore, Walters Art Gallery.

Daumier made a name for himself as a satirical cartoonist in the Parisian left-wing press. Although the pressures of censorship forced him to change over from politics to the foibles of bourgeois society in the mid 1830s, he never lost the sharpness of his social perspectives. This is evident in the contrasting views of railway travel illustrated here. The clear outlines and vivid characterization reveal the influence of his work as a cartoonist.

James McNeill Whistler (1834-1903)
60 'Symphony in White No 2: The Little White Girl'

Canvas, 30 × 20⅛ in. Signed; 1864. London, Tate Gallery.

A witty man with a strong theatrical streak, Whistler was fond of playing the dandy and liked to stress the importance of 'art for art's sake' in a society that still valued pictures primarily for their narrative content and supposed representational accuracy. Whistler would have none of that: 'To say to the painter, that Nature is to be taken as she is, is to say to the player, that he may sit on the piano.' His belief in the value of colour and tone in their own right is partially expressed in the musical reference in the title (the influence was reciprocal: some of Debussy's *Nocturnes* are said to have been inspired by Whistler's paintings). At a time when interior decoration was often rich in character and garish in colour, the extensive use of white was a symbol of the new aesthetic purity. Whistler shared the current enthusiasm for Chinese and Japanese art, as can be seen from the fan, the vase, the red pot and even the spray of flowers in the lower right corner of the canvas. The girl was Joanna Heffernan, the artist's Irish model and mistress. Although he studied in Paris and in London, where he eventually settled, Whistler was American by birth.

Frederic, Lord Leighton (1830-96)
61 Miss May Sartoris

Canvas, 59½ × 36 in. About 1860. Fort Worth, Texas, Kimbell Art Museum.

The only British painter elevated to the peerage, Leighton achieved fame and prestige with a long series of mythological and historical pictures, remarkable for their meticulous finish. He did not take portraiture so seriously; the best of his portraits, however, have lasted rather better than many of his more ambitious productions. This one shows the daughter of close friends of the artist. It was probably painted in the winter of 1859–60 at the Sartoris's home in Hampshire, visible in the background.

Mary Cassatt (1844-1926)
62 Hélène of Septeuil

Pastel, 25¼ × 16 in. About 1890. Storrs, Connecticut, The William Benton Museum of Art (Louise Crombie Beach Collection).

Mary Cassatt was one of the first American artists to become a fully fledged Impressionist. She settled in Paris, where she became a close friend of Degas, who advised and encouraged her, and where she contributed to the Impressionist Group Exhibitions. The 'mother and child' was her favourite theme.

Edgar Degas (1834-1917)
63 Dancer Resting

Pastel, 24⅜ × 19¼ in. Probably about 1881–3. Paris, Louvre.

Degas, who greatly admired Ingres (see Plates 47 and 48), was one of the master draughtsmen of the nineteenth century; and his belief in pictorial definition through outline prevented him from adopting wholeheartedly one of the chief tenets of Impressionism: that the edges of forms dissolve when observed in strong sunlight. At the same time, Degas's interest in themes from contemporary life, shorn of literary overtones, and his experiments in new types of composition, influenced by photography and Japanese prints, linked him with the Impressionists, to whose early Group Exhibitions he contributed. The dancer shown here is posed as if she were unconscious of the spectator; this visual equivalent of eavesdropping adds to the naturalism of the image. Unlike their modern counterparts, dancers in Degas's time wore tutus even for practice and rehearsals.

Jean François Millet (1814-75)
64 The Gleaners

Canvas, 32⅞ × 43¾ in. Signed; shown at the Paris Salon of 1857. Paris, Louvre.

Millet's origins were humble. He came from a Normandy peasant family and never forgot the basic values of the community in which he grew up. He knew that work on the land was hard, the rewards often meagre, and he would return again and again in his art to the unsparing themes of rural life. *The Gleaners* is his masterpiece. It combines a design of great clarity and stability with a delicate observation of light that, in front of the original, brings to mind both Vermeer and Corot, so lovingly is the paint applied, so accurate the effects described. Van Gogh was a great admirer and copier of his work.

Winslow Homer (1836-1910)
65 'Snap the Whip'

Canvas, 22 × 36 in. 1872. Youngstown, Ohio, The Butler Institute of American Art.

Homer, who was one of the most influential American artists of the late nineteenth century, received no formal training but steadily built up his experience and knowledge of art by attending evening classes and doing illustrations for periodicals. The observation of light in '*Snap the Whip*' might imply Impressionist influence; and he had been to France in 1866 and 1867. But the rather sentimental narrative element in the picture (which the French Impressionists would not have cared for) suggests, rather, a parallel development. Homer lived an open-air life himself; and many of his later pictures were inspired by the sea and the hard life of sailors and fishermen.

James McNeill Whistler (1834-1903)
66 (*left*) Rotherhithe: Wapping

Etching, 10⅝ × 7¾ in. 1860

(*right*) The Lime Burner

Etching, 10 × 6⅞ in. 1859.

Before taking up painting, Whistler had worked for a time as a Navy cartographer; and this helps to explain both the themes of much of his early work and their meticulous treatment. He was a very fine etcher, as can be seen from the two subjects reproduced here. See also note to Plate 60.

Frederic Remington (1861-1909)
67 Mexican Vaqueros Breaking a Bronc

Pen and ink and wash, 25 × 37½ in. Boston, Museum of Fine Arts.

As a young man, Remington worked on ranches in Montana and Kansas; later, during the 1880s, he travelled with the United States Army while they routed the Apache Indians. These experiences, softened and mellowed by his affection for the Old West, formed the basis of his paintings and drawings, which were often published as magazine illustrations. Their themes, and treatment, anticipated the Hollywood Western.

Edgar Degas (1834-1917)
68 Horses on the Course, in Front of the Stands

Canvas, 18⅛ × 24 in. About 1869-72. Paris, Jeu de Paume.

After an early phase in which he tried to revitalize the decaying tradition of grand history painting, Degas turned to themes of modern life, often connected with some professional skill: singers, dancers (Plate 63), musicians, milliners, laundresses and jockeys. This picture may *look* casual; but in fact it is the result of careful thought. His was an art of great cunning in which the planning of the design and the use of preparatory drawings were concealed, like a great actor's years of training and accumulated experience, beneath a deceptively informal surface. The light is relatively strong for Degas; but it has not been allowed to encroach on the clear definition of the horses and jockeys, which already have the stressed silhouettes that Toulouse-Lautrec, twenty years later, developed and incorporated in his celebrated posters.

Thomas Eakins (1844-1916)
69 The Biglen Brothers Racing

Canvas, 24⅛ × 36⅛ in. Probably 1873. Washington, D.C., National Gallery of Art.

Like Winslow Homer (see Plate 65), Eakins was one of the most important American artists of his generation. He was an unusual and interesting man, who combined the normal concerns of a painter with an almost Renaissance appetite for knowledge. Mathematics, photography, complicated perspective studies—he was involved in them all. *The Biglen Brothers Racing*, with its quiet precision and carefully calculated composition, is one of Eakins's best-known works and owes a great deal to his preliminary brain-work.

Edvard Munch (1863-1944)
70 The Scream

Lithograph, 14 × 10 in. 1895.

One of the most famous and powerful designs by the greatest of Scandinavian painters. Munch studied for some time in Paris, where he became familiar with the works of the Impressionists and Post-Impressionists. Their influence can be seen in the diagonal tilt of the jetty, which runs out of the composition at the bottom (compare Pissarro's painting, Plate 73) and in the rhythmic patterns of the sky and land, which recall Van Gogh. *The Scream*, like much of Munch's best work, expresses a mood of anxiety and tension; and it is appropriate that it should have been produced in the same period as psychoanalysis was being developed by Freud. An entry from Munch's diary, dated 22 January 1892, suggests the origin of *The Scream*, which was also worked up as a painting: 'I was walking along the road with two friends. The sun set. I felt a tinge of melancholy. Suddenly the sky became a bloody red. I stopped and leaned against the railing, dead tired, and I looked at the flaming clouds that hung like blood over the blue-black fjord and the city. My friends walked on. I stood there, trembling with fright. And I felt a loud, unending scream piercing nature.'

Dante Gabriel Rossetti (1828-82)
71 Study for 'The Day Dream'

Pastel and black chalk, 41¼ × 30¼ in. About 1872-8. Oxford, Ashmolean Museum.

A study of the beautiful Jane Morris, whose looks fascinated Rossetti for many years; she was the wife of William Morris (1834-96), the influential pioneer in the Arts and Crafts Movement. The sorrowful expression, with its conflicting suggestions of sensuality and spiritual *malaise*, are typical of Rossetti's mature imagery; so are the thick lips and abundant hair. Rossetti painted an elaborate picture of this design in 1879-80 (now in the Victoria and Albert Museum, London).

Claude Monet (1840-1926)
72 Terrace at Sainte-Adresse

Canvas, 38½ × 51 in. About 1867. New York, Metropolitan Museum of Art.

An important early work by one of the founding fathers of Impressionism. The terrace was part of property owned by Monet's family at Sainte-Adresse, two and a half miles south-east of Le Havre; and the bearded gentleman in the white boater is usually identified as his father. Note, once again, how important figures in the composition have their backs to the spectator, so as to increase the effect of unposed naturalism (see also Plates 68 and 73). The picture was probably painted in August (when gladioli usually bloom); the real subject is sunlight and the way it falls, and how it sometimes softens, and sometimes hardens, the appearance of things. Compare, for example, the almost harsh brilliance of the white parasol and the soft tones of the sea. The *Terrace*, however, is much more than a technical exercise in optical illusion; like Constable's *Haywain* (Plate 56), it reflects a passionate response to a familiar, much loved milieu. 'Sainte-Adresse—it's heavenly and every day I turn up things that are constantly more lovely,' Monet wrote in the early 1860s. 'It's enough to drive one mad, I so much want to do it all!'

Camille Pissarro (1830-1903)
73 Crystal Palace, London

Canvas, 19 × 28¾ in. Signed and dated 1871. Chicago, Mr and Mrs B. E. Bensinger.

The oldest of the Impressionists, Pissarro was one of the pioneers of the movement together with Monet (Plate 72) and Renoir (Plate 77). Among their main aims was the direct recording of everyday life and unidealized landscape, partly in opposition to the academic tradition, with its stress on elevated subject-matter, an elaborate system of preparatory drawings and conventional, often subdued colour harmonies. One of the experiences the Impressionists valued most was working out-of-doors, straight on to the canvas (like Corot, whose work Pissarro admired enormously: see Plate 57); and while they were certainly not the first to depict sunlight and changing atmosphere (see, for example, Cuyp's landscape,

Plate 21), they rendered the play of light and the way in which it seems to modify the colour of objects—especially at a distance—with a brilliance and accuracy that had been previously matched only by Vermeer (Plate 25) and Corot, and which has not been surpassed since. Pissarro came to England as a refugee from the Franco-Prussian War in the autumn of 1870. He settled with his mistress and their two children in the London suburb of Upper Norwood, an area then much less built up than it is today and not unlike the outskirts of Paris from which they had fled. The Crystal Palace, which had been moved from Hyde Park to Sydenham after the Great Exhibition of 1851, was not very far from Upper Norwood; and with its vast areas of light-reflecting glass might have seemed to offer an interesting visual challenge to an Impressionist painter. But Pissarro remained true to his doctrine of recording what he saw without any kind of artificial emphasis. The Palace takes its place as just one element in the composition; if anything, it is less important than the sky. No one since Constable (Plate 56) had rendered quite so well as Pissarro the changeable quality of the English sky, with its patterns of cloud and seemingly perpetual movement. The simple composition, with the road running straight out of the picture, is characteristic of Pissarro's anti-academic intentions; so is the treatment of the figures—the three nearest all have their backs to the spectator.

Edouard Manet (1832-83)
74 The Cats' Rendezvous

Ink wash and gouache, 16½ × 12 in. 1868. Paris, Private Collection.

Manet, who was very fond of cats, made this drawing in preparation for a lithograph, used to illustrate an article on cats by the Duc d'Aleria, published in *Chronique Illustré* on 25 October 1868. The image was also used as a poster advertising the second edition of Champfleury's book on cats, *Chats*, in 1869. The flat design, with its strong emphasis on outlines, and the sharp contrasts of tone reveal the influence of Japanese colour prints, which were being imported into France in large numbers in the 1860s, much to the delight of *avant-garde* artists, who found in their simple forms and colours a satisfying antidote to the enervating tradition of contemporary French academic painting (see also notes to Plates 60, 76 and 84).

Henri de Toulouse-Lautrec (1864-1901)
75 The Laundress

Indian ink, 30 × 24¾ in. Signed; 1888. Cleveland, Ohio, Cleveland Museum of Art.

Lautrec's telling sense of line and his eye for the significant detail made him an ideal designer of posters and popular illustrator. This beautiful drawing, more tender in mood than is usual with him, was made for an issue of the magazine, *Paris Illustré* (7 July 1888), to go with an article on 'Summer in Paris' by Emile Michelet.

John Singer Sargent (1856-1925)
76 'Carnation, Lily, Lily, Rose'

Canvas, 68½ × 60½ in. 1885–6. London, Tate Gallery.

Painted at Broadway, Worcestershire, this picture was based on a scene, witnessed by the artist, of Chinese lanterns among trees and beds of lilies. Although painted from life, this charming idyll, like Whistler's *Little White Girl* (Plate 60), had its origins in the contemporary cult of Japanese art. Sargent admired and collected Japanese prints, and something of their flat, decorative effect is retained in the painting. The title came from a popular song of the day. Like Whistler, Sargent was an American who settled in London after a formative period in Paris.

Pierre-Auguste Renoir (1841-1919)
77 Spring Flowers in a Vase

Canvas, 40¾ × 31 in. Signed and dated 1866. Cambridge, Massachusetts, Fogg Art Museum.

Renoir was full of contradictions. Like the other Impressionists, he believed in an art that showed and reflected the values of modern life. But he hated the Industrial Revolution that was going on around him. Jean Renoir tells us how his father preferred candles to electricity; stairs to lifts; flagstones to asphalt. Even bread cut

into slices annoyed him: it should, Renoir felt, be broken. The subjects that he painted reflect both his optimism and love of nature: fruit and flowers—as here, in an early masterpiece; landscapes, usually drenched in sunshine; and young people, especially pretty girls. Mme Renoir even complained that the maids were chosen for their complexions rather than their skills with brush and duster.

Jan Toorop (1858-1928)
78 'O Grave, where is thy Victory?'

Pencil, 23⅝ × 29½ in. Amsterdam, Rijksmuseum.

A good example of sinuous Art Nouveau rhythms applied to a conventional subject. Toorop was a Dutch painter, who was born in Java but went to Holland as a child with his family. Late in life he became a Roman Catholic and devoted his energies to religious themes.

Léon Spilliaert (1881-1946)
79 Woman on the Dike

Watercolour and pencil, 13⅛ × 28¾ in. Signed and dated 1908. Brussels, Musées Royaux des Beaux-Arts.

Spilliaert was born in Ostend, Belgium, and spent most of his life there. *Woman on the Dike*, which is a representation of the beach at Ostend, is typical of his extremely simple draughtsmanship and economy of palette. Like Munch's *The Scream* (Plate 70), this strange work is characteristic of the Symbolist Movement in the way in which an emotional state is conveyed by the setting as much as by the human figure.

Paul Cézanne (1839-1906)
80 Still-Life with Apples and Oranges

Canvas, 28¾ × 36¼ in. 1895-1900. Paris, Jeu de Paume

Cézanne's mature ideas about art were extremely complex. He wanted to create the maximum conviction, to impose on the spectator his view of a landscape, a figure or, as in this case, a still-life with fruit on a table, but without concealing the fact that what the spectator was looking at was a series of brush-strokes on a flat canvas. And the common denominator was the stroke of paint itself, which, for Cézanne, had to describe the colour of an object; indicate the fall of light and, therefore, the modelling of the object; and, at the same time, contribute to the underlying flat structure of the painting itself. But in spite of his intellectual approach, Cézanne's best works – like the *Still-Life* reproduced here – have an extraordinary vitality, thanks in part to his very rich artistic personality, with its fusion of intellect, nerves, powers of observation, sensitivity and passion.

Edouard Manet (1832-83)
81 A Bar at the Folies-Bergère

Canvas, 37¾ × 51¼ in. Signed and dated 1882. London, Courtauld Institute Galleries.

Although he did paint some brilliant landscapes, Manet generally shared Degas's artistic distaste for natural scenery. Contemporary life was his main theme; and like Renoir, Manet had a keen eye for a pretty girl. The *Bar* was his last important work; it shows the barmaid talking to a customer, visible in the mirror (the artist has jiggled with the reflected perspective), who would actually be where the spectator stands. This play with reflected images was by no means new (see the Van Eyck, Plate 4, and the Boucher portrait, Plate 42); but Manet does give it a charming twist. Also visible in the glass are the audience in the foyer and dress circle and the legs of a trapeze artist.

Henri Rousseau (1844-1910)
82 Tropical Storm with a Tiger

Canvas, 51¼ × 63¾ in. Signed and dated 1891. London, National Gallery.

The fourth son of an impoverished tradesman, Rousseau was the first 'naïve' painter to achieve full recognition as a major artist. He worked for a living first as a clerk and later as a customs

official (hence his nickname 'Le Douanier'), and though he claimed, among other things, to have served in the army in Mexico, his exotic scenes – especially the jungle pictures, of which this was the first – depended on photographs, visits to the Botanical Gardens in Paris and a lively imagination: 'When I get inside those green-houses', he wrote, 'and see strange plants from exotic countries, I seem to enter a dream.' Although not conventionally trained, Rousseau was a master craftsman with a most delicate feeling for spatial intervals and a subtle sense of colour. In this picture there must be at least twenty different shades of green in the tossed foliage; and the curtain of rain is delicately suggested by a mesh of soft strokes, often in a very pale grey over positive colours. Rousseau's work was dismissed by conventional opinion as a joke but admired by artists like Picasso, who in 1908 organized a famous dinner in his honour.

Paul Gauguin (1848-1903)
83 'Nevermore'

Canvas, 23⅜ × 45⅝ in. Signed and dated 1897. London, Courtauld Institute Galleries.

Painted during the second visit to Tahiti, where Gauguin, dis-illusioned with life in Europe, had gone in search of what he hoped would be a simpler and nobler world. He described 'Nevermore' in a letter to an old friend and supporter, G. D. de Monfreid: 'I wanted to suggest by means of a simple nude a certain long-lost barbarian luxury. . . . As a title, Nevermore [in English in the original letter]: not the raven of Edgar Poe, but the bird of the devil that is keeping watch.' The idea of painting an informal nude like this goes back to Manet's Olympia (greatly admired by Gauguin, who even had a print of it in his hut in Tahiti), which itself was a variation on an old theme – see Ingres's Odalisque with the Slave (Plate 47). The first owner of 'Nevermore' was the English composer Frederick Delius.

Vincent van Gogh (1853-90)
84 Self-Portrait with Bandaged Ear

Canvas, 23½ x 19¼ in. 1889. London, Courtauld Institute Galleries.

For years Van Gogh dreamed of creating an artistic colony. In the autumn of 1888, Gaugin, with whom he felt linked by a particular artistic bond, came to join him at Arles, in the South of France. Van Gogh (now barely eighteen months away from suicide) was nervous and tense; Gaugin was his usual difficult, assertive self. On 23 December 1888, after a violent quarrel with Gaugin, Van Gogh, in a state of terrible excitement and in a high fever, sliced off a piece of his own ear. He then took it to a woman in a brothel. After hospital treatment lasting about two weeks, he returned to his house. This famous Self-Portrait was painted a few days later. Note the Japanese print in the background (see also Plates 60 and 76).

Pablo Picasso (1881-1973)
85 Child with a Dove

Canvas, 28¾ × 21¼ in. Painted in 1901. London, The Dowager Lady Aberconway.

Children and doves were a recurring motif in Picasso's work; and after the Second World War, Picasso transformed the frail bird into the well-known image of the Dove of Peace. This picture, painted soon after the artist had arrived in Paris from his native Spain, reveals the influence of both Gauguin (see Plate 83) and Van Gogh (see Plate 84) in its simplifications of form, clear outlines and patterns of bold brush-strokes.

Henri Matisse (1869-1954)
86 Window in Tangiers

Canvas, 46⅞ × 30¾ in. 1912. Moscow, Pushkin Museum of Art.

This is one of the most beautiful of Matisse's paintings, in which the Impressionist concept of painting straight from the motif is both extended and simplified. Pleasure in the subject, in this case the view from a window in Tangiers, is partly expressed by the beauty of the colour; but it is Matisse's colour, imposed on the scene rather than discovered in it. 'What I dream of,' Matisse once wrote, 'is an art of balance, of purity, and serenity devoid of troub-

ling or disturbing subject-matter . . . like a comforting influence, a mental balm . . .'

Pablo Picasso (1881-1973)
87 Three Musicians

Canvas, 79 × 87¾ in. Signed and dated 1921. New York, Museum of Modern Art.

Painted at Fontainebleau in the summer of 1921, this is one of the culminating masterpieces of Picasso's second Cubist style, known as Synthetic Cubism. The painting shows Pierrot playing a recorder (left), Harlequin strumming a guitar (centre) and a third figure, probably meant to be a barefooted monk, singing from a score. The masked musicians are seated around a table, which has a brown top and on which are a pipe, a package of tobacco and a pouch. A large dog lies under the table. Pierrot and Harlequin belong to the tradi-tional commedia dell'arte troupe (compare Plate 37); Picasso had close contacts with the Diaghilev Company and the Three Musicians may have been partly inspired by the ballet Pulcinella, first produced (with a Stravinsky score) in 1920, and based on the commedia characters. Picasso is not nearly as difficult an artist to understand as has often been made out in the popular press. The Three Musicians is a painting of great wit and charm, in which people are presented simultaneously as flat patterns, and abstract shapes are made to turn into people. It is a picture where a great deal is constantly happening, not in terms of narrative, but visually: wherever you look, you are never quite sure whether you are seeing hands, arms, musical instruments or patches of brown or yellow or blue. The Three Musicians is like a kaleidoscope—but in reverse: it is the painting which is static and the spectator's sensations and optical experience that are shaken up.

Gustav Klimt (1862-1918)
88 The Kiss

Canvas, 71 × 71 in. 1907–8. Vienna, Österreichische Galerie.

Klimt was the leading painter of the Jugendstil, the Austrian equivalent of the international Art Nouveau style. He began as a specialist in mural painting, but in 1897 he became one of the founder-members of the Vienna Secession, a break-away group committed to avant-garde ideas in the arts. Klimt explored to the full the Art Nouveau preference for decorative and sinuous pictorial rhythms combined with colour used decoratively as pattern. The effect is deliberately two-dimensional. The design for The Kiss was created as part of the frieze commissioned for the dining-room of a banker's newly built house in Brussels.

Amedeo Modigliani (1884-1920)
89 Nude

Canvas, 36¼ × 23½ in. Signed, about 1917. London, Courtauld Institute Galleries.

Dogged by poverty and lack of recognition in his lifetime, Modigliani has become one of the most popular of twentieth-century artists. This Nude shows why. Modigliani, who was born in Italy, settled in Paris in 1906 and absorbed many of the artistic ideas of the day. The head of the nude shown here reveals the influence of Cubism; the elongation of the figure is Expressionist; while the colouring owes a debt to the strong tones of the Fauves, the group of painters who specialized in the use of strong, even violent colours and were given this name (meaning 'wild beasts') by a hostile critic. But all these influences were subservient to Modigliani's beautiful sense of line, which in its grace and supple-ness recalls a much older tradition—even the Venus of Botticelli (Plate 6). Modigliani died of tuberculosis at the age of 36.

Grant Wood (1891-1942)
90 American Gothic

Canvas, 29⅞ × 24⅞ in. 1930. Chicago, Art Institute.

This is the masterpiece of a man who spent his life in Iowa, and whose avowed intention was to reflect in his art the values of provincial America. Like the musical, Oklahoma, American Gothic is a telling image of small-town life. Wood's meticulous style reflects his experiences as a designer and manufacturer of jewellery and the influence of the early German and Flemish

paintings that he had seen in Munich, where he studied as an art student in the late 1920s.

Jackson Pollock (1912-56)
91 Full Fathom Five

Oil and other materials, 50⅞ × 30⅛ in. 1947. New York, Museum of Modern Art.

Jackson Pollock will always be assured of a place in the history of art as the first American painter to exert an international influence through his Abstract Expressionist style. Throughout the 1930s and 1940s, Pollock's work was often symbolic and fantastic in character; and it was not until after the Second World War that he began to develop his wholly abstract manner. He had always been interested in Surrealism (see Plate 93) and in evolving the new style he was influenced by Surrealist principles of free association: as he applied the paint with his brush to the surface of the canvas, he would take advantage of the visual accidents that occurred, chance confrontations and amalgamations of tone and colour. As time went on, Pollock began to paint on a large scale; and he would not only apply the oil or aluminium paint with a brush but drip the paint on to the surface in swirls and splashes. This new style was soon dubbed 'Abstract Expressionism'— 'Abstract' for obvious reasons, and 'Expressionism' because the very act of creating the picture became as important a part of the work of art as the marks left upon the canvas. From there it was but a short step to the 'Happening'.

Roy Lichtenstein (born 1923)
92 Whaam!

Acrylic, 68 × 160 in. 1963. London, Tate Gallery.

Most art reflects, directly or indirectly, the realities of power in any given society. The vast number of religious paintings produced in earlier centuries testifies to the importance and influence of the Church in people's lives; mythological paintings such as Titian's *Diana and Actaeon* (Plate 14) or Rubens's *Judgement of Paris* (Plate 15) tell one a good deal about the educational standards of the ruling class. In the twentieth century, one of the most potent influences on artists has been the taste of the 'man in the street', who has become a source of real power in societies with democratically elected governments. Both Lichtenstein and Warhol (Plate 96) have been preoccupied with mass taste; and *Whaam!*, one frame from a comic strip simulated on an enormous scale, even down to the constituent dots that make up a reproduction in a newspaper, should be seen as a kind of tribute to the universal comic, the favourite reading matter of twelve-year-olds of all ages.

Salvador Dali (born 1904)
93 Metamorphosis of Narcissus

Canvas, 20 × 30¾ in. 1937. London, Tate Gallery (on loan from the Edward James Foundation).

In classical mythology, Narcissus was a beautiful youth who fell in love with his own reflection in the water and pined away, the flower that bears his name springing up on that spot. Dali, one of the key figures in the Surrealist Movement, has used the legend as the basis for one of his Freudian dreamscapes. Narcissus, at the edge of the pool, has been turned into stone. Narcissism, or morbid vanity and self-love, naturally came into the psychological investigations of Sigmund Freud; and Dali actually showed him this canvas in London in July 1938. It still belongs to one of the major English supporters and patrons of Surrealism.

Andrew Wyeth (born 1917)
94 Christina's World

Tempera on gesso panel, 32¼ × 47¾ in. 1948. New York, Museum of Modern Art.

One of the most successful of modern American artists, Wyeth is the son of the painter and illustrator, Newell Convers Wyeth, and was something of a child prodigy. His style, with its precision and clarity of presentation, has been influenced by photography and the cinema. This is the most famous of a number of paintings of Christina Olson, a neighbour of Wyeth's in Maine, who was crippled by polio. 'The challenge to me', the artist has said, 'was to do justice to her extraordinary conquest of a life which most people would consider hopeless. Christina's world is outwardly limited—but in this painting I tried to convey how unlimited it really is.' The idea for the picture came to Wyeth when he saw Christina one day as she was picking berries and had paused to gaze back across the fields towards her home.

David Hockney (born 1937)
95 Mr and Mrs Ossie Clark and Percy

Acrylic, 84 × 120 in. 1970-1. London, Tate Gallery.

This is one of a series of large double portraits that Hockney has painted of his friends. The sitters here are Ossie Clark, a British fashion designer, and his wife, the fabric designer Celia Birtwell. The setting is the drawing-room of their Bayswater home. The picture was based on drawings and photographs; Hockney simplified the appearance of the room for pictorial reasons. What is particularly intriguing about the image is the way it cleverly combines highly traditional elements, of scale and composition, with a deliberately 'cool' mood, expressed in the reversal of traditional roles (the woman here stands while the man sits: compare Ingres's portrait, Plate 48) and in the deliberately inexpressive handling of the paint.

Andy Warhol (born 1930)
96 Marilyn Monroe

Silk-screen print, 35½ × 35½ in. 1971. London, Tate Gallery.

Warhol has always been fascinated by publicity and its symbols: posters, photographs, even labels of well-known products. This silk-screen print is based on one of the most famous photographs of Marilyn Monroe (1926–62) at the height of her career. The deliberate coarseness of the print is a kind of token of its popularity, like a worn printer's block, from which too many prints have been pulled.

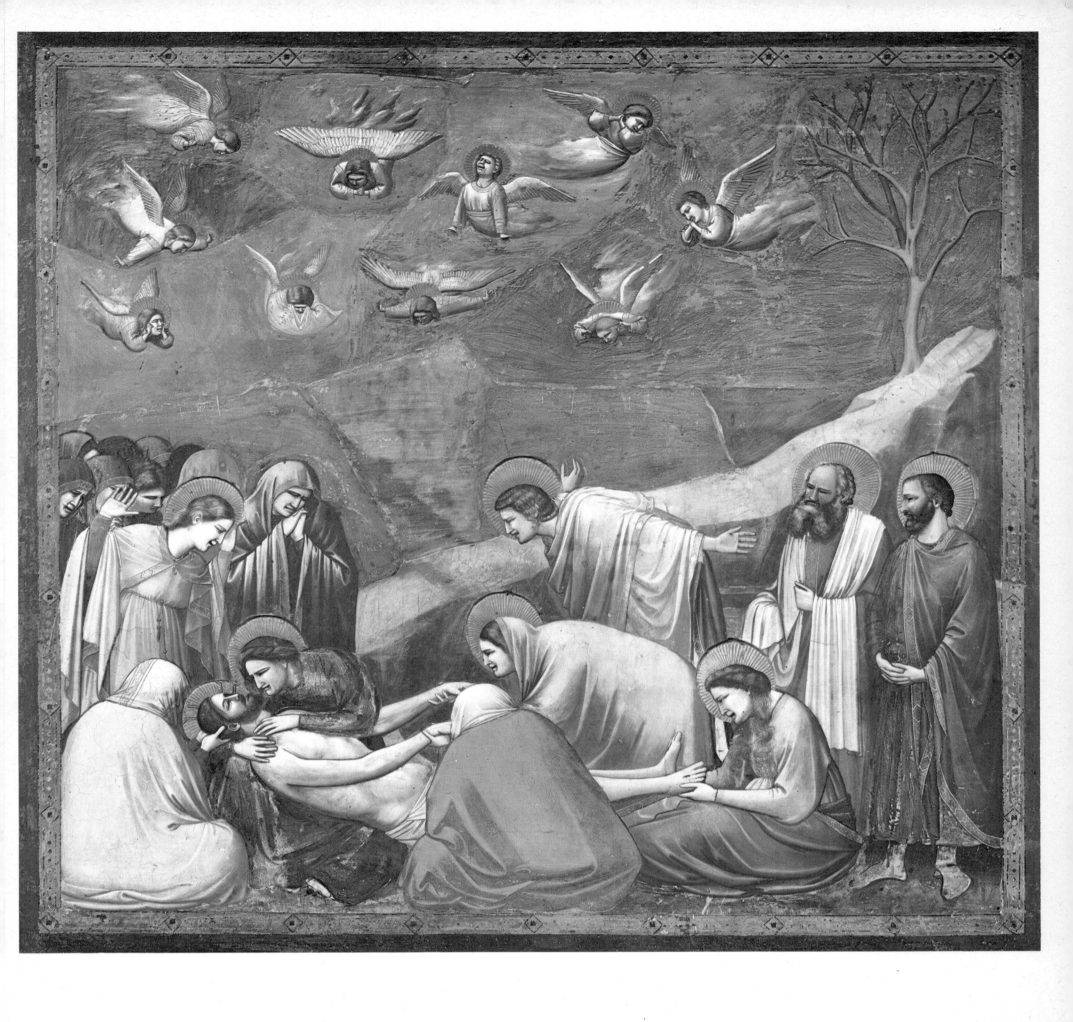

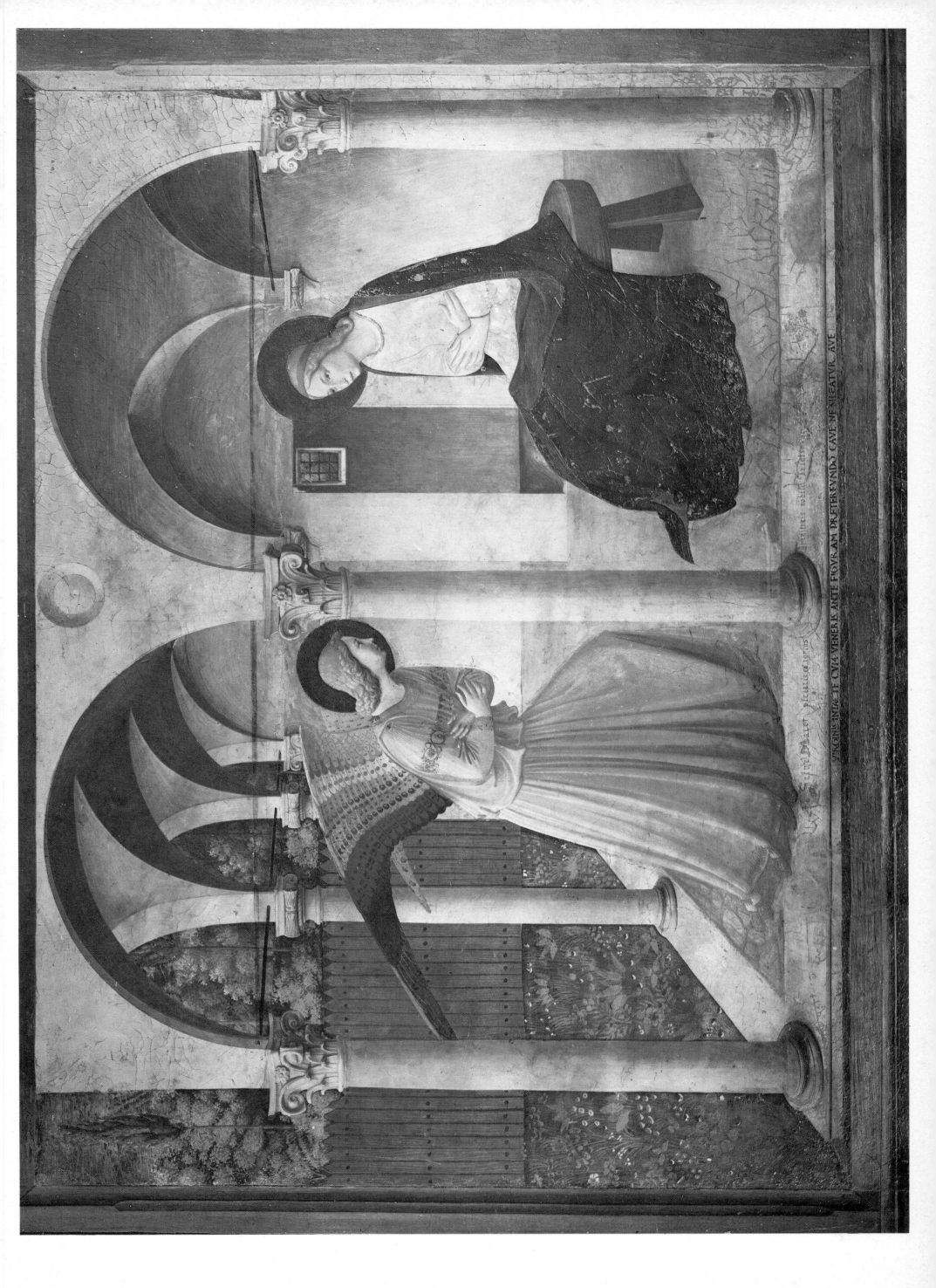

3

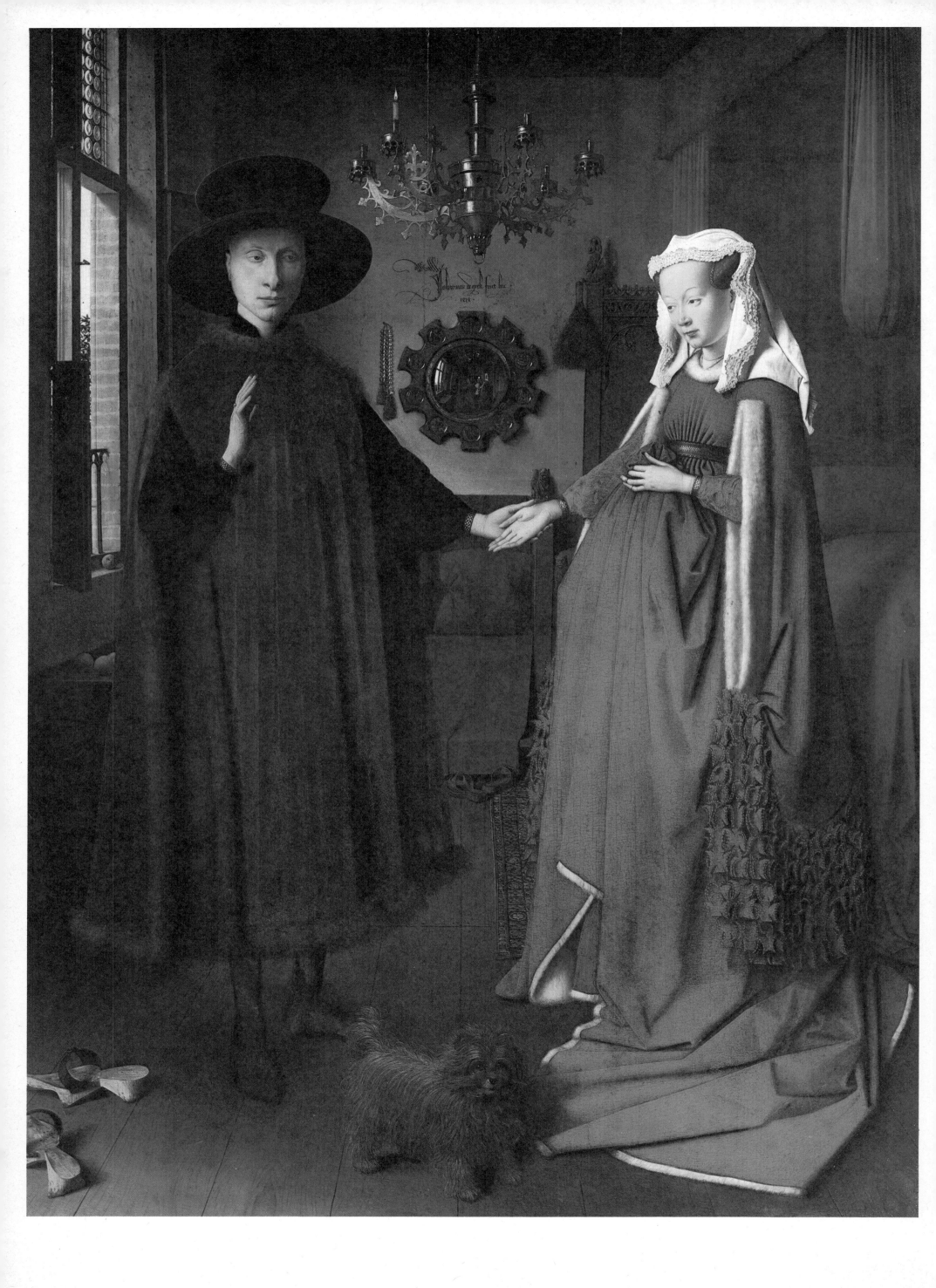

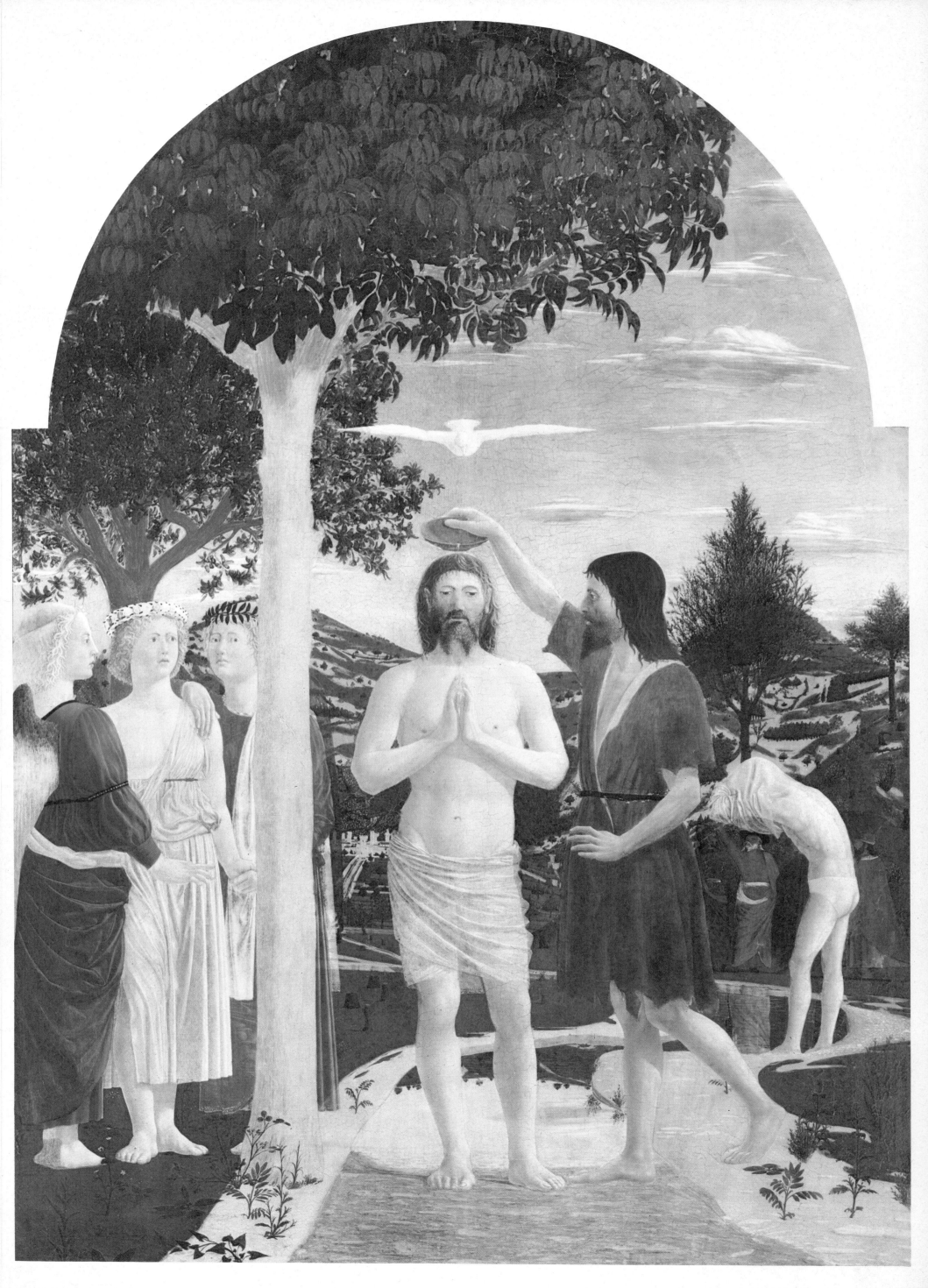

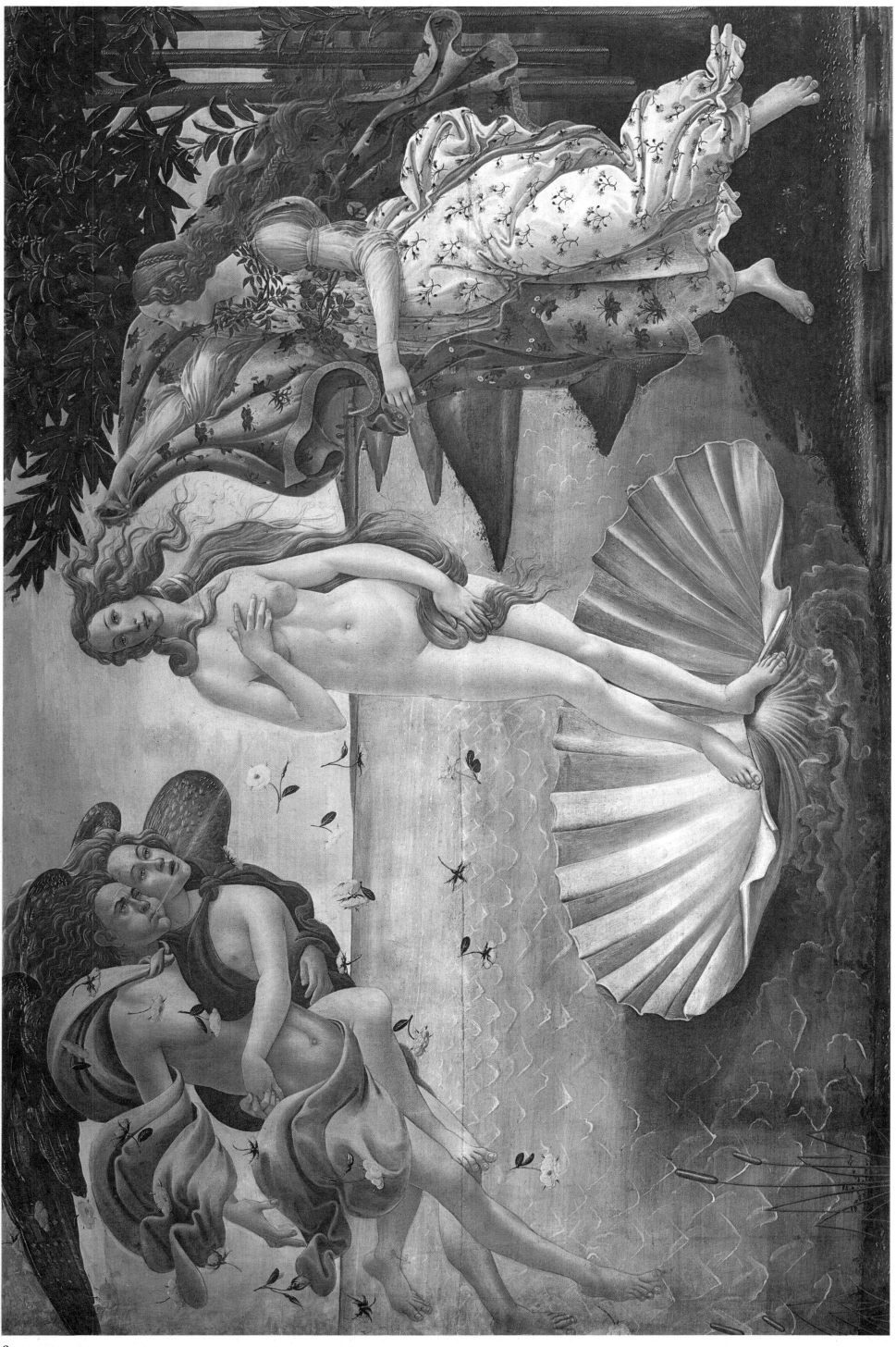

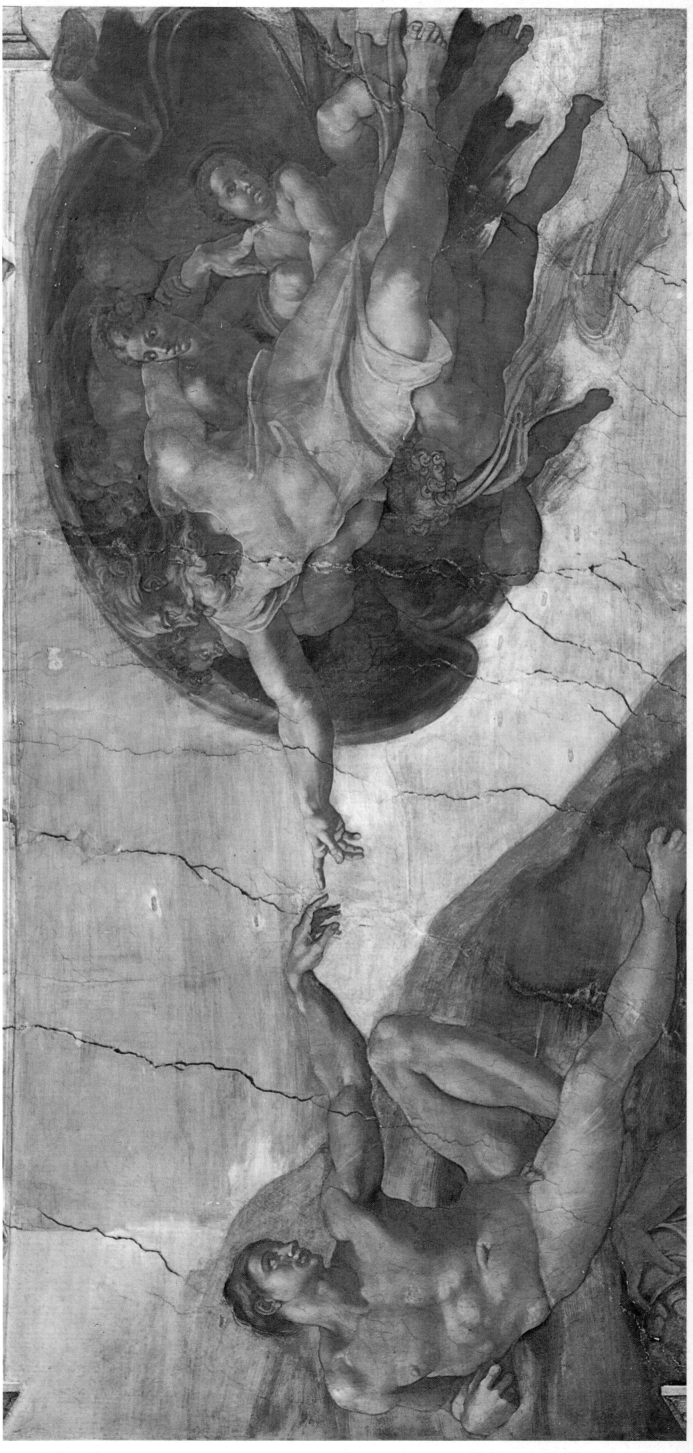

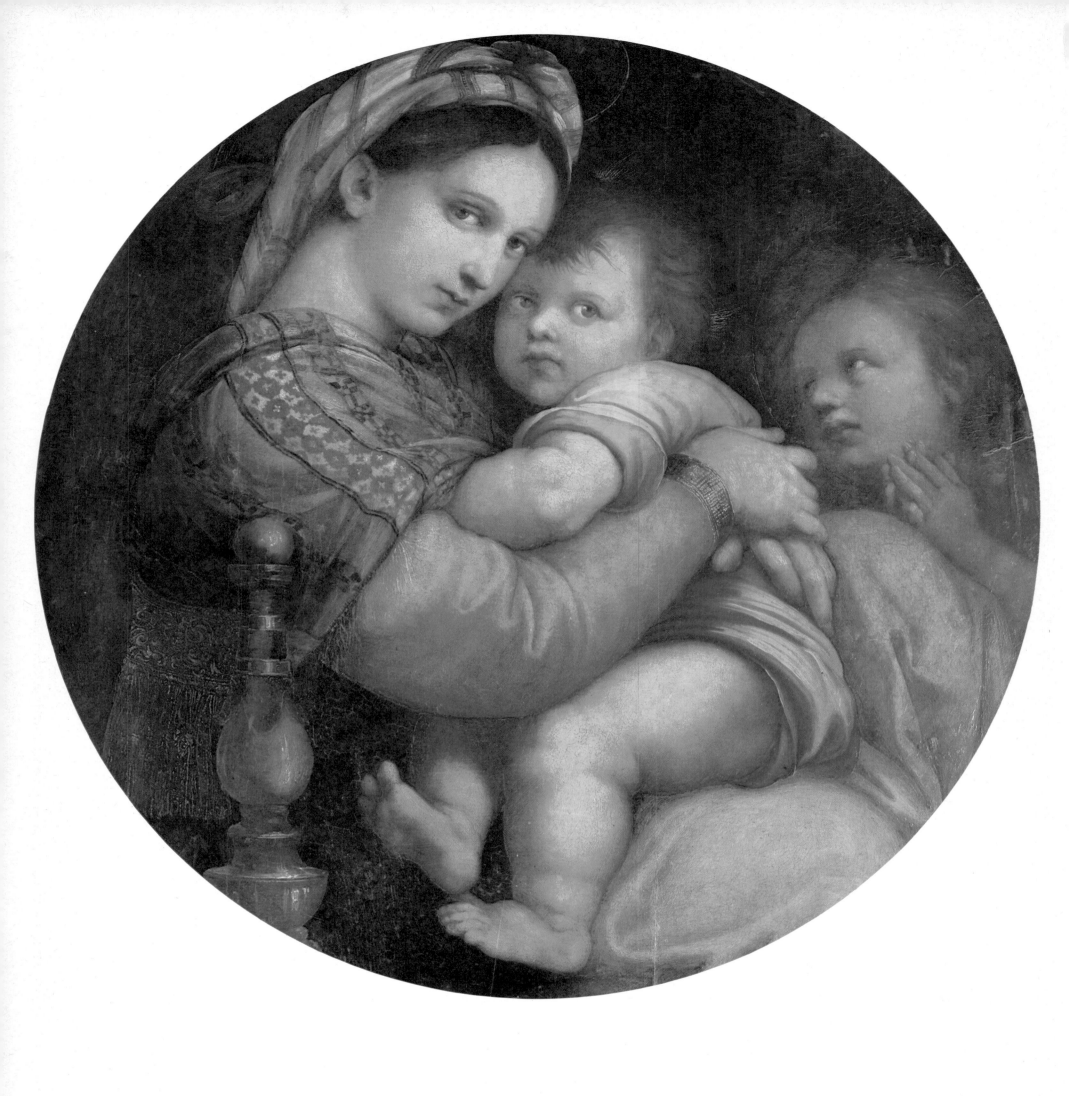

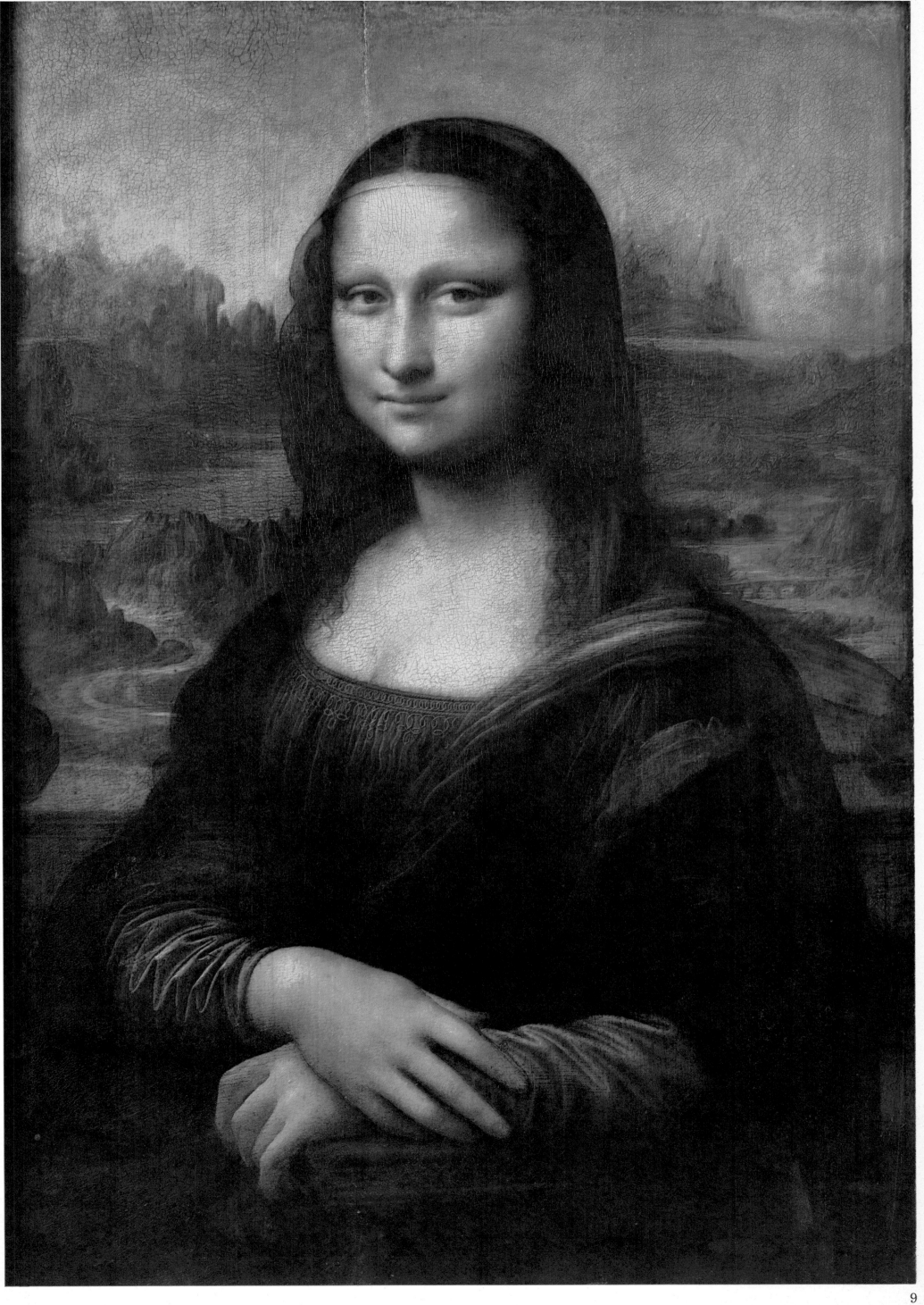

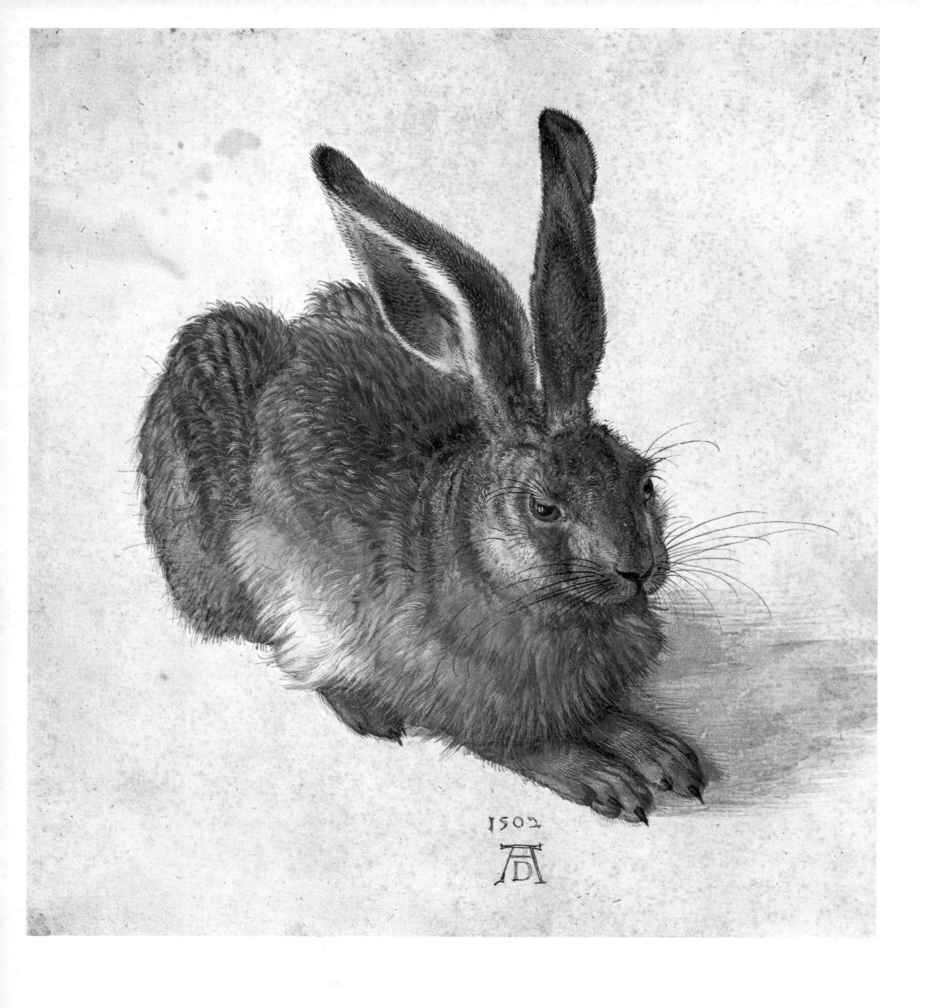

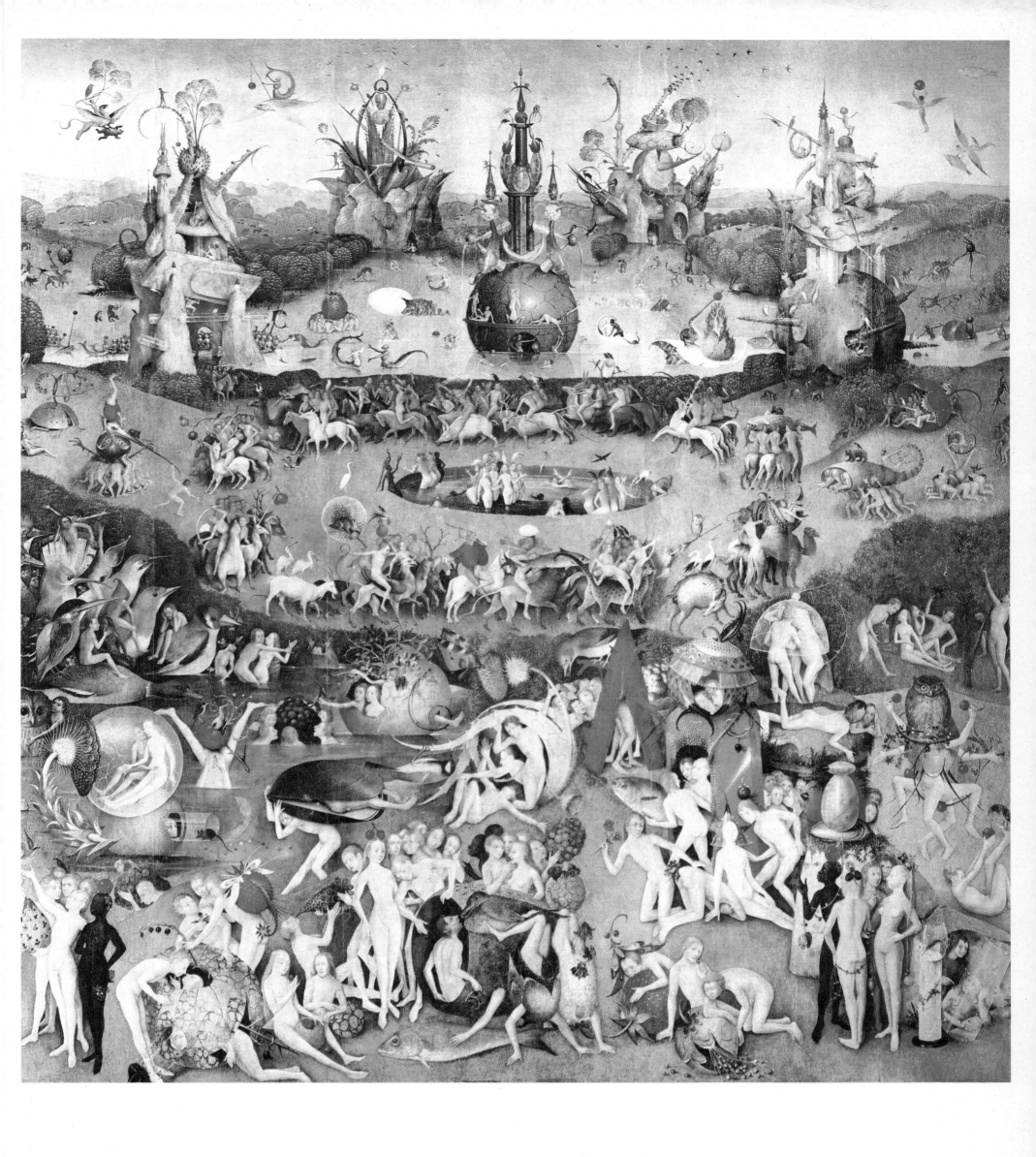

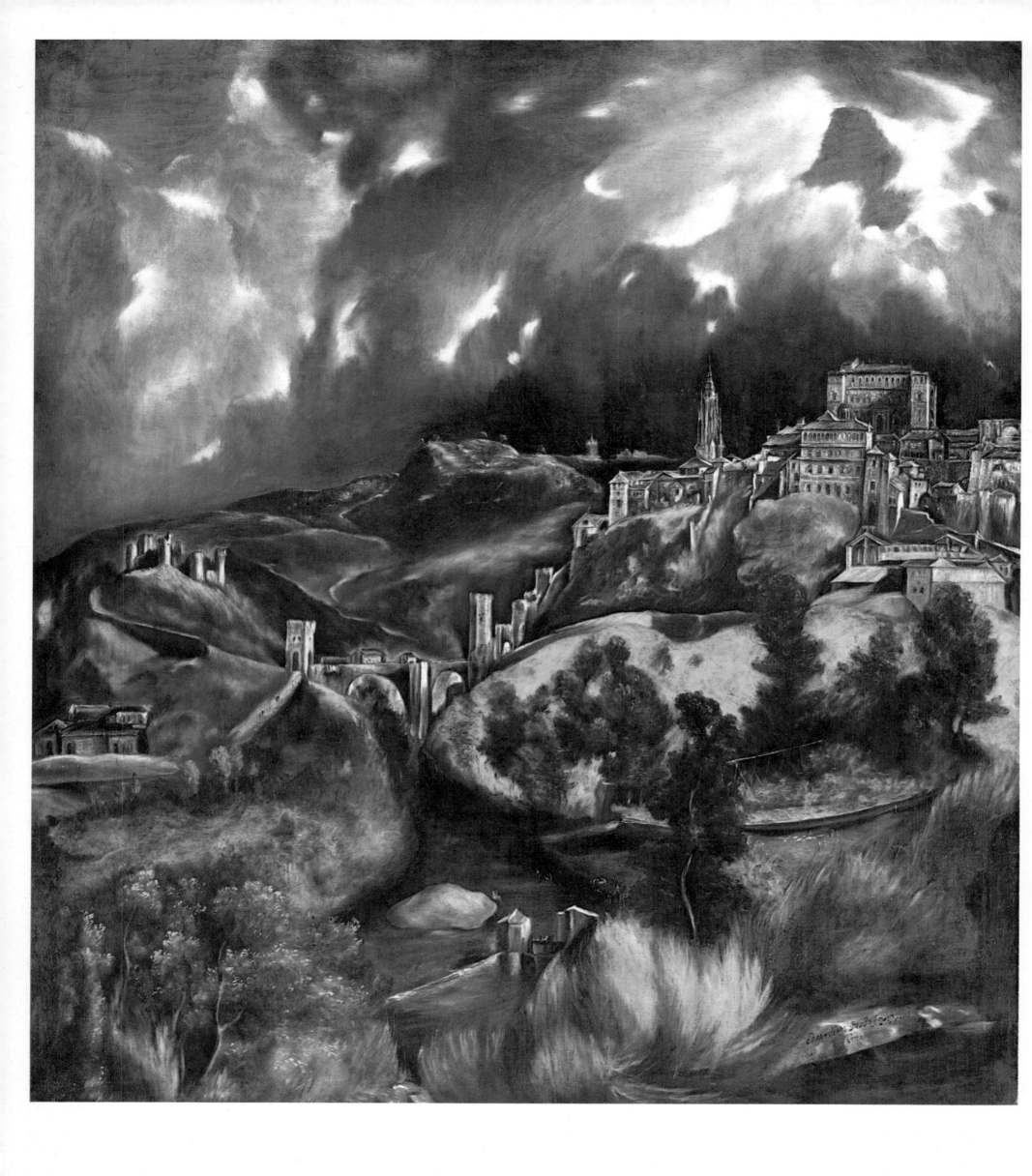

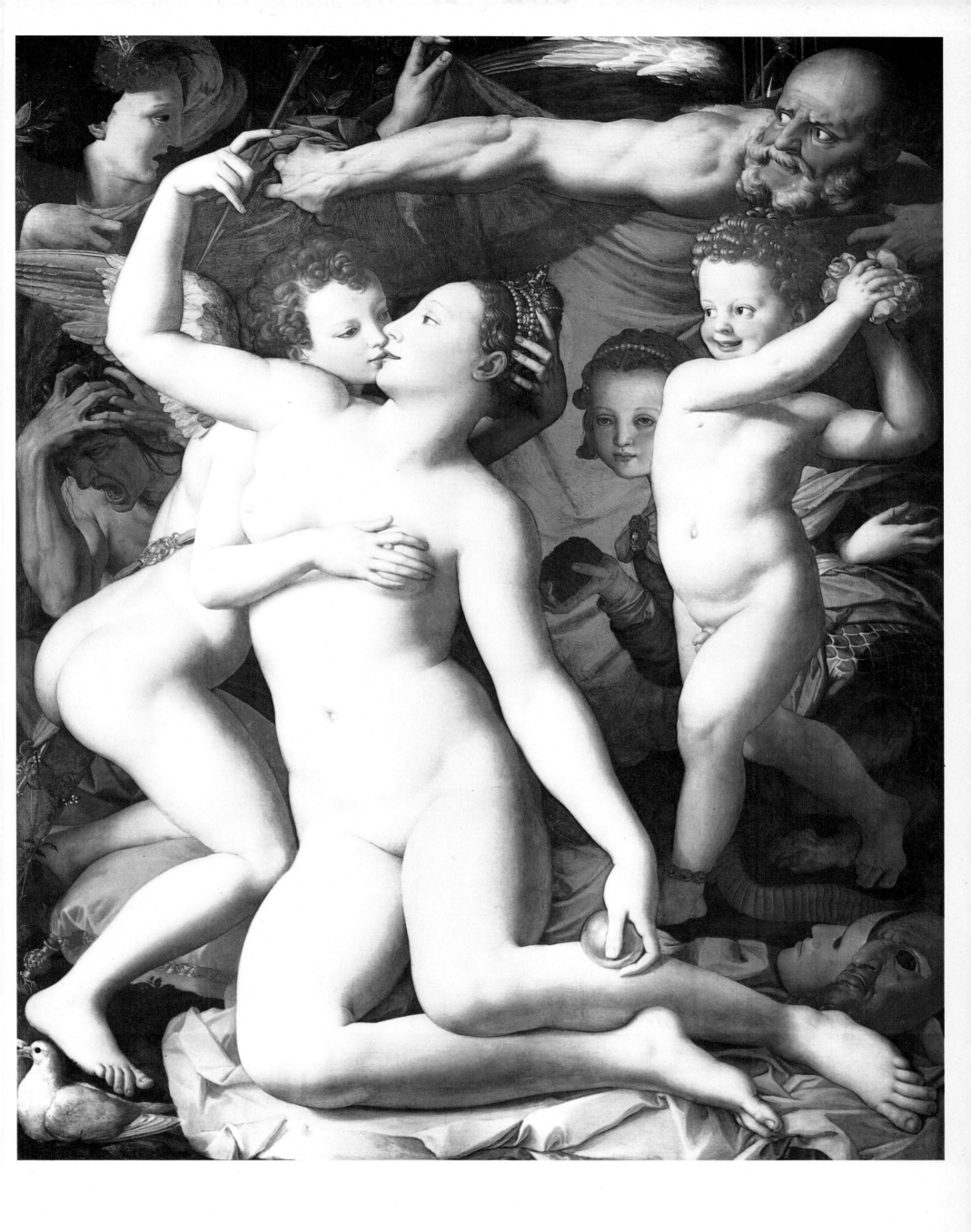

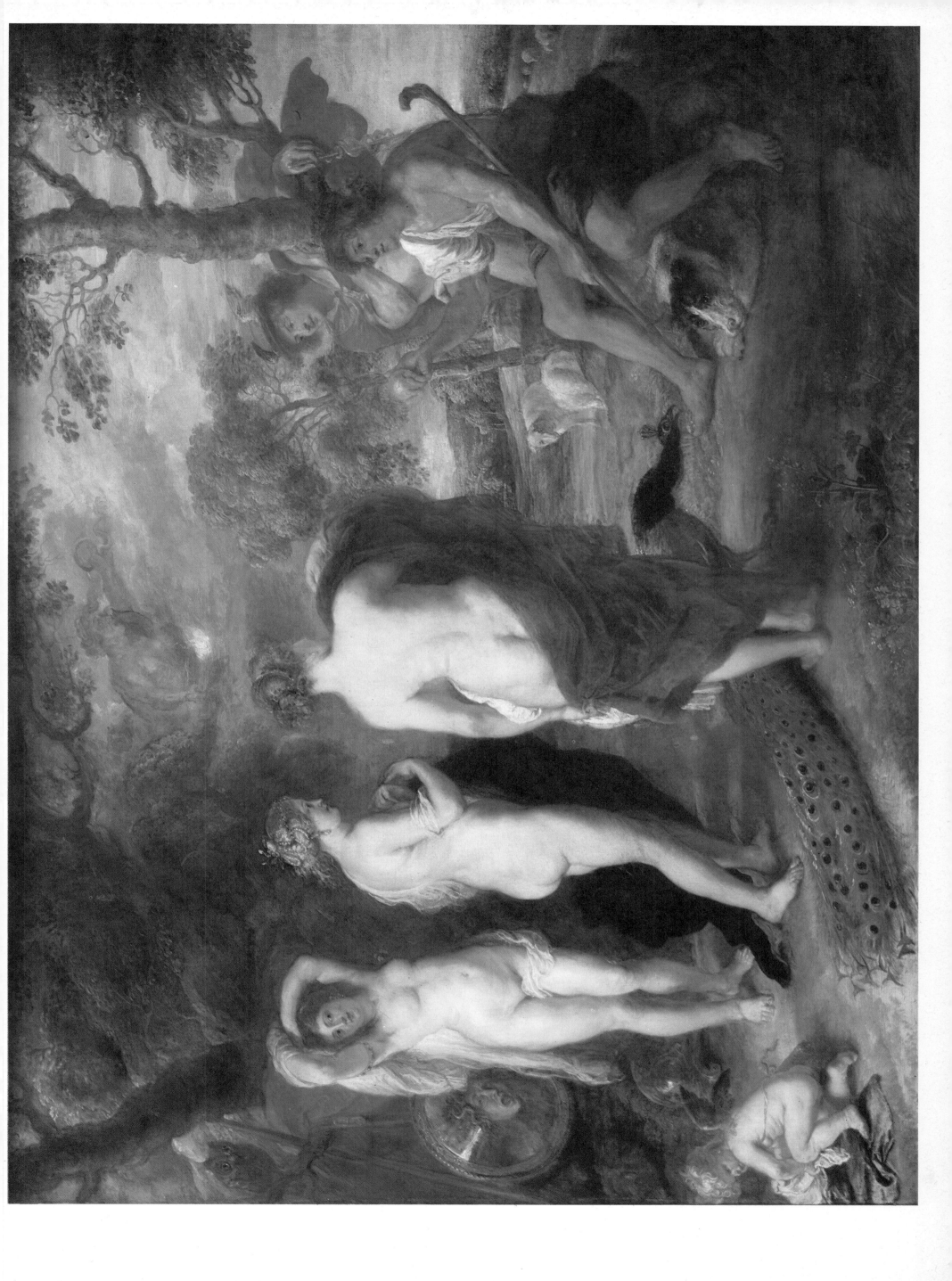

15

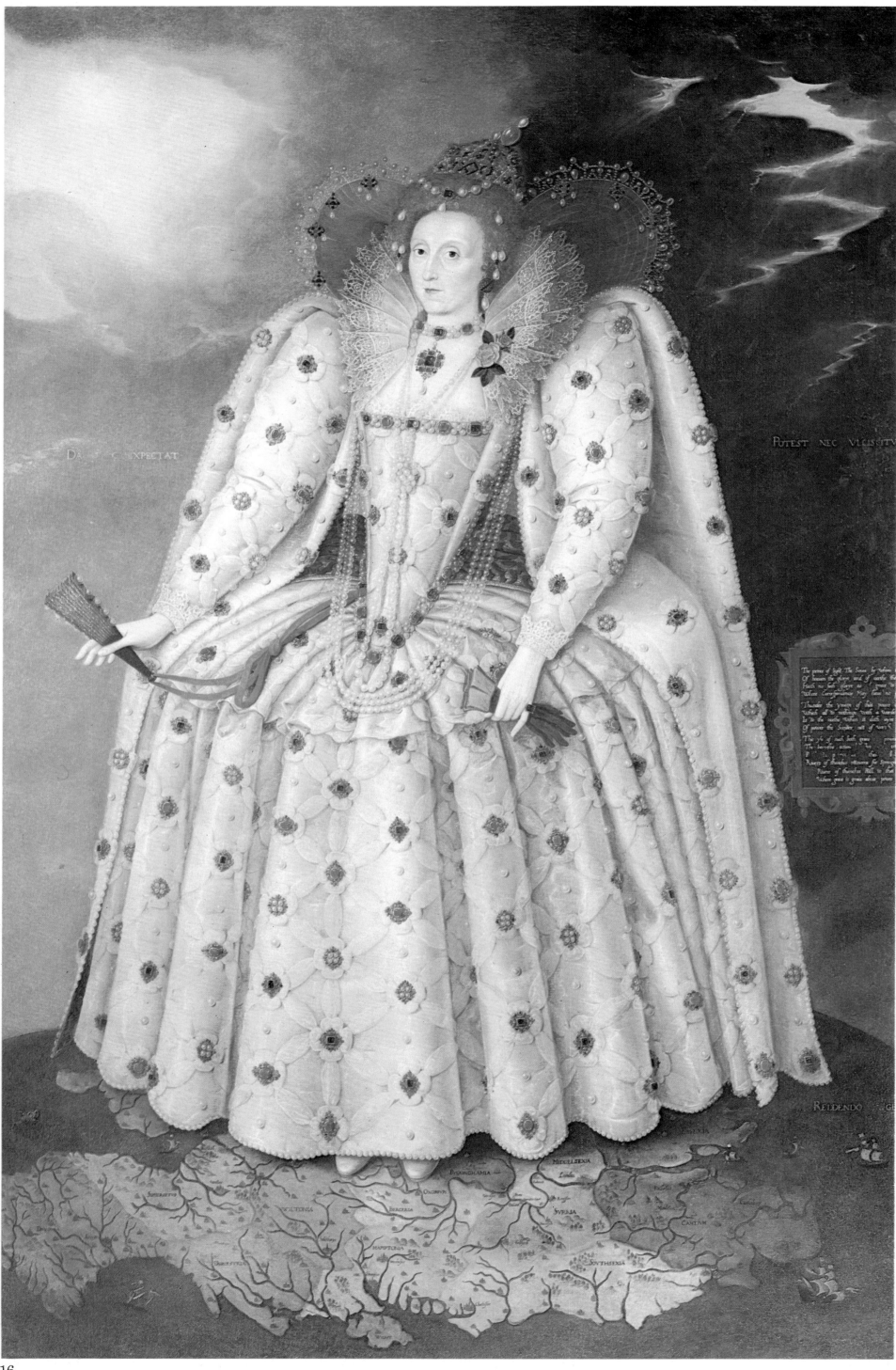

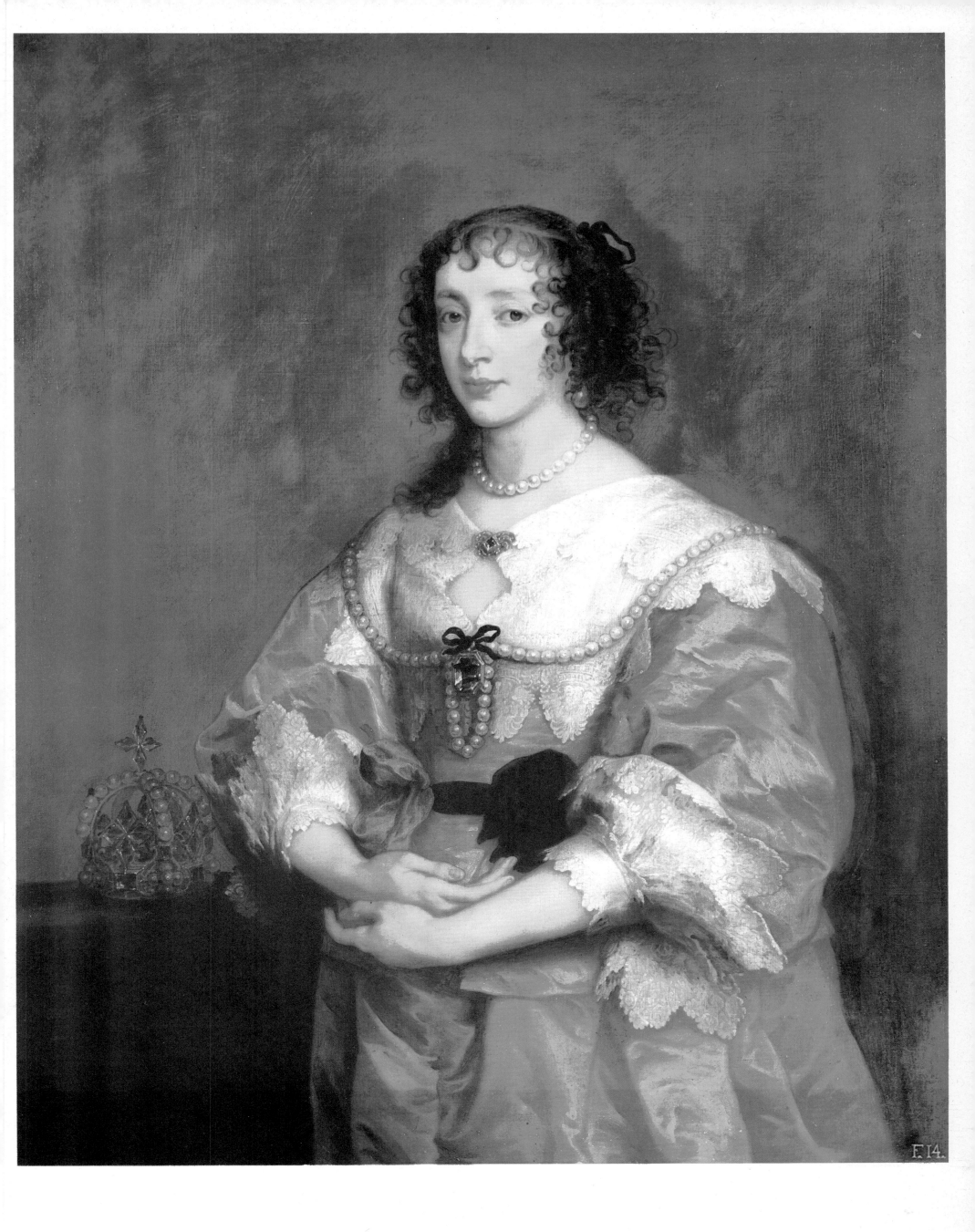

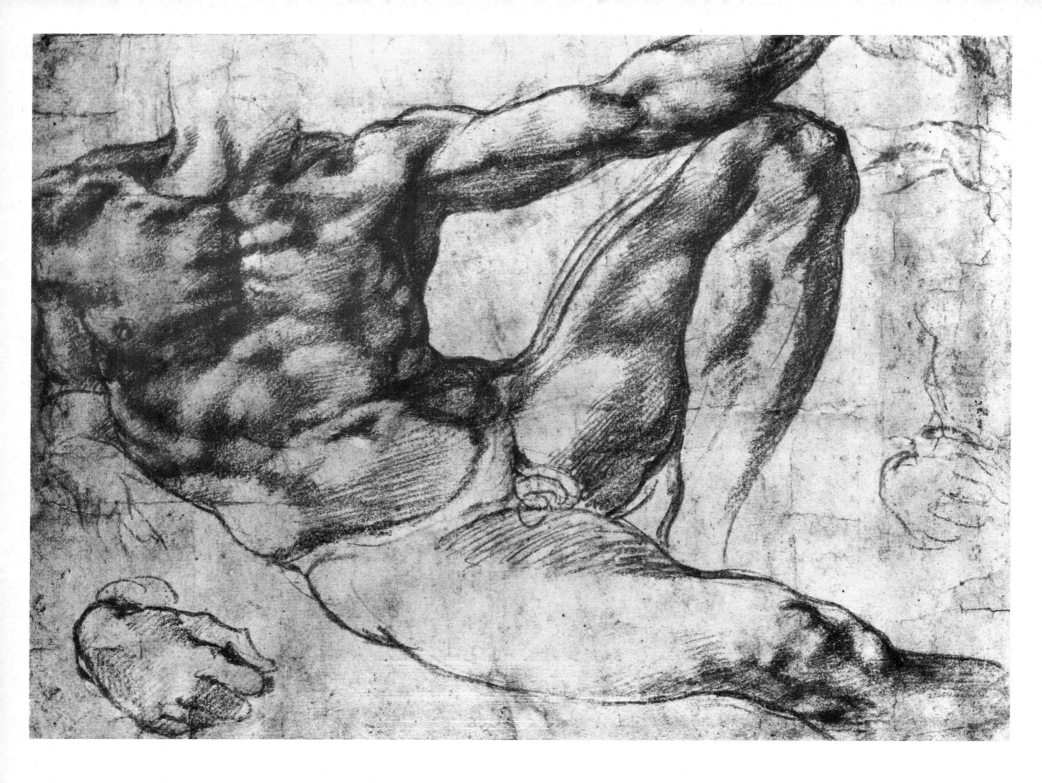

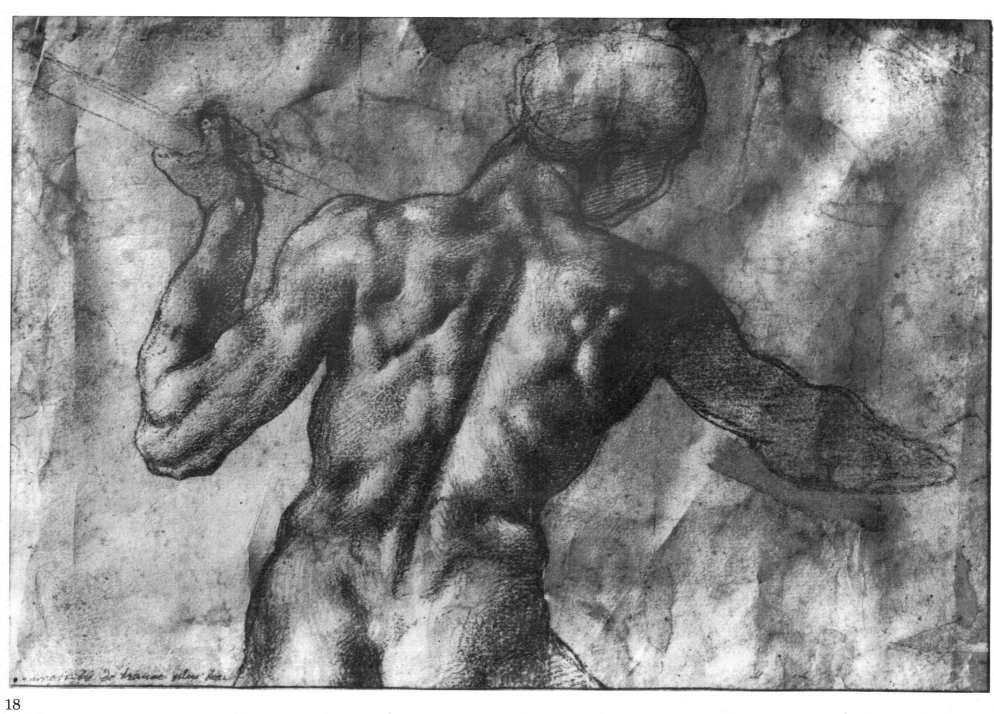

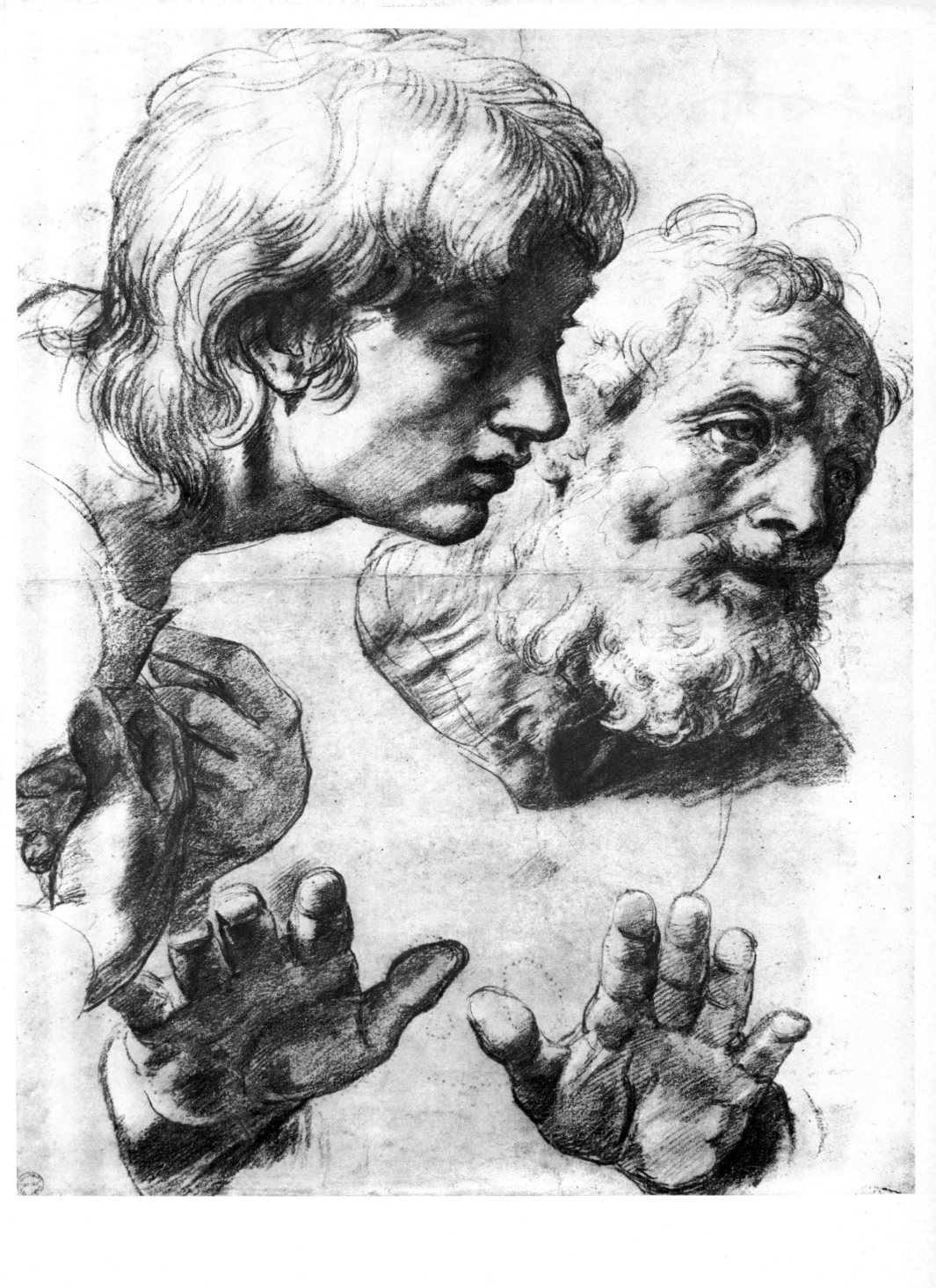

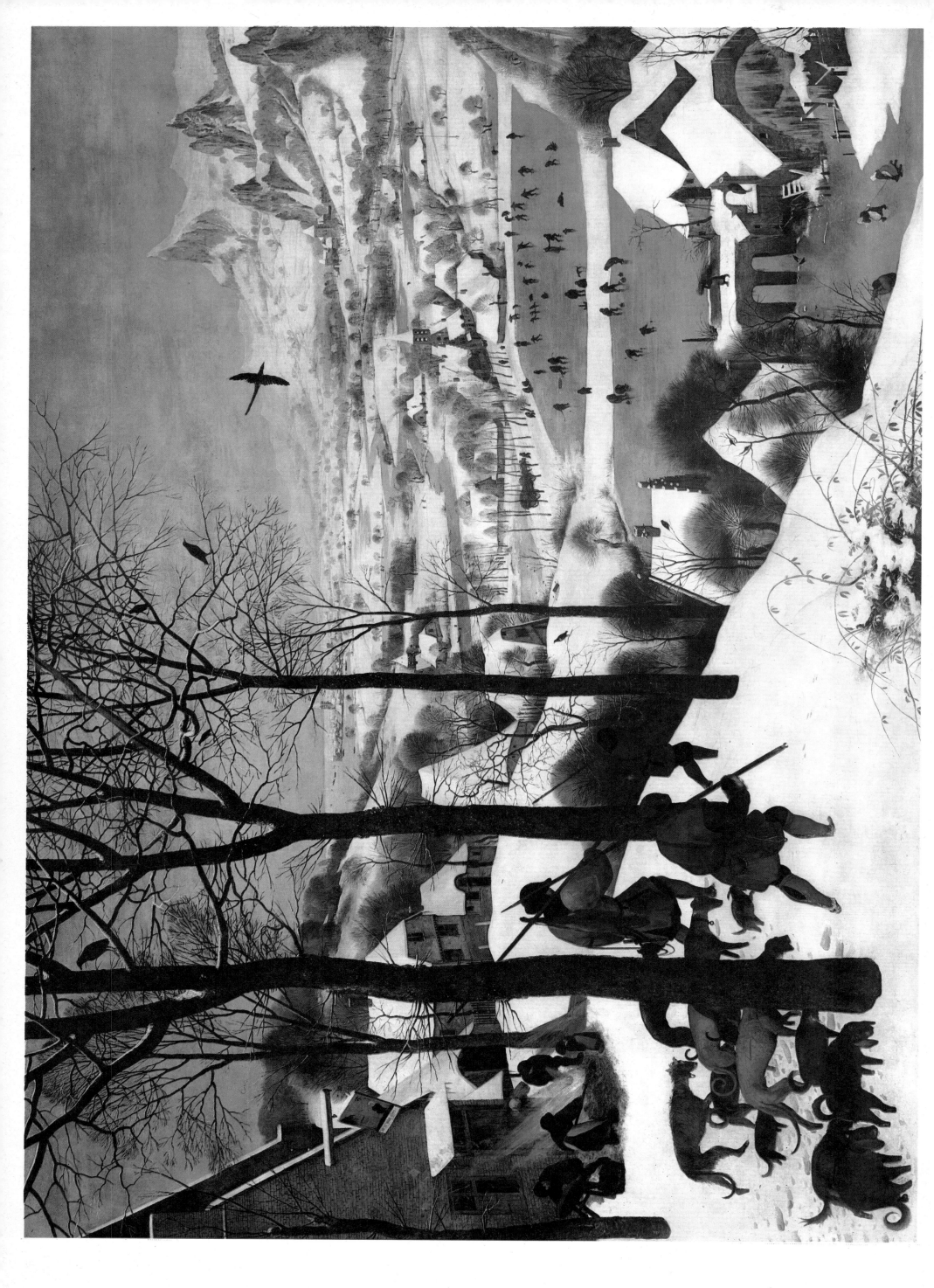

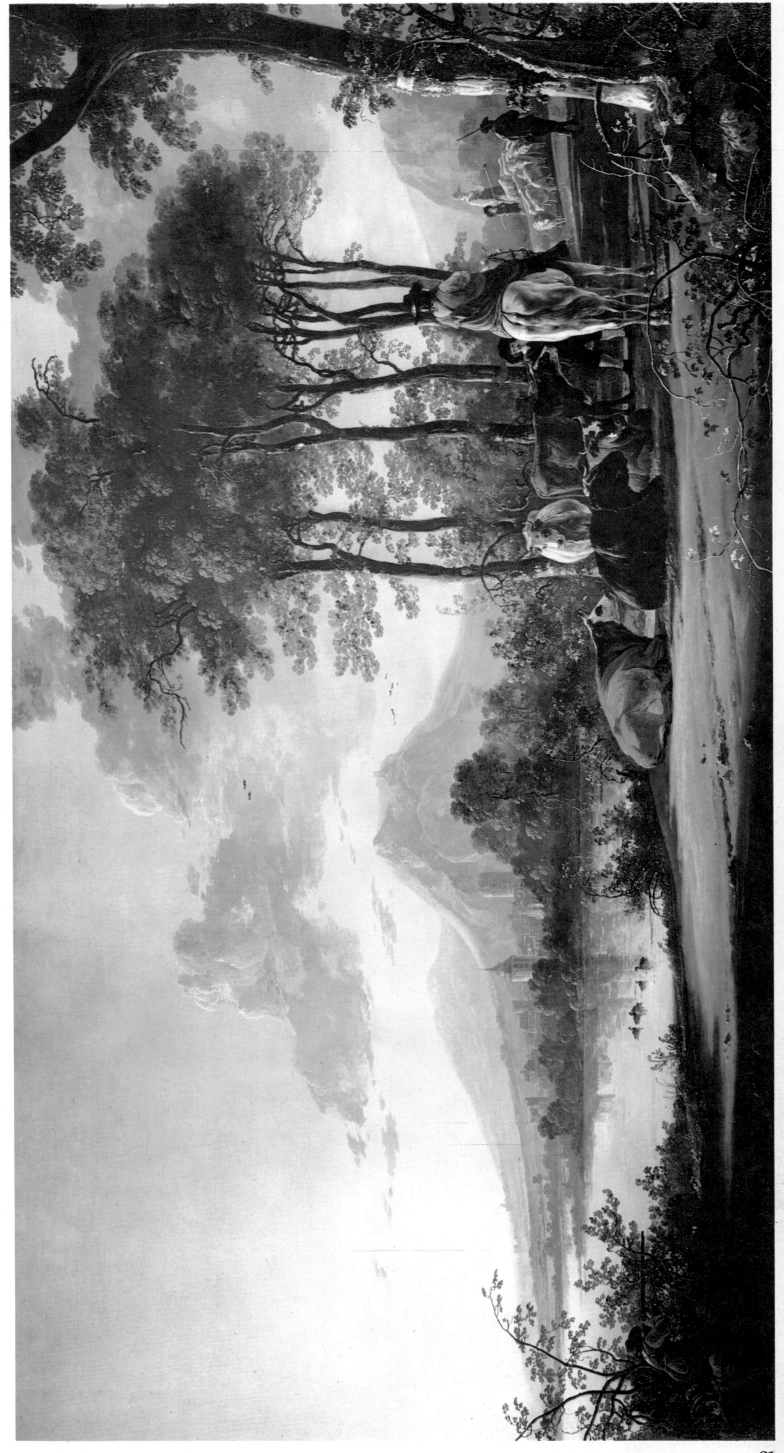

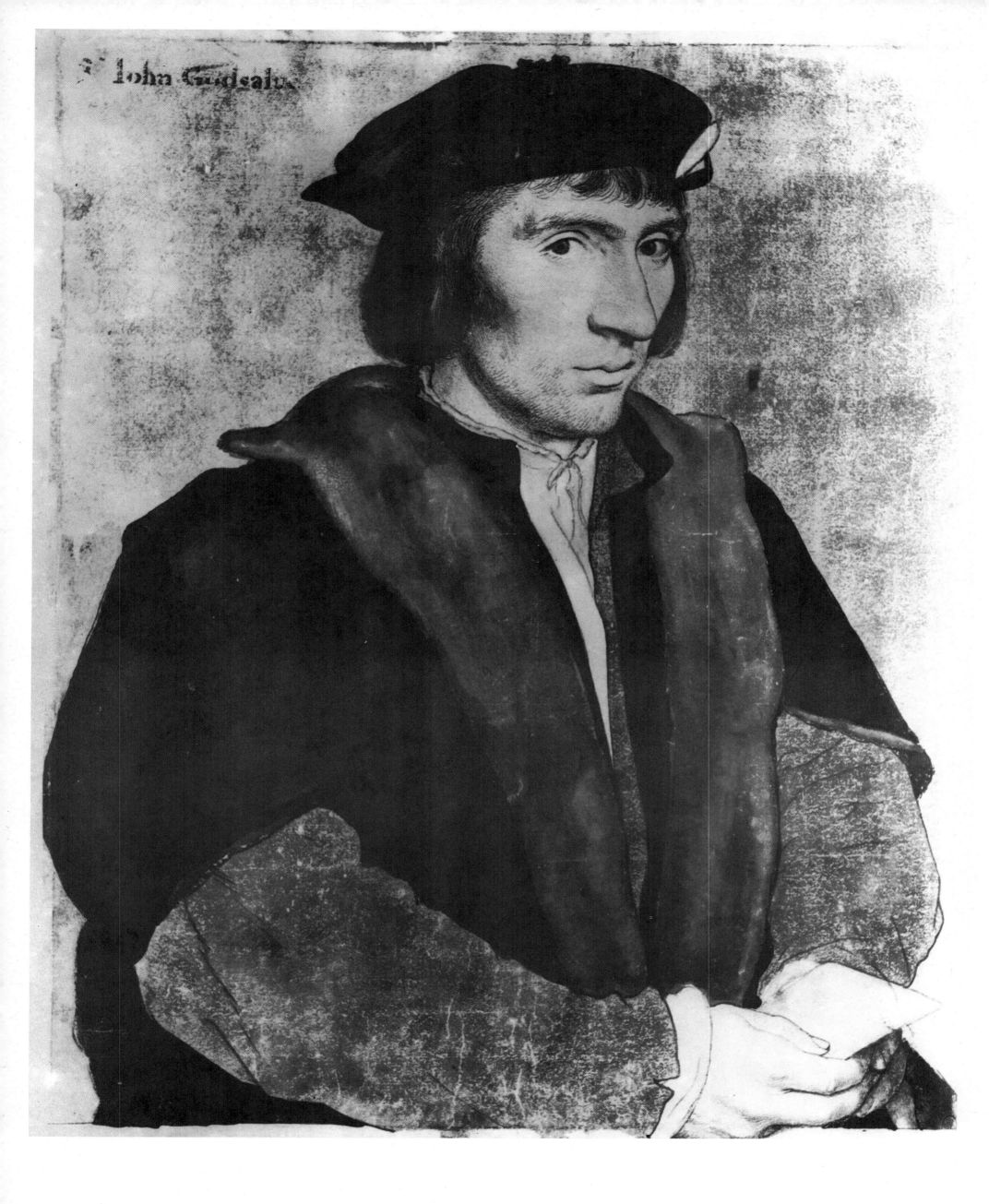

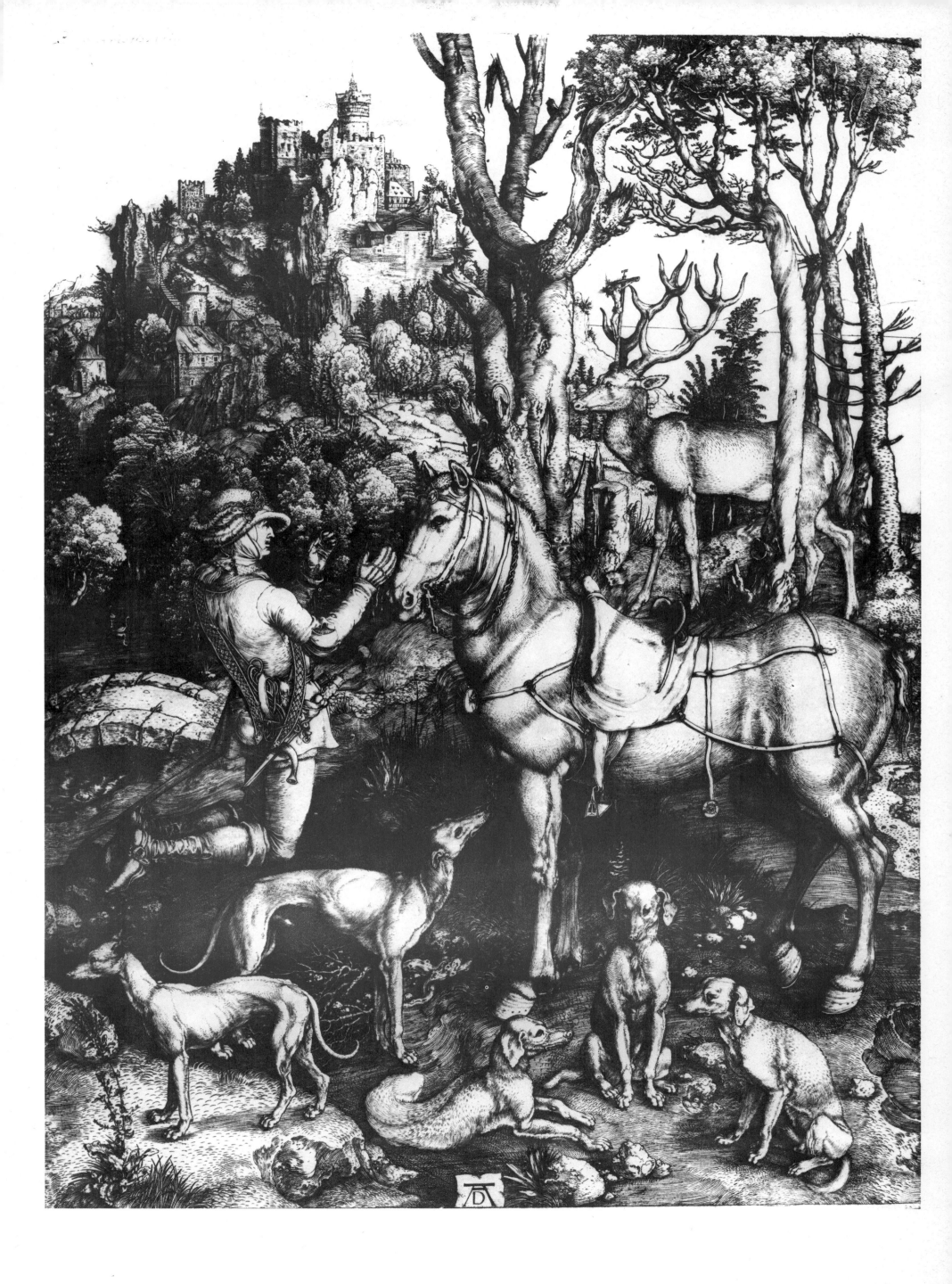

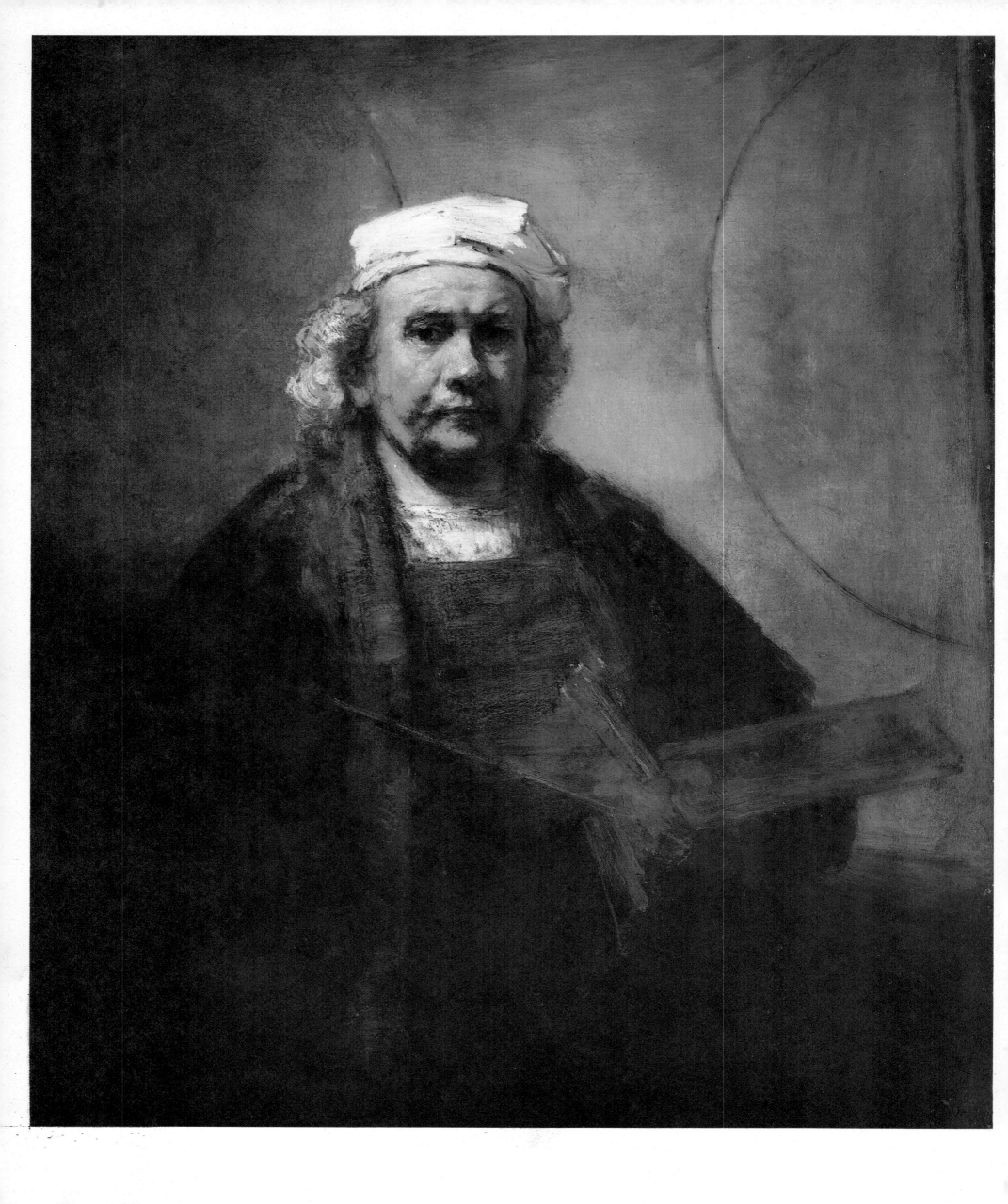

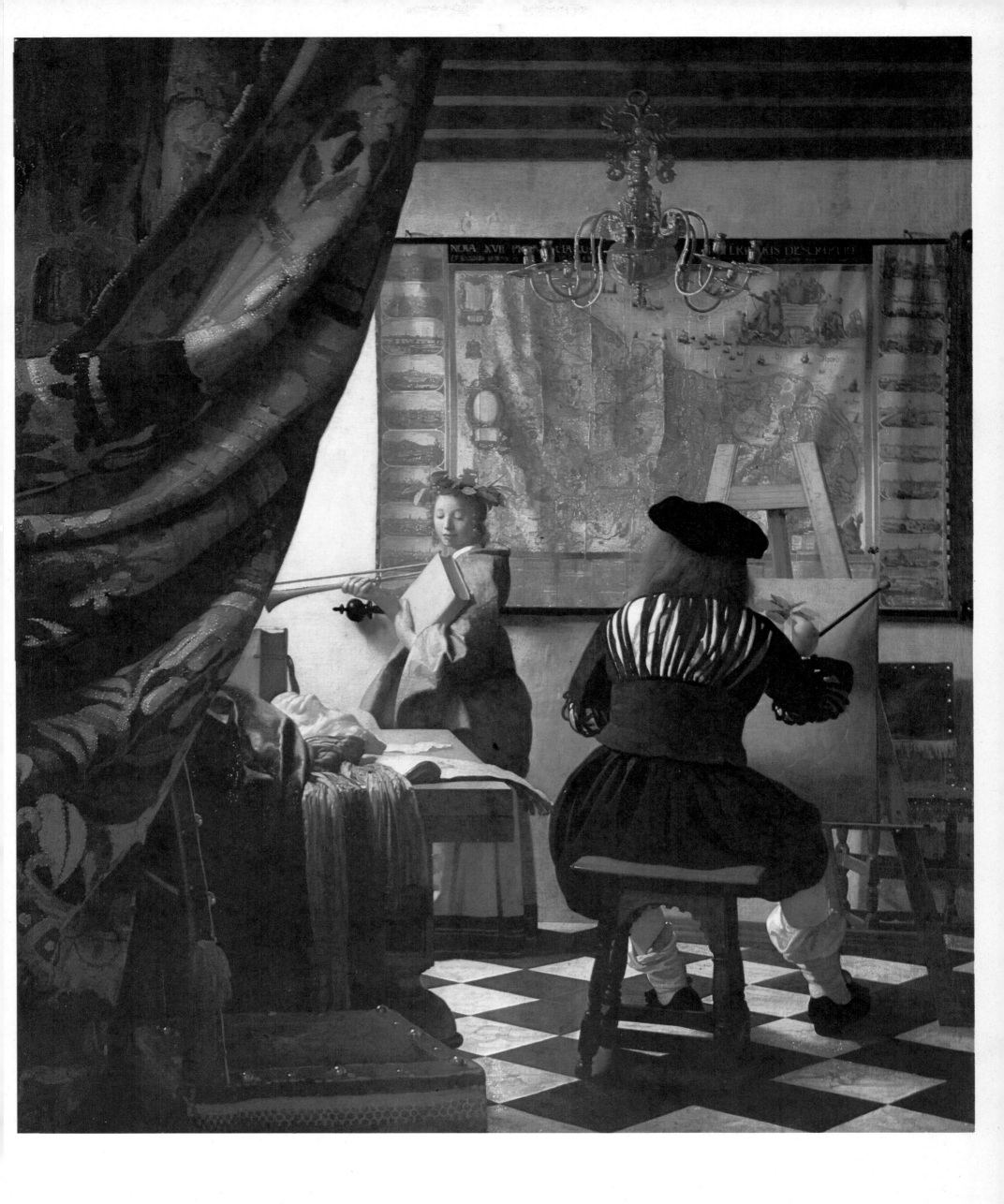

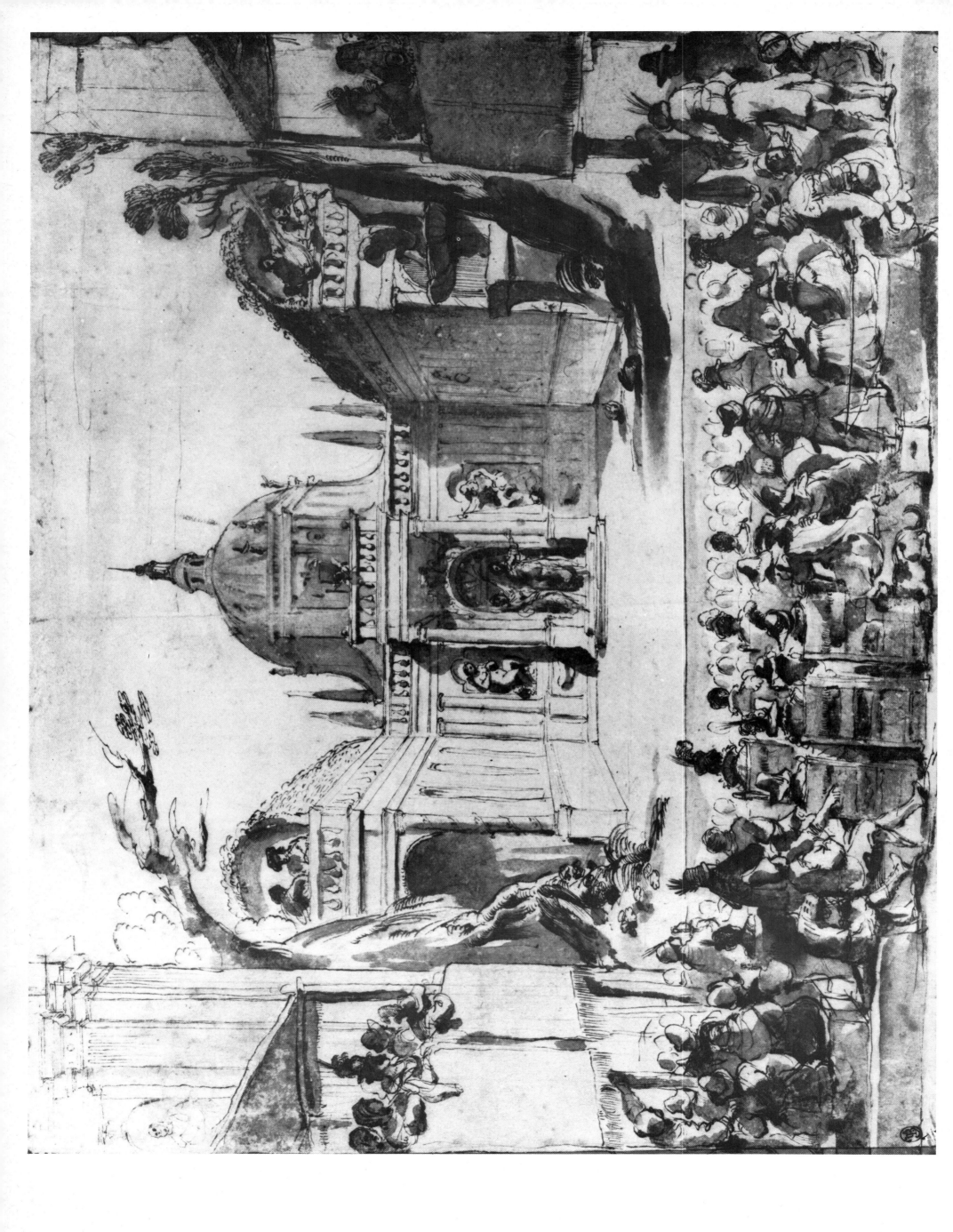

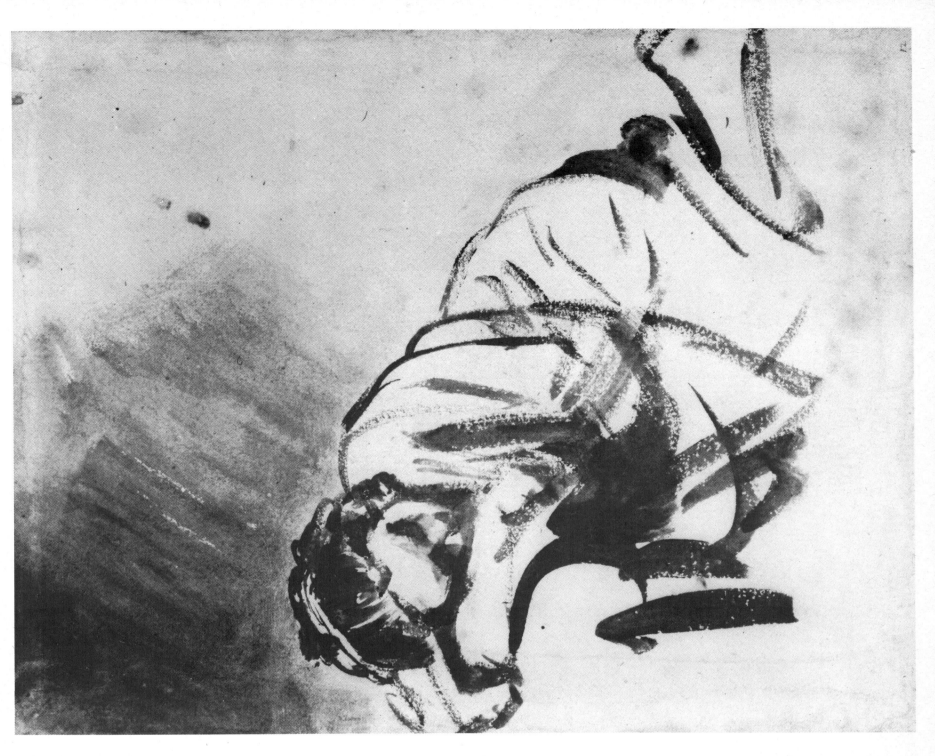

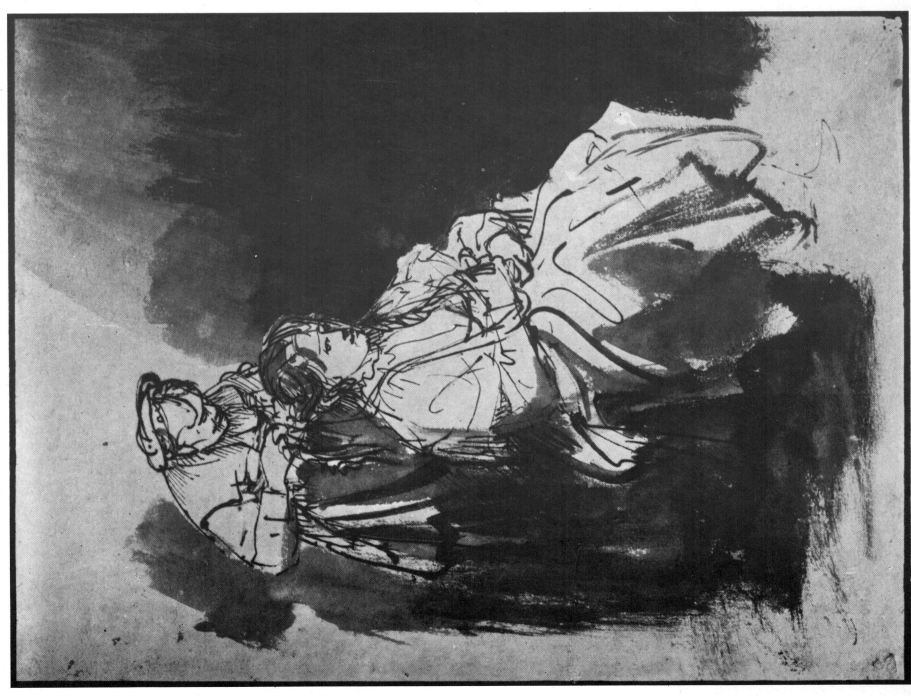

27

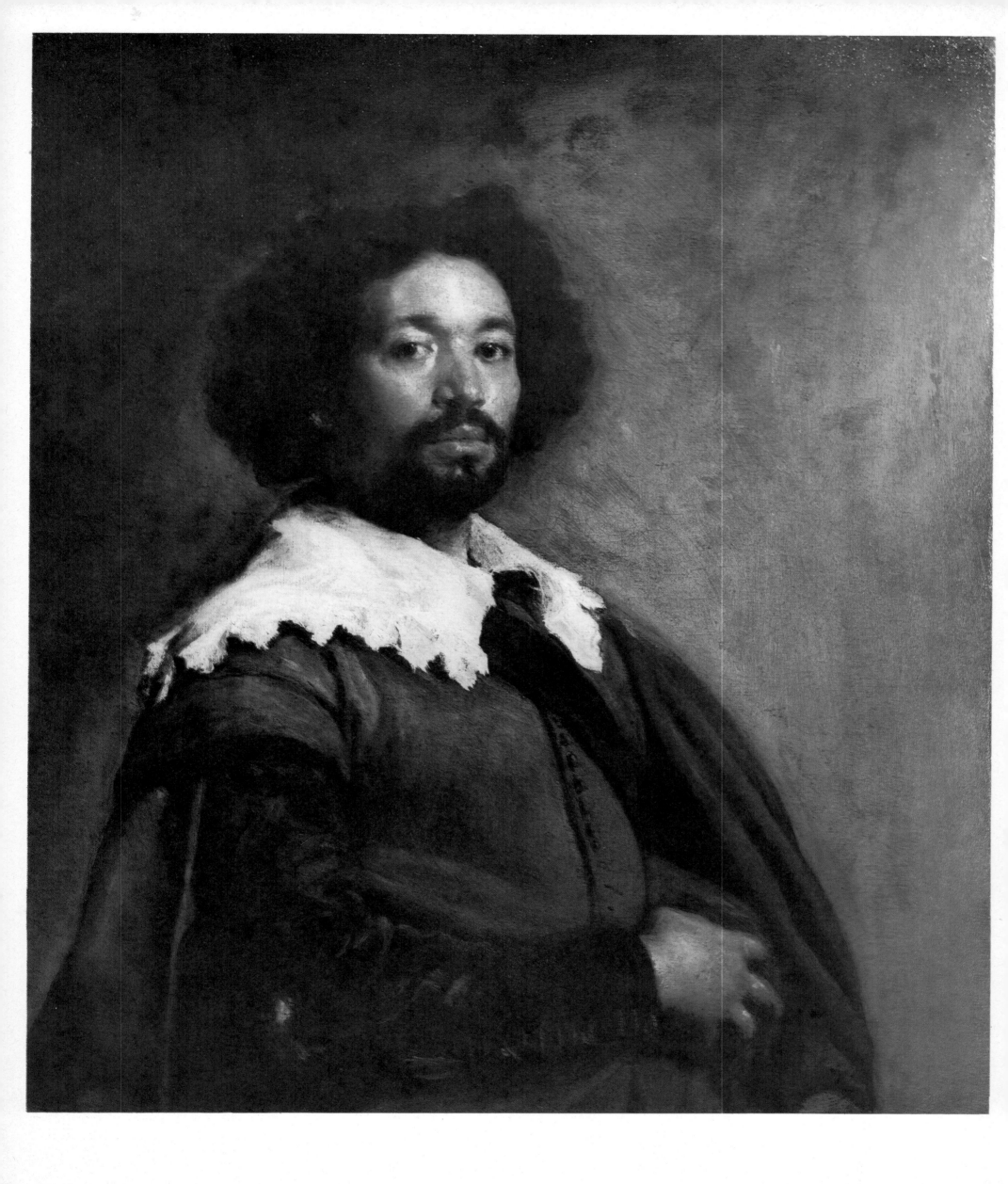

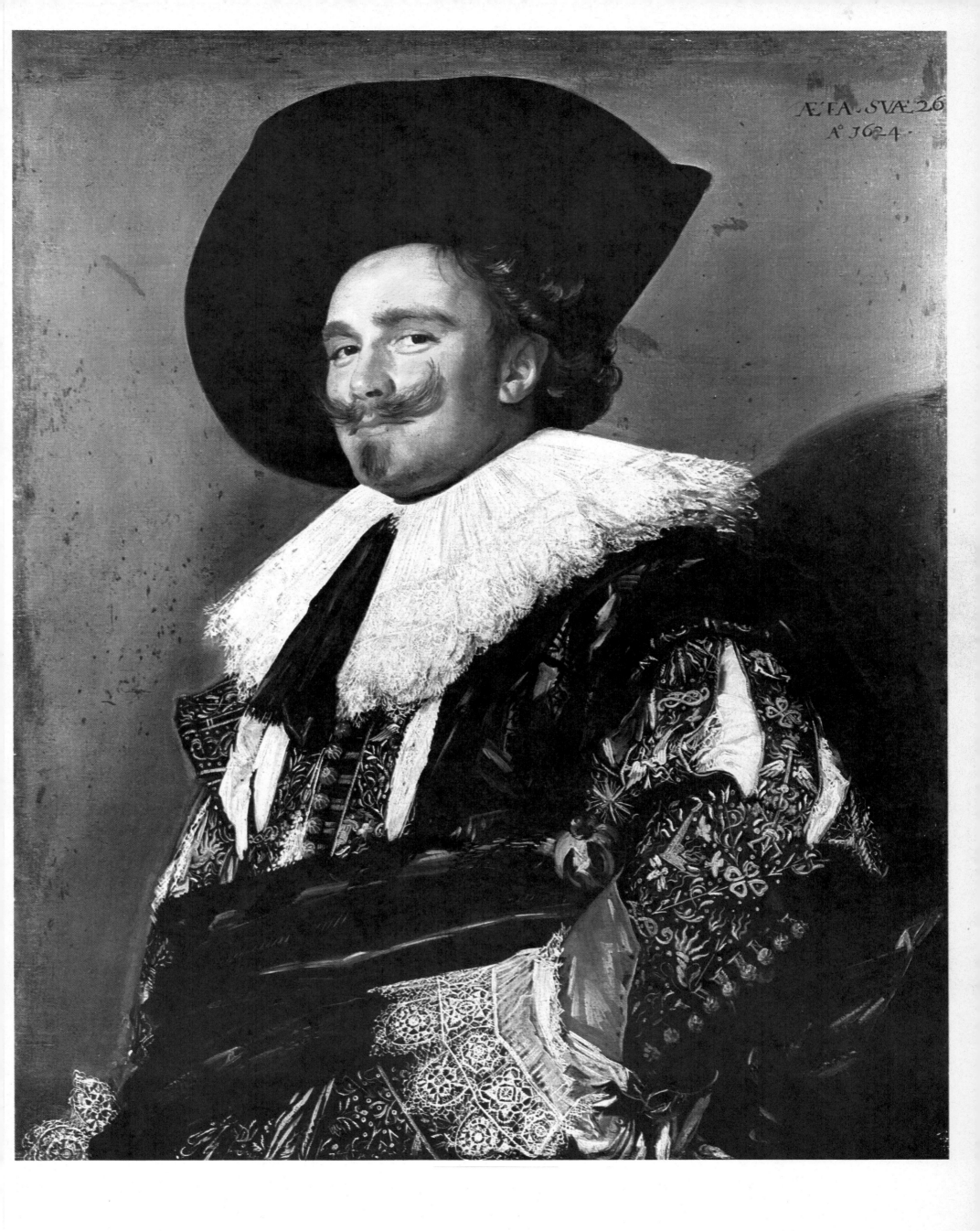

AETA·SVAE·26
A° 1624·

29

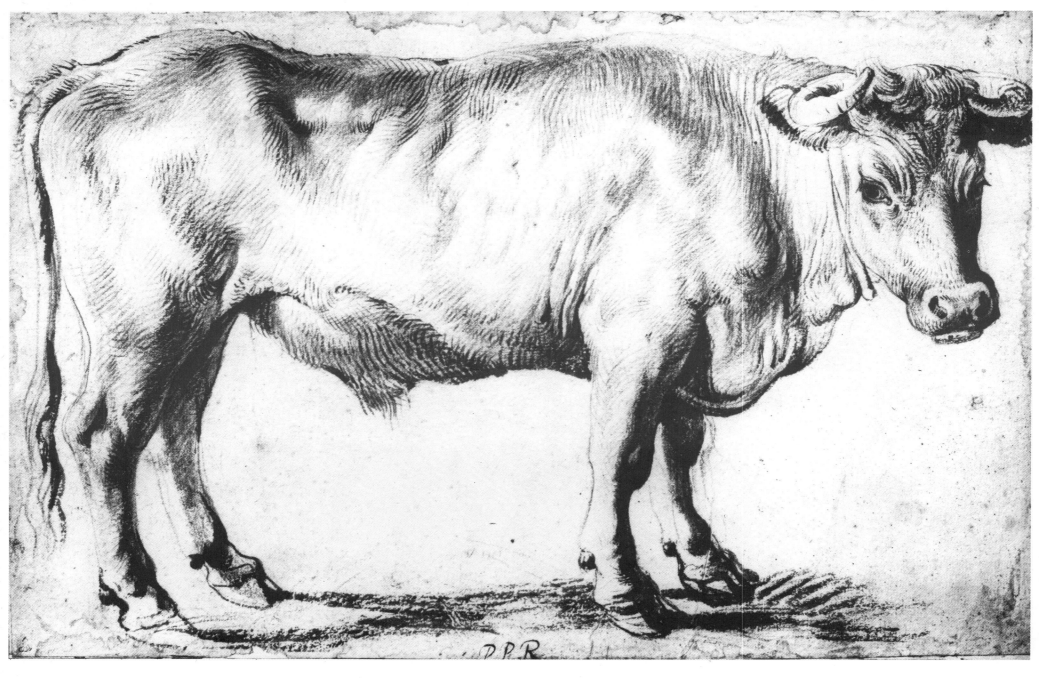

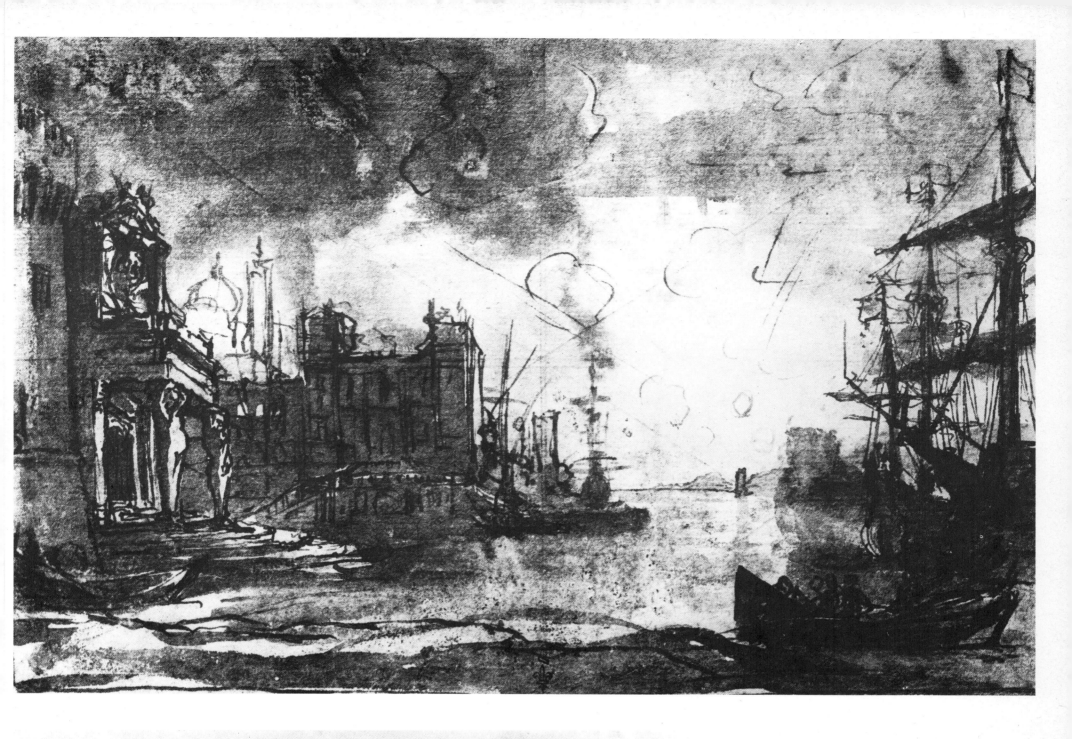

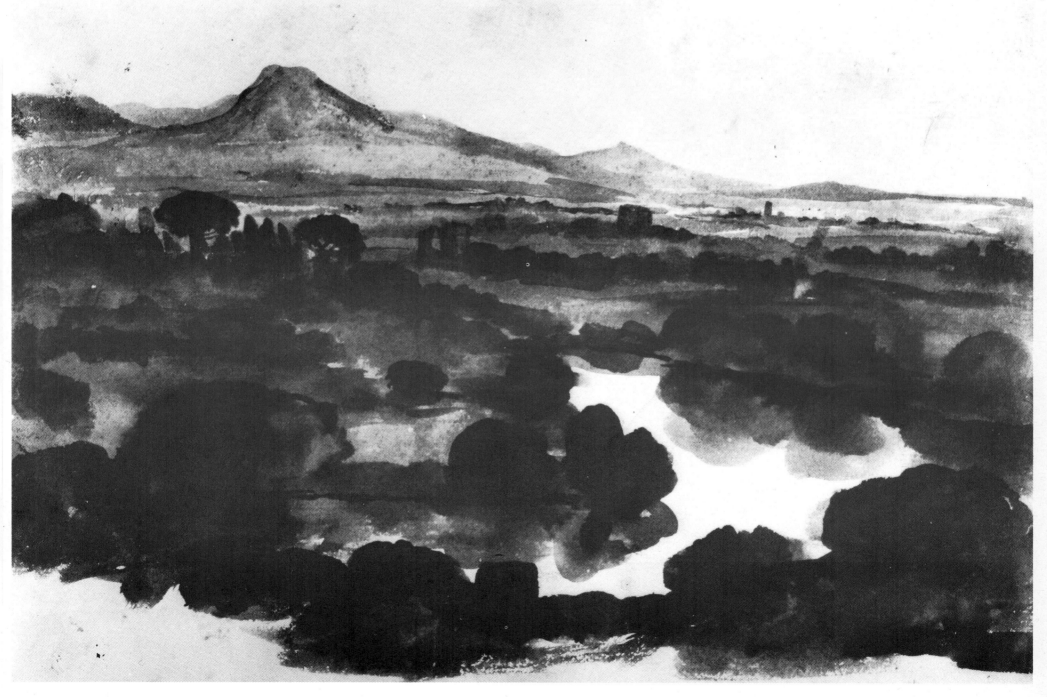

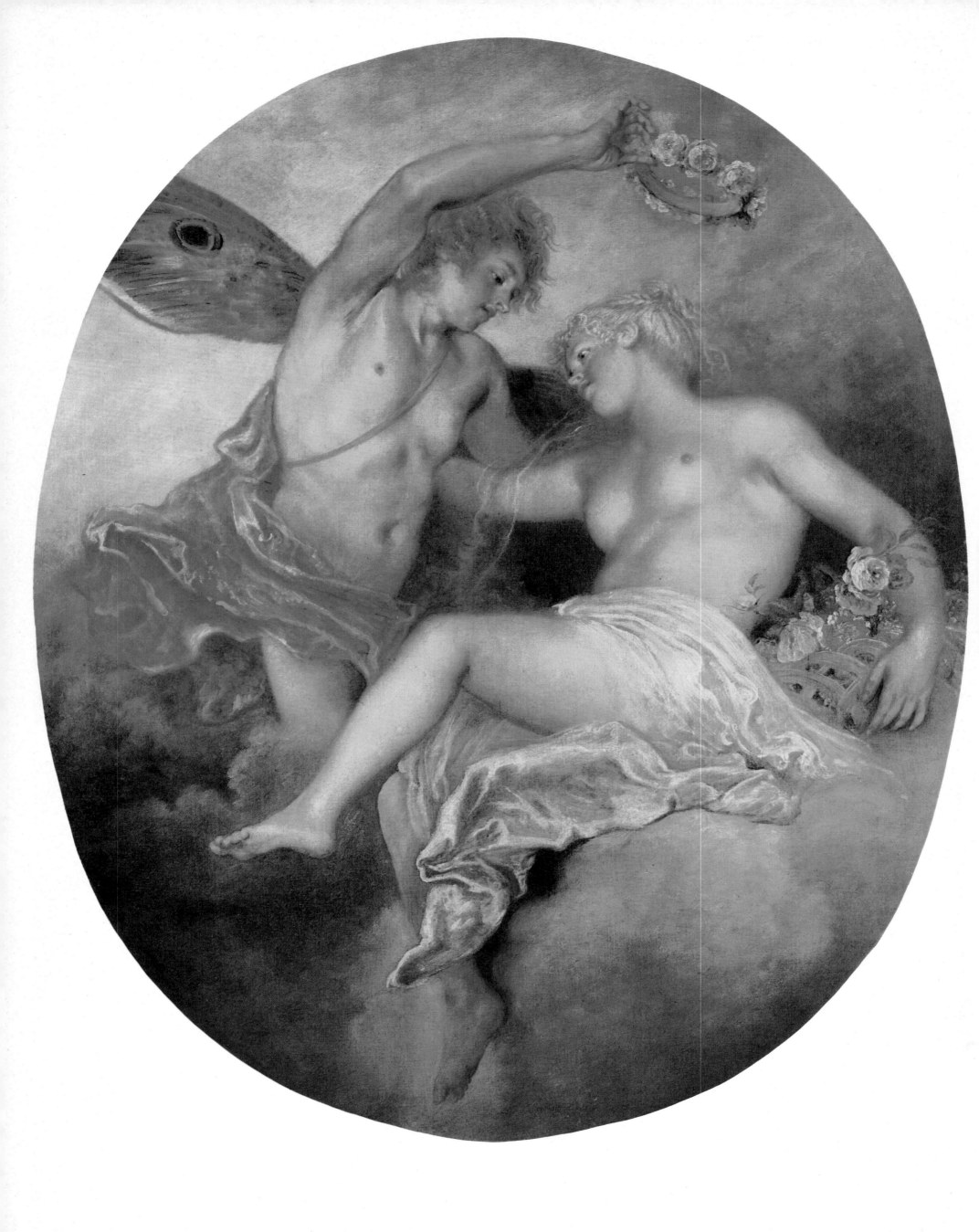

32

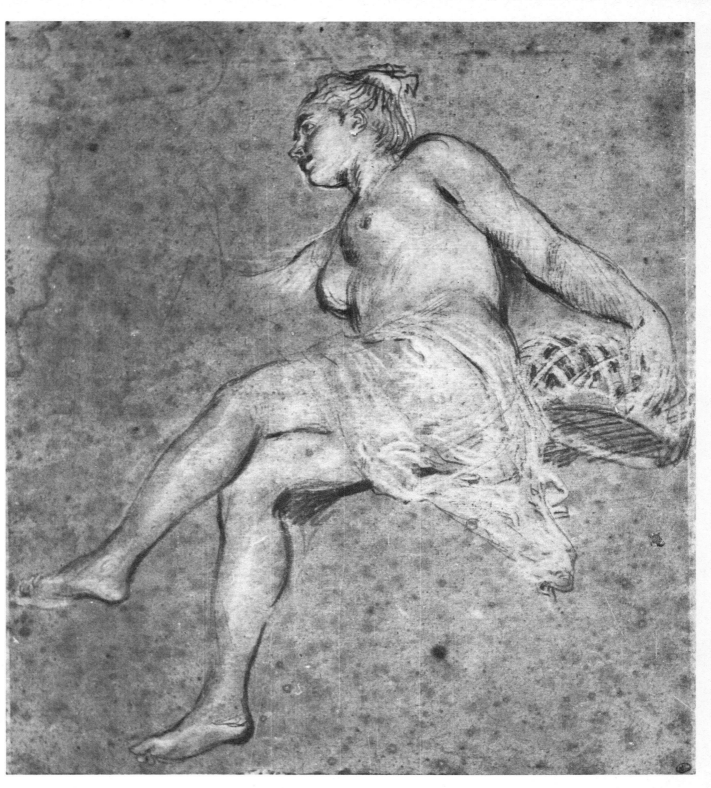

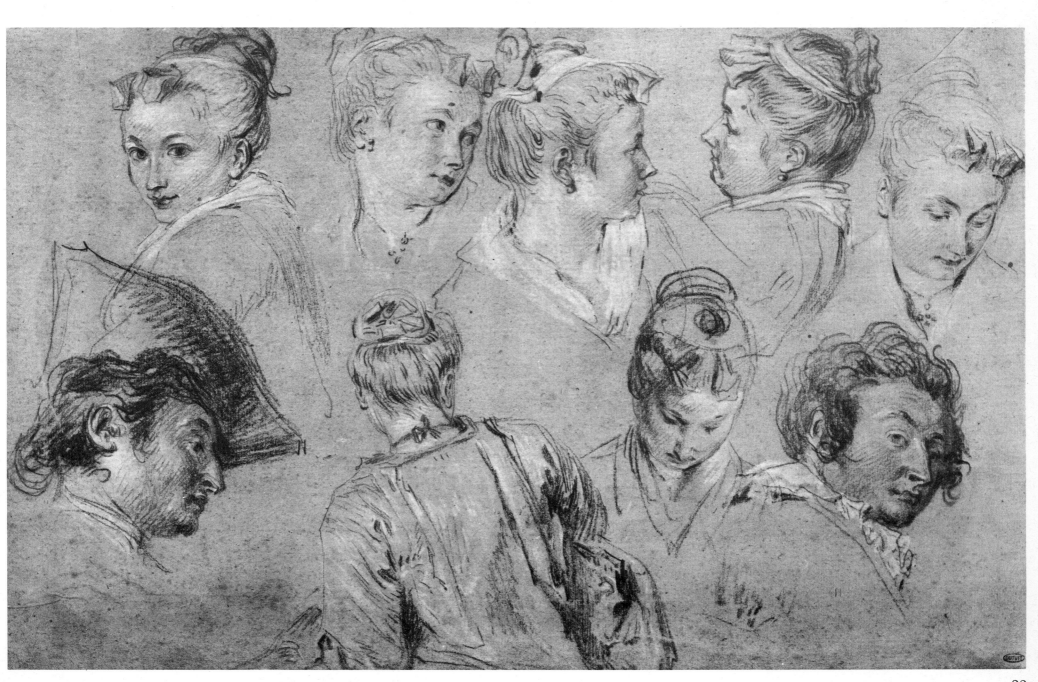

33

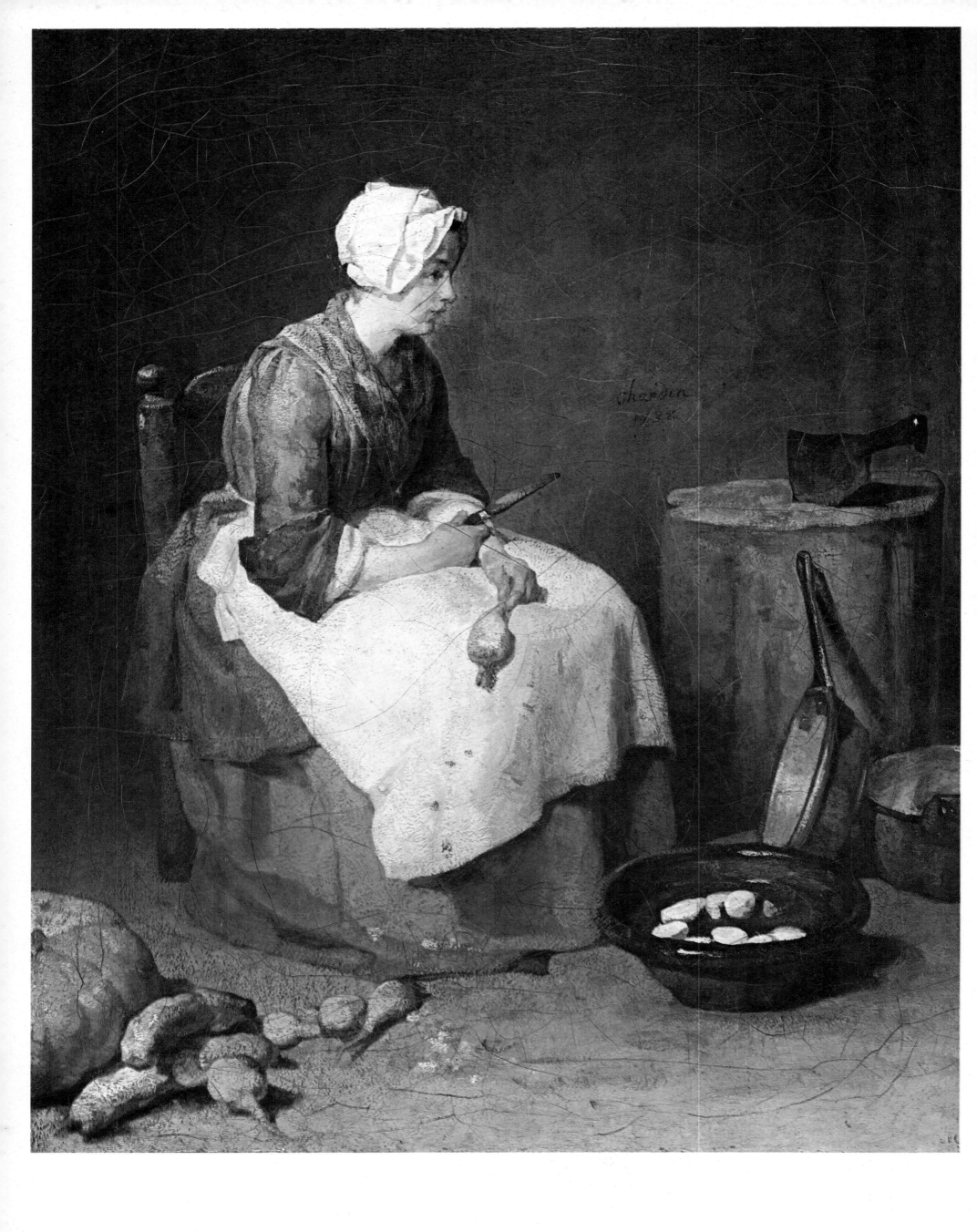

34

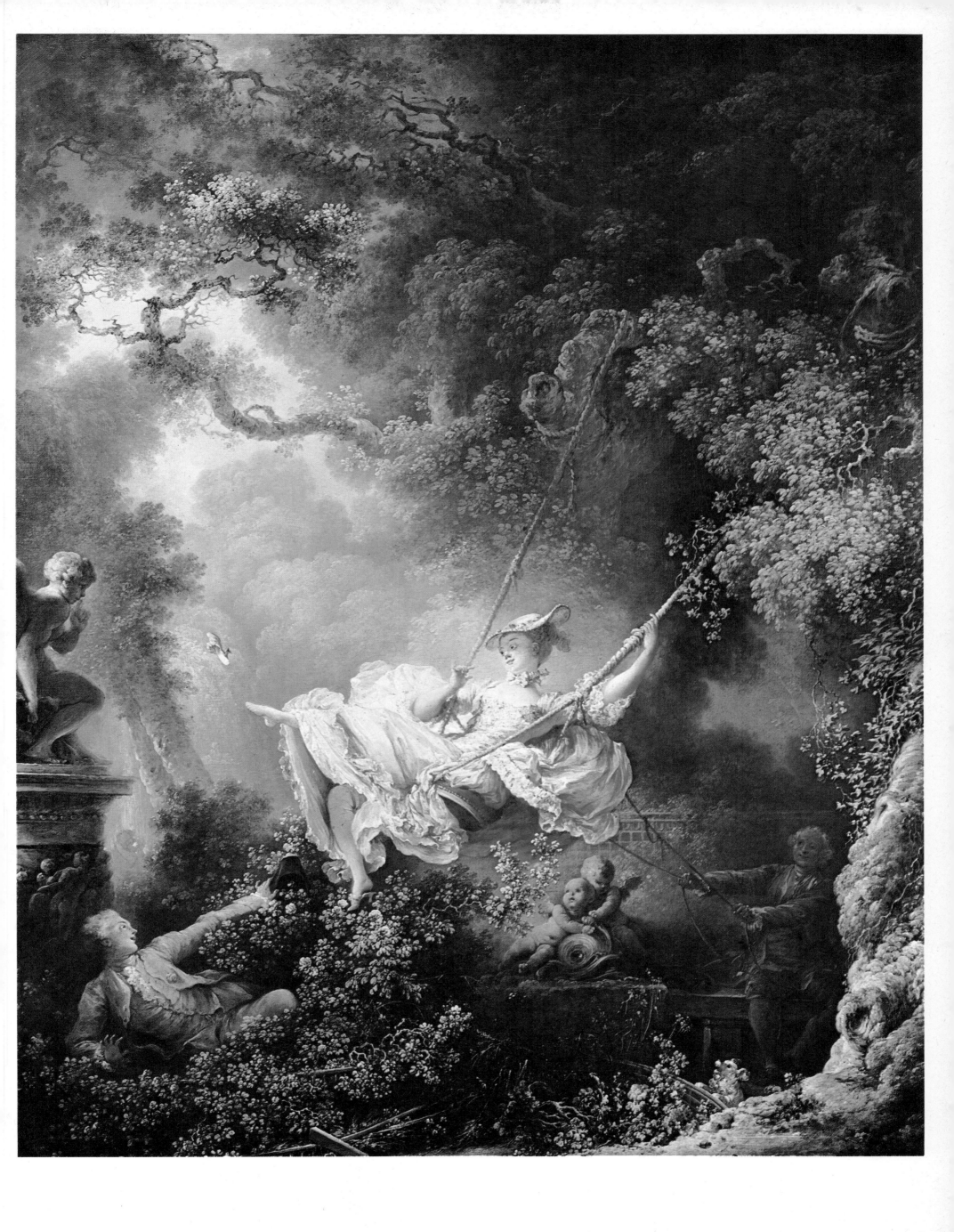

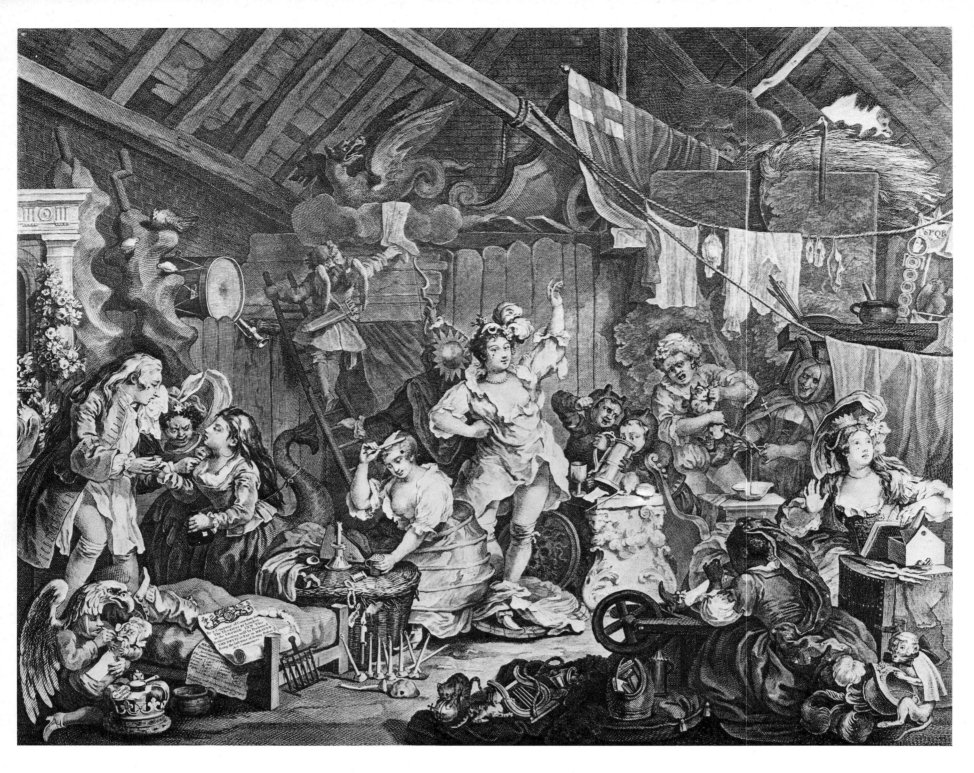

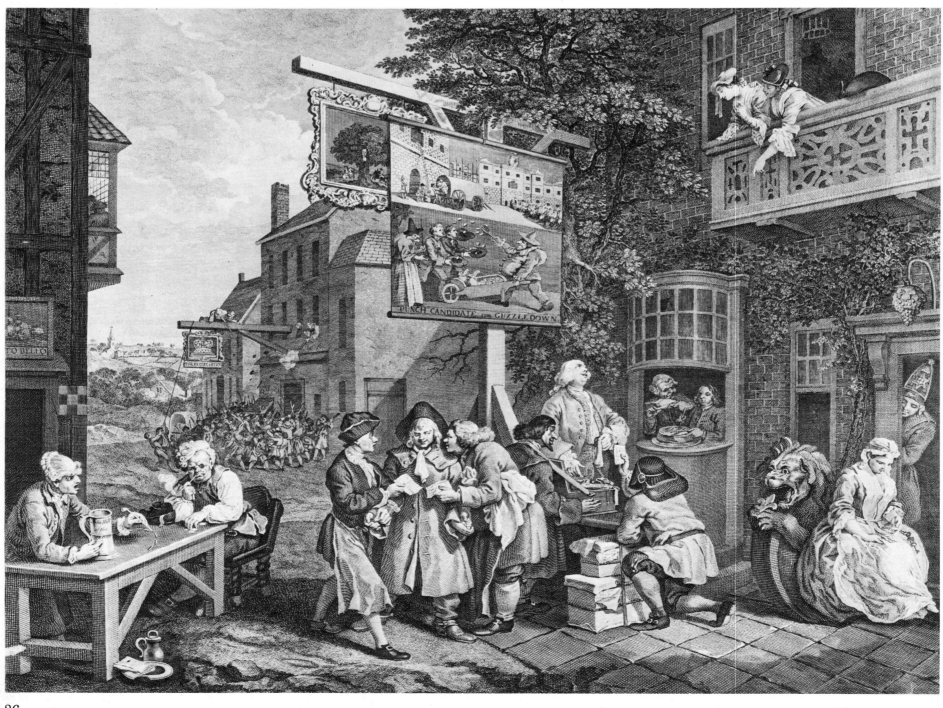

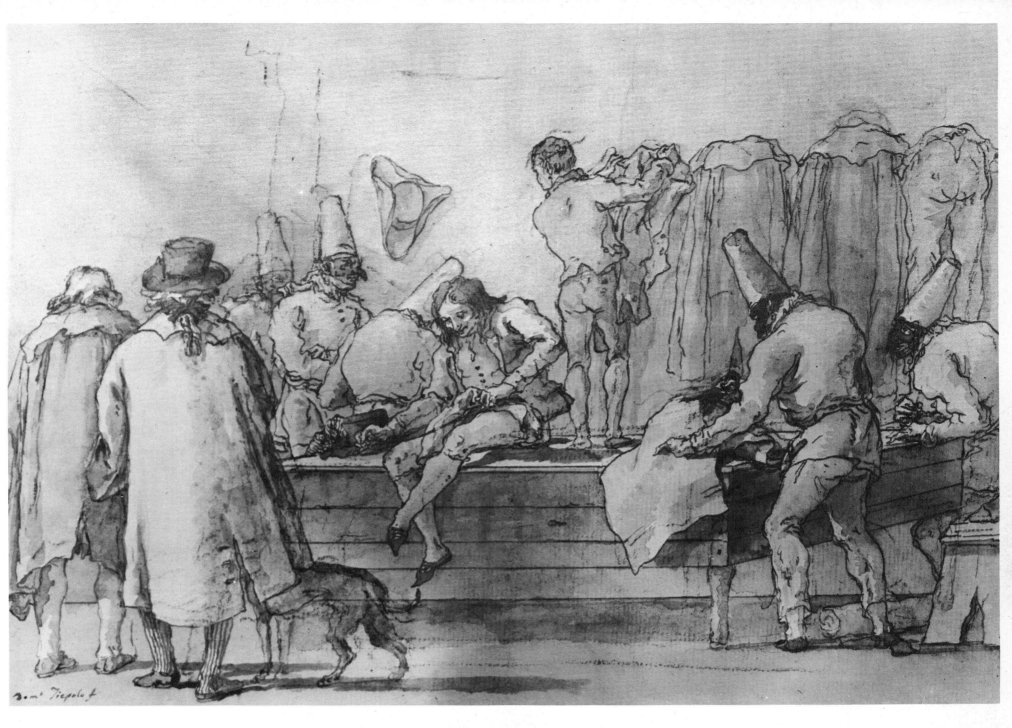

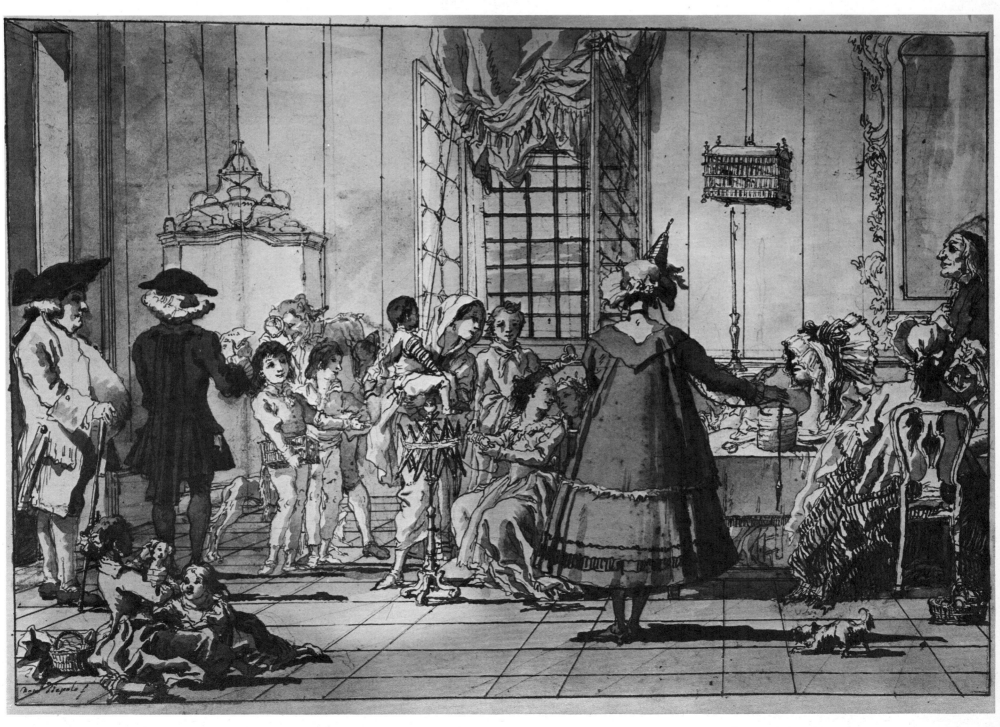

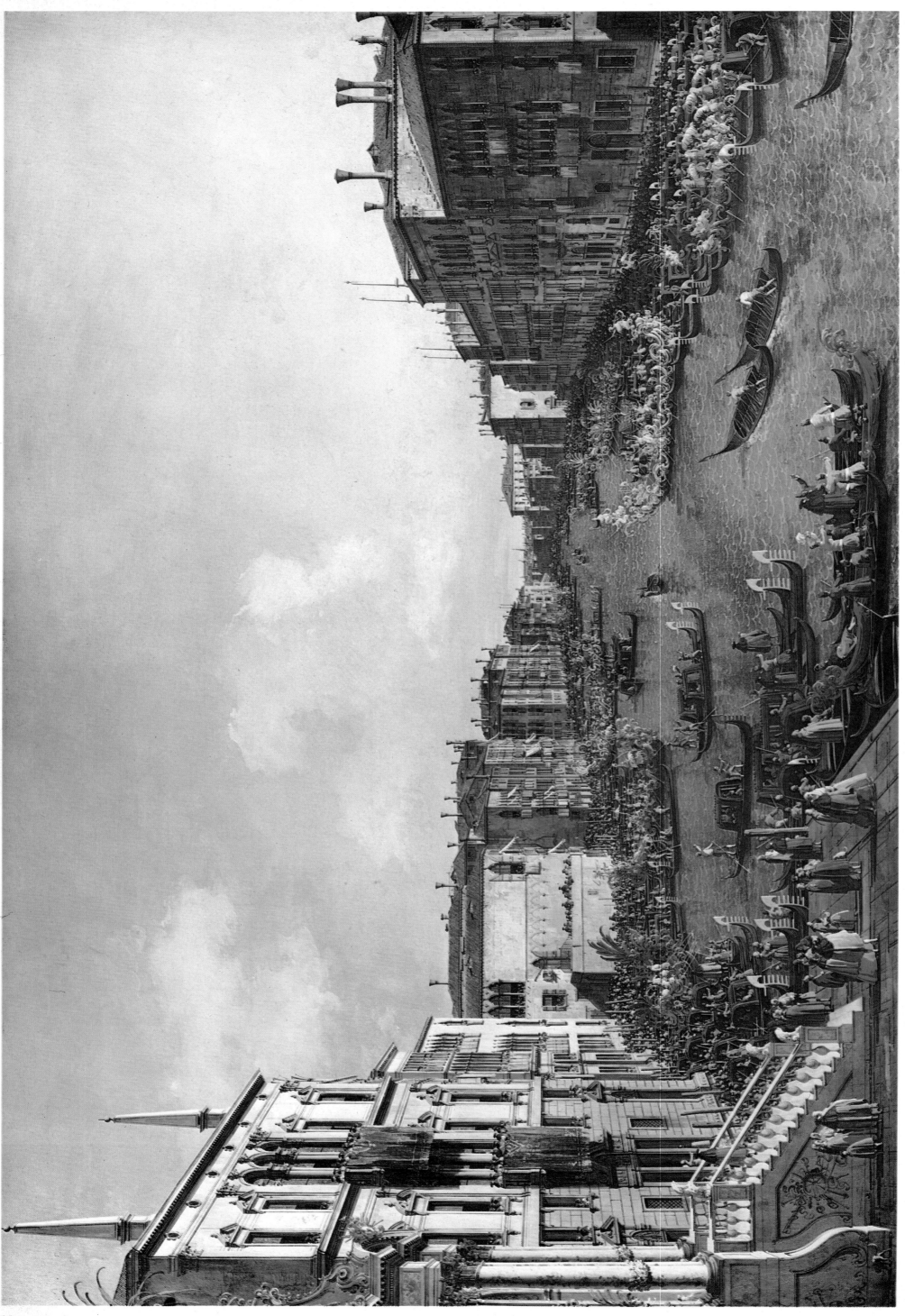

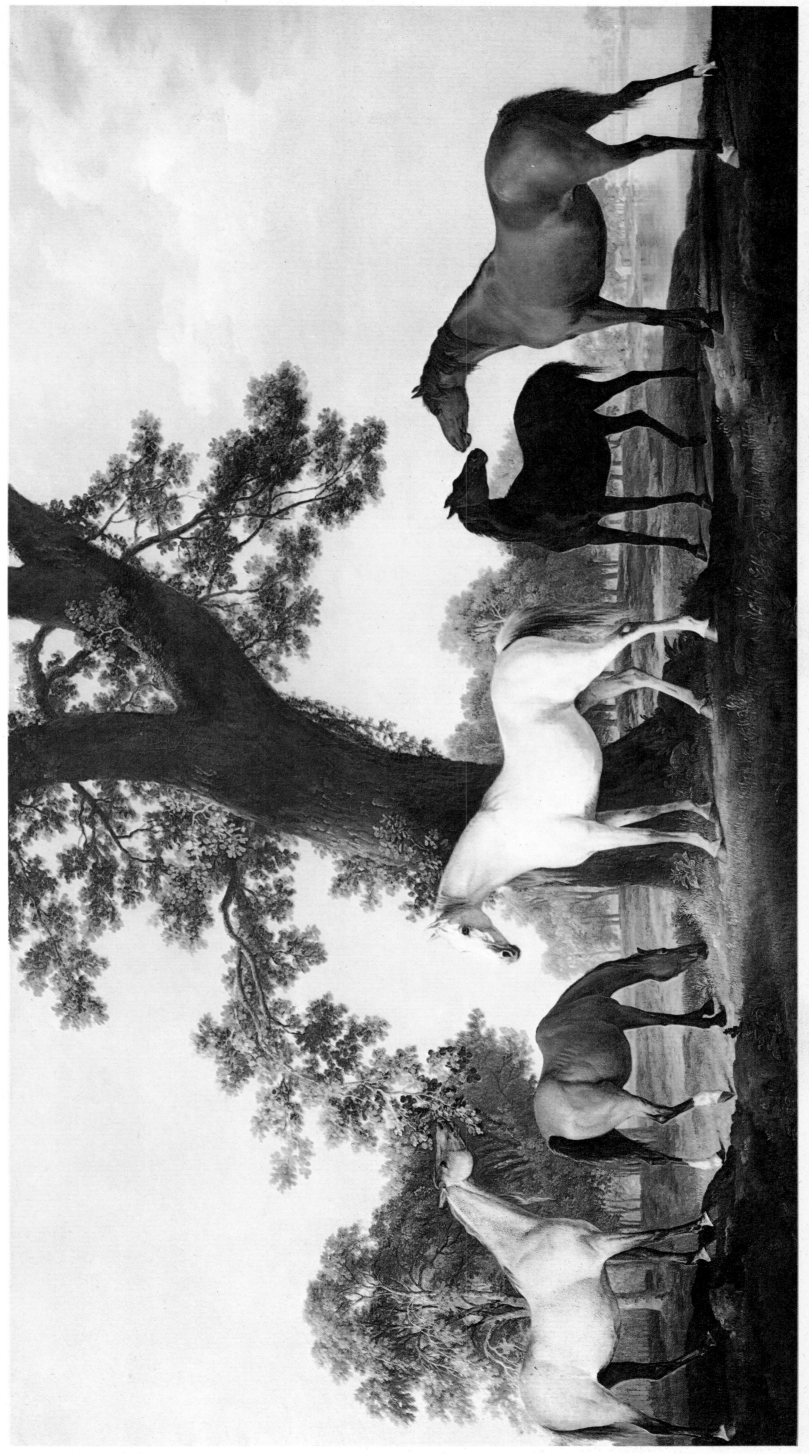

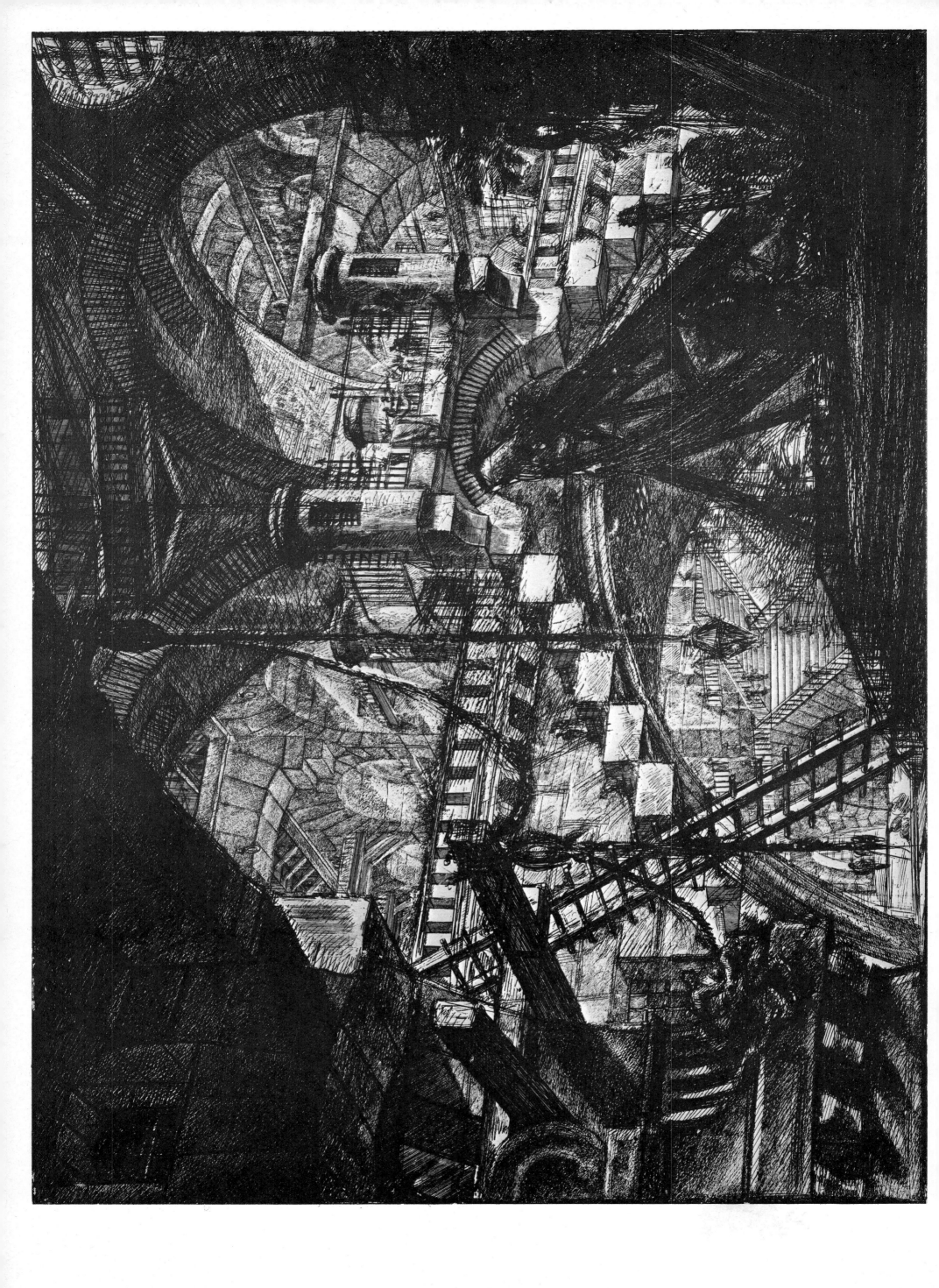

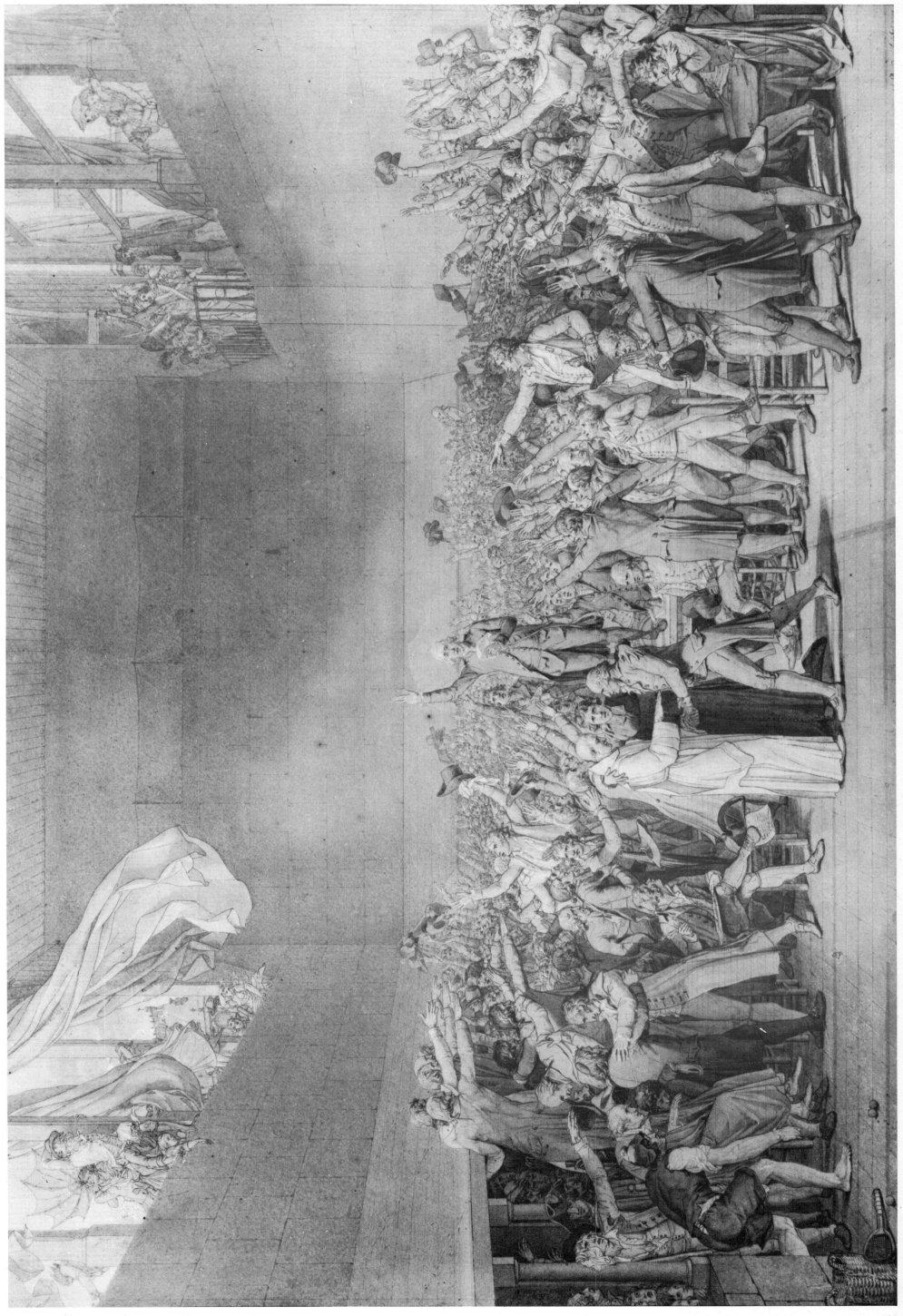

41

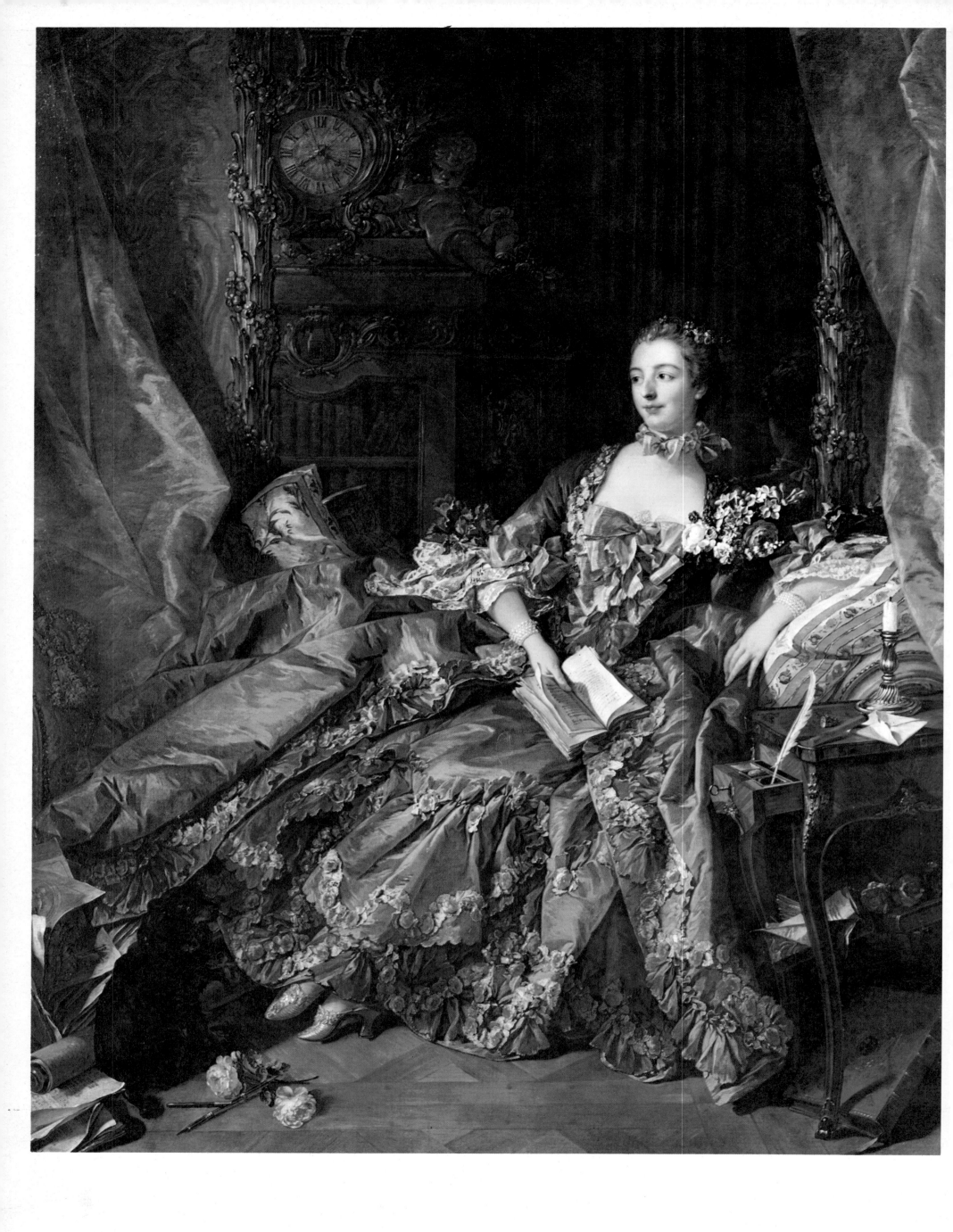

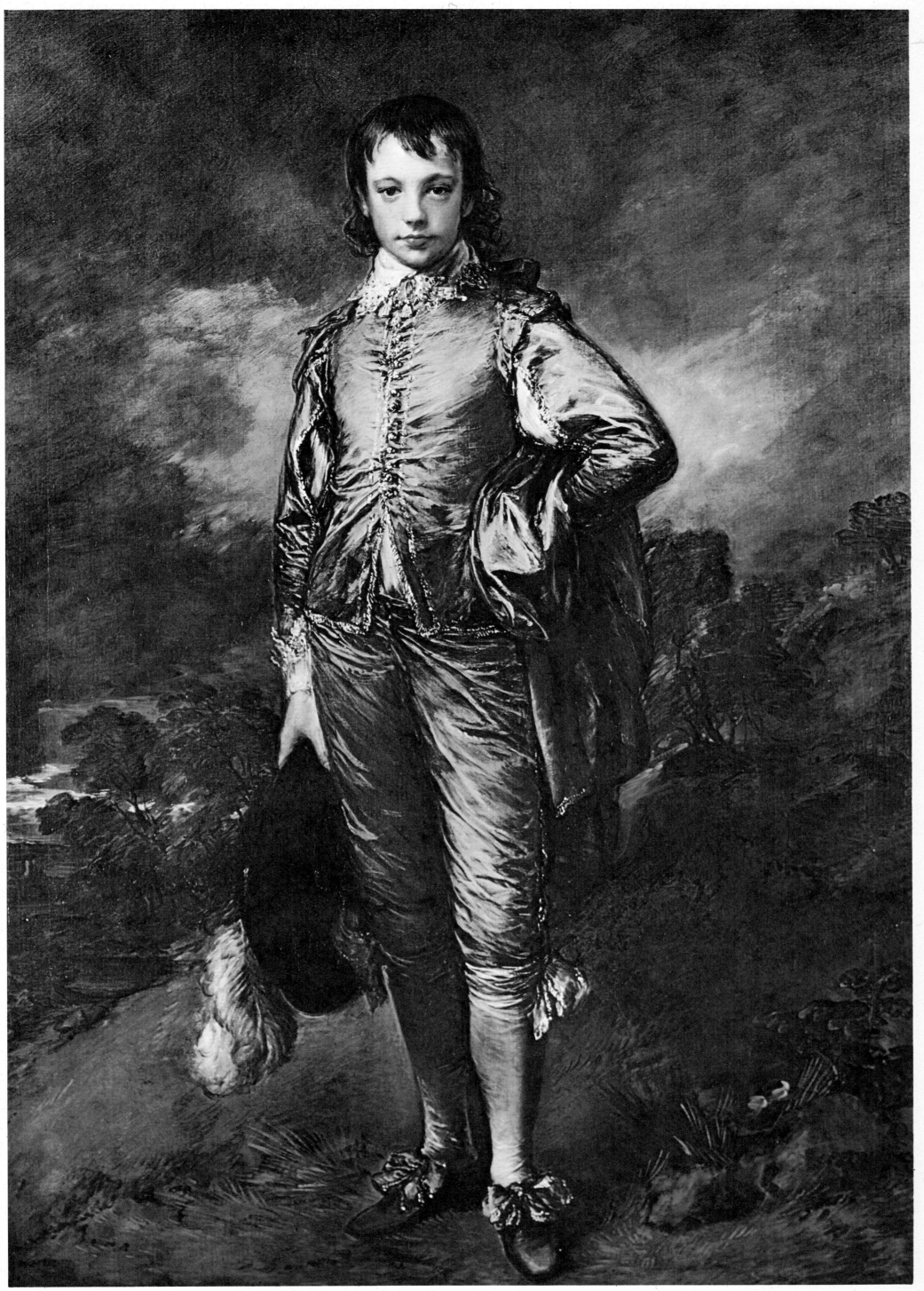

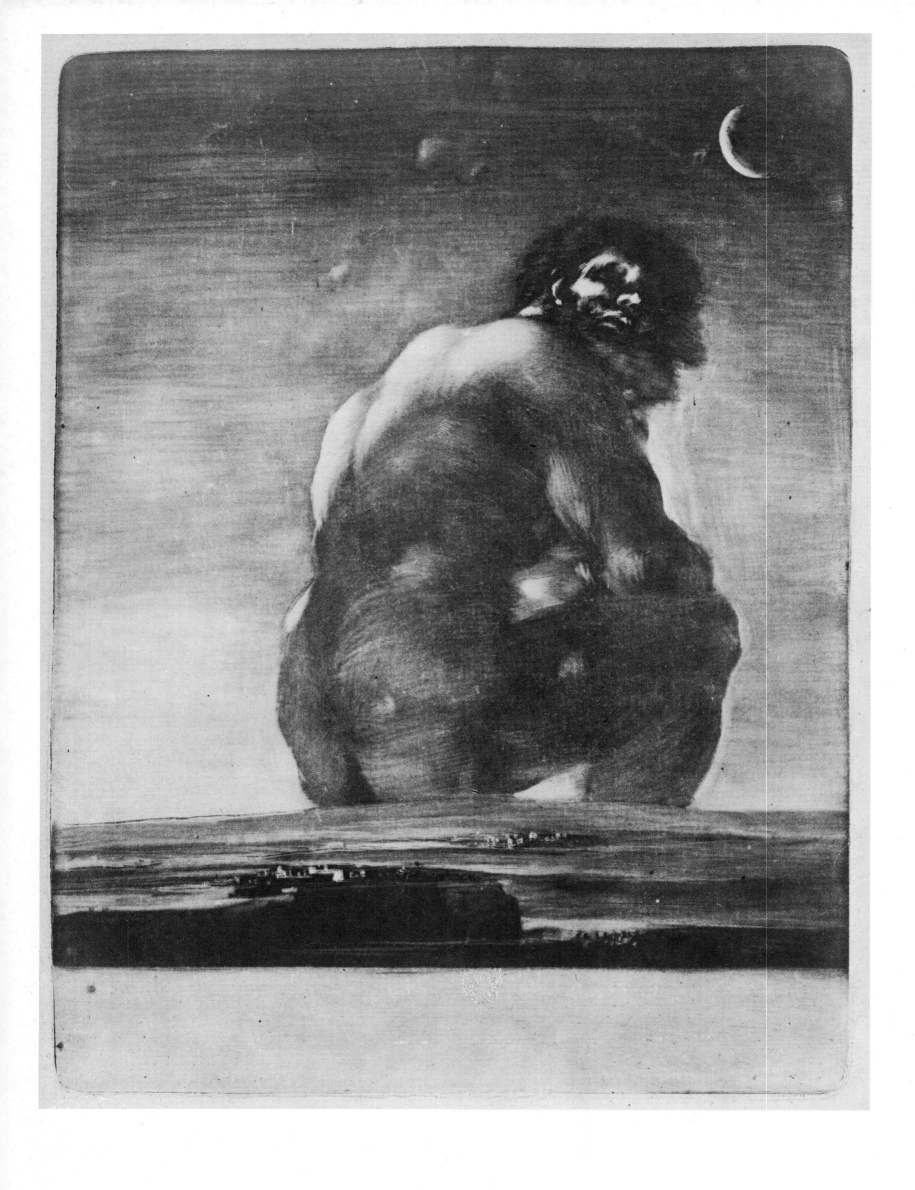

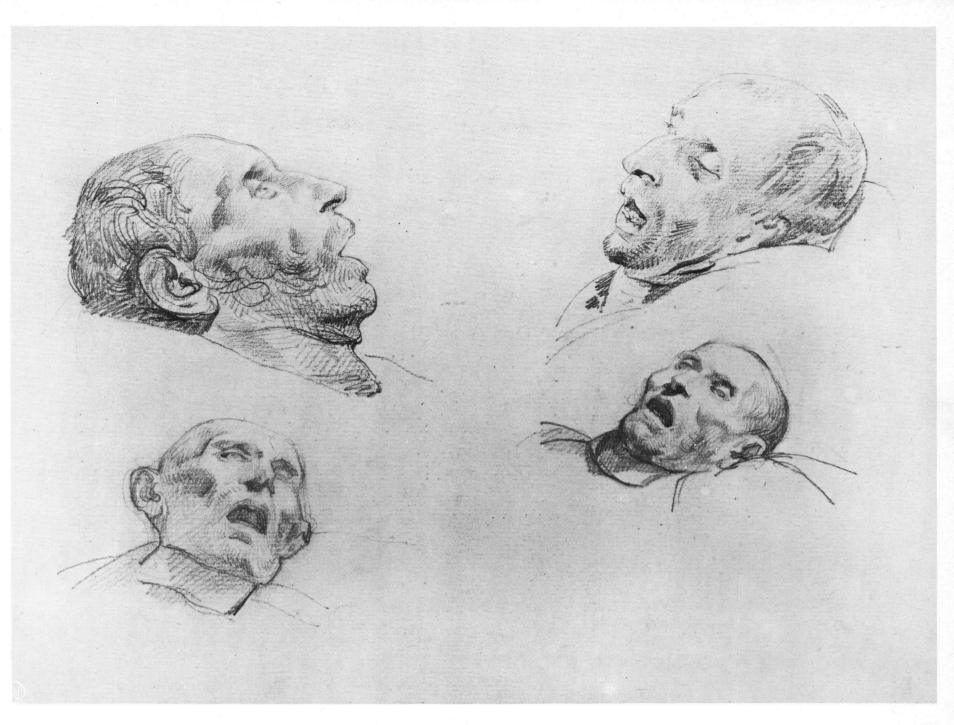

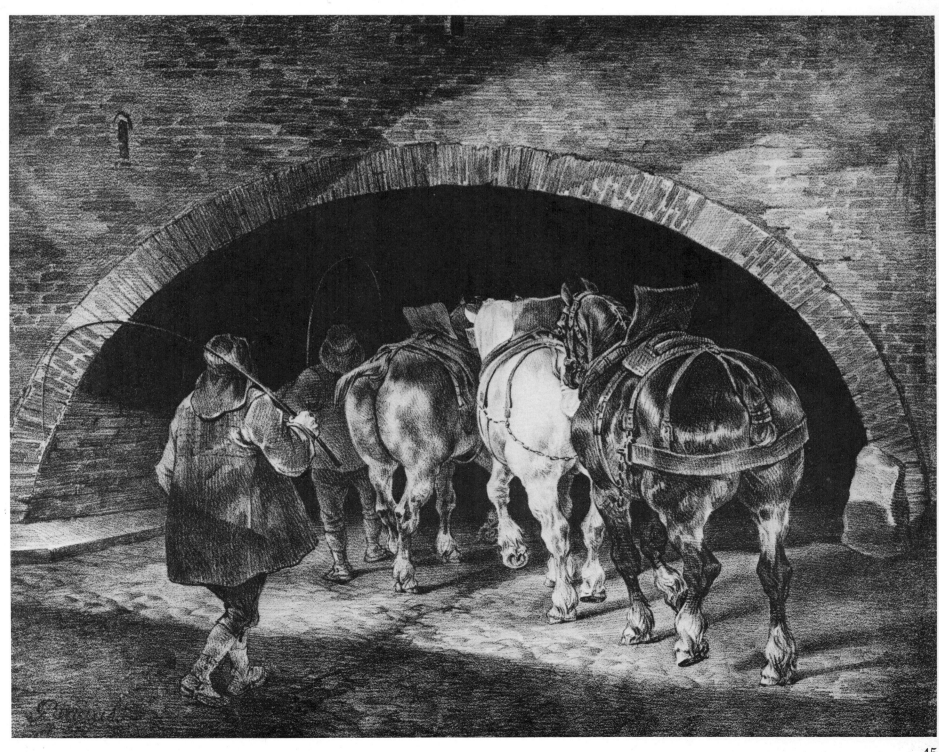

45

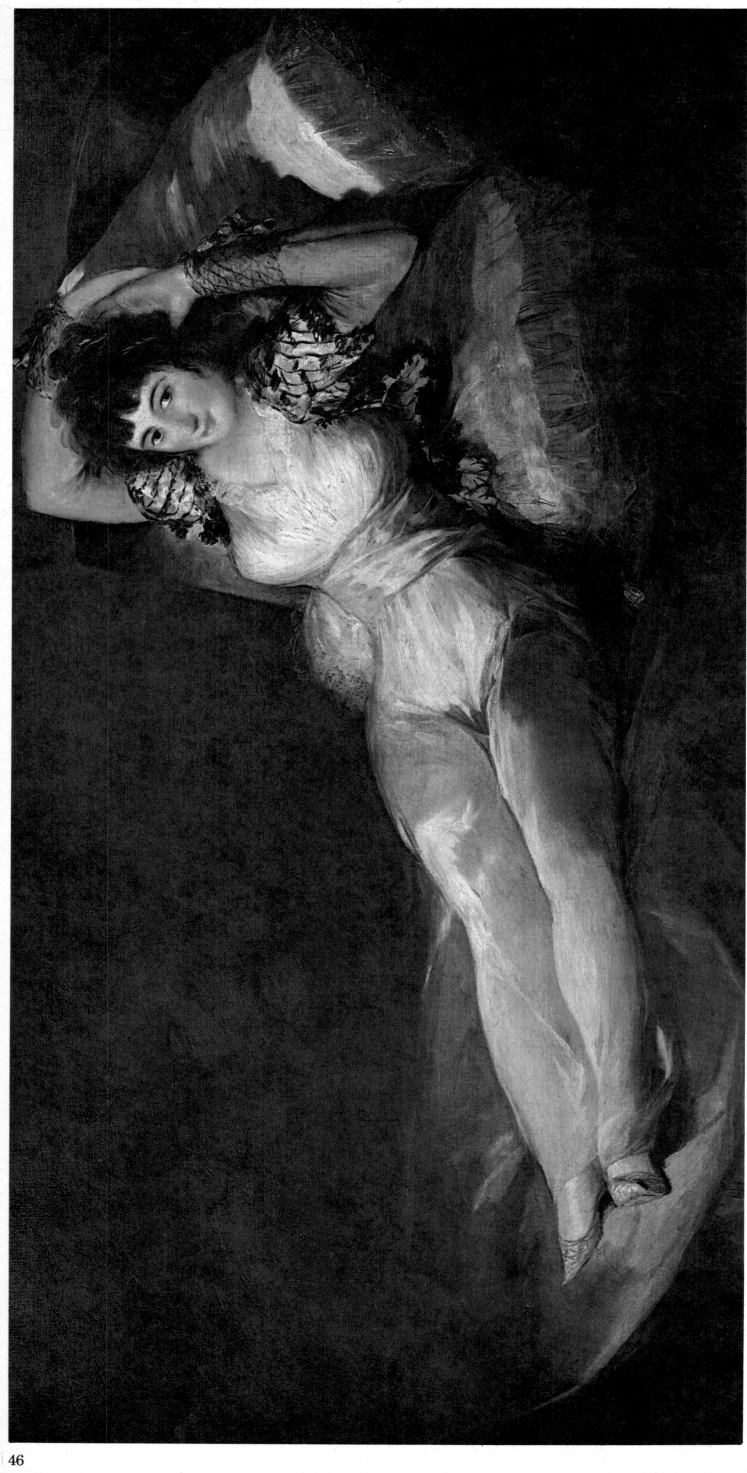

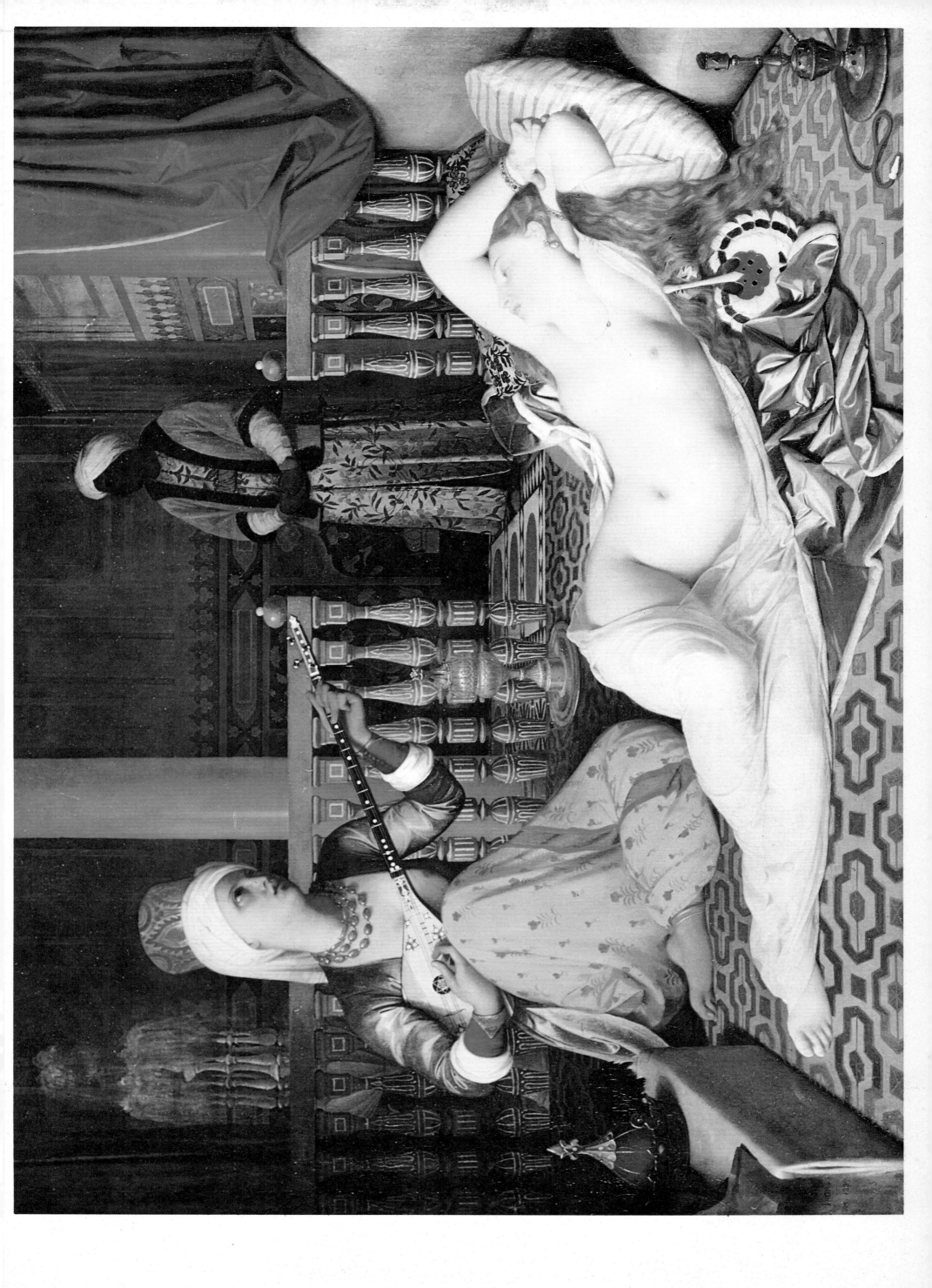

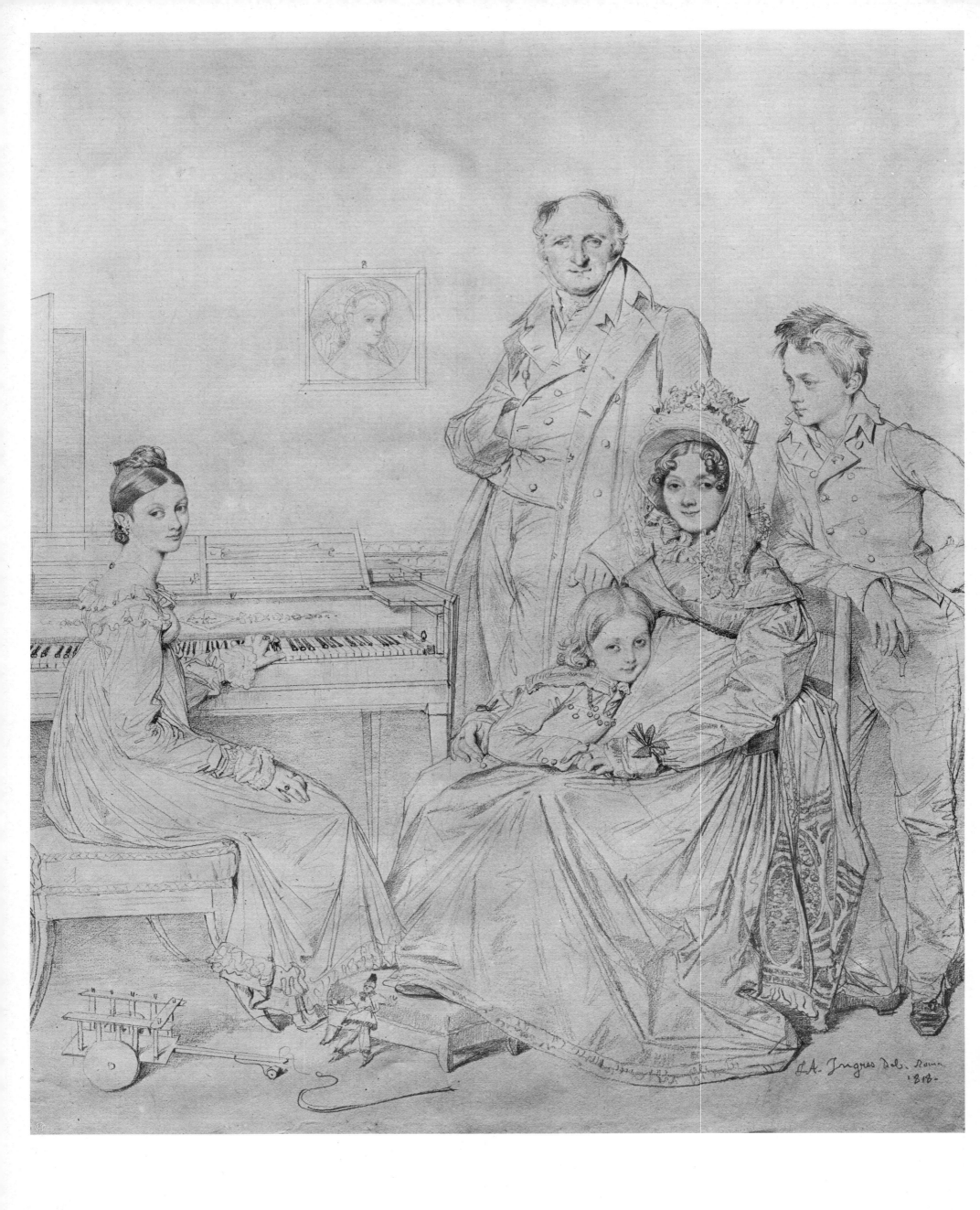

48

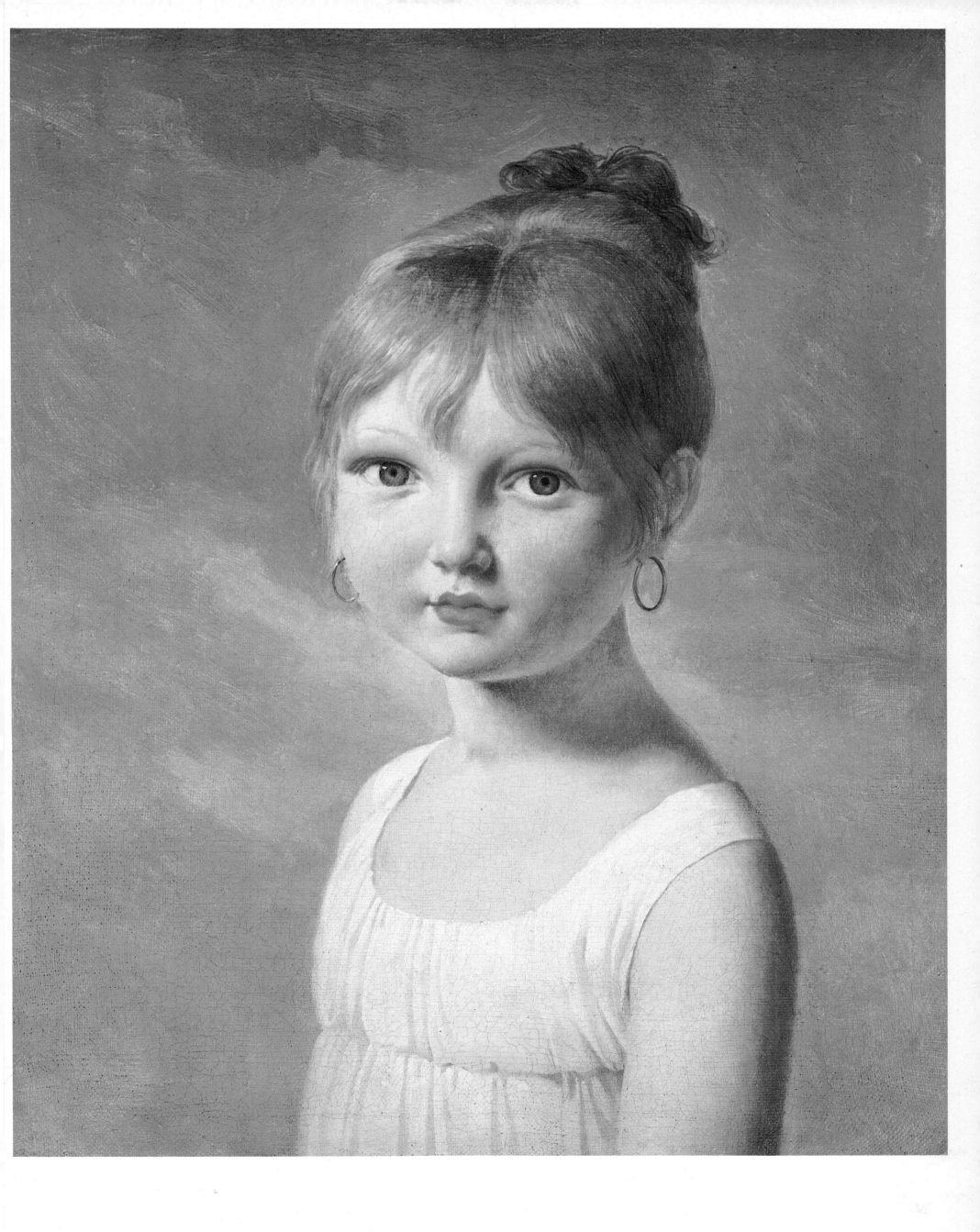

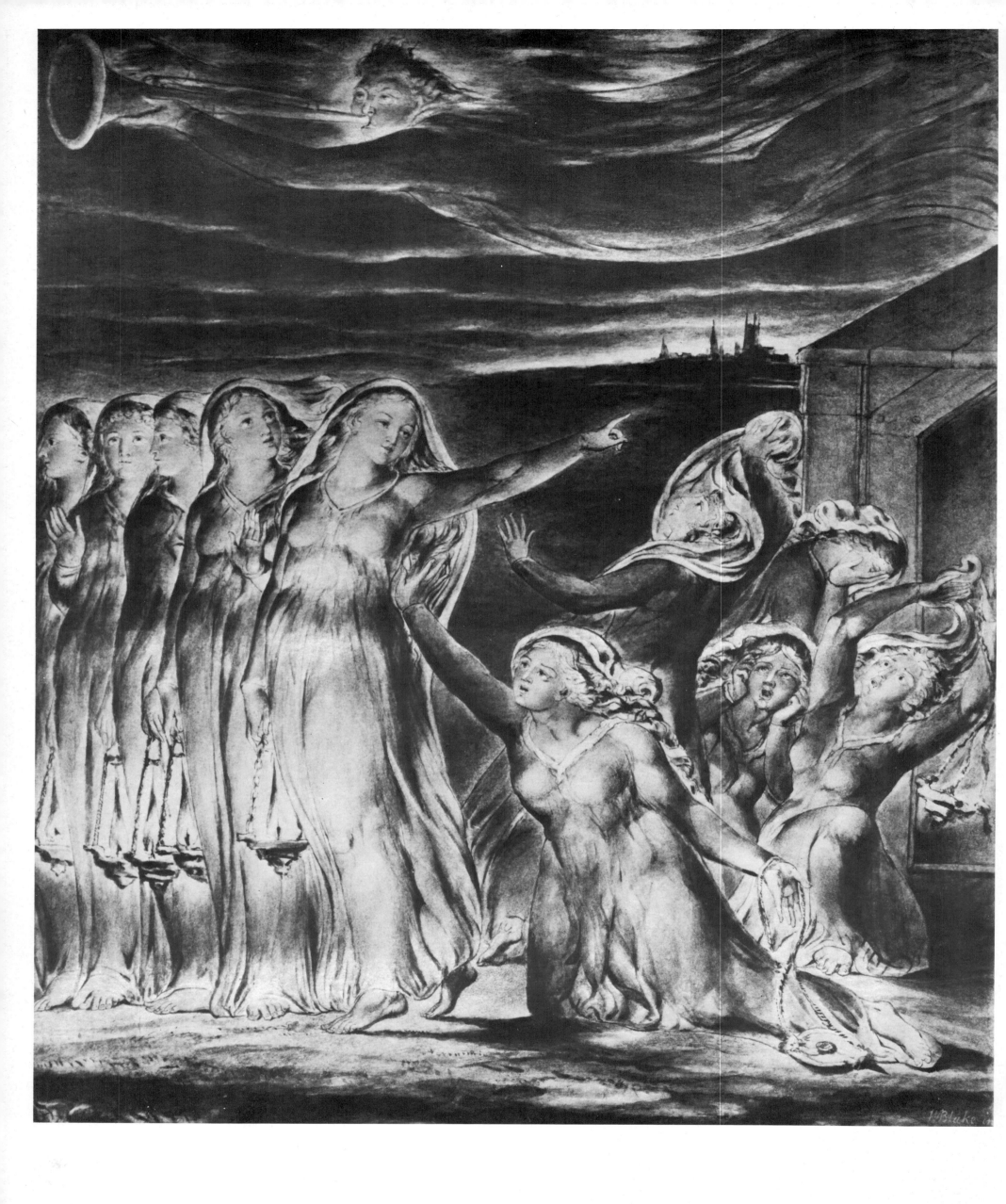

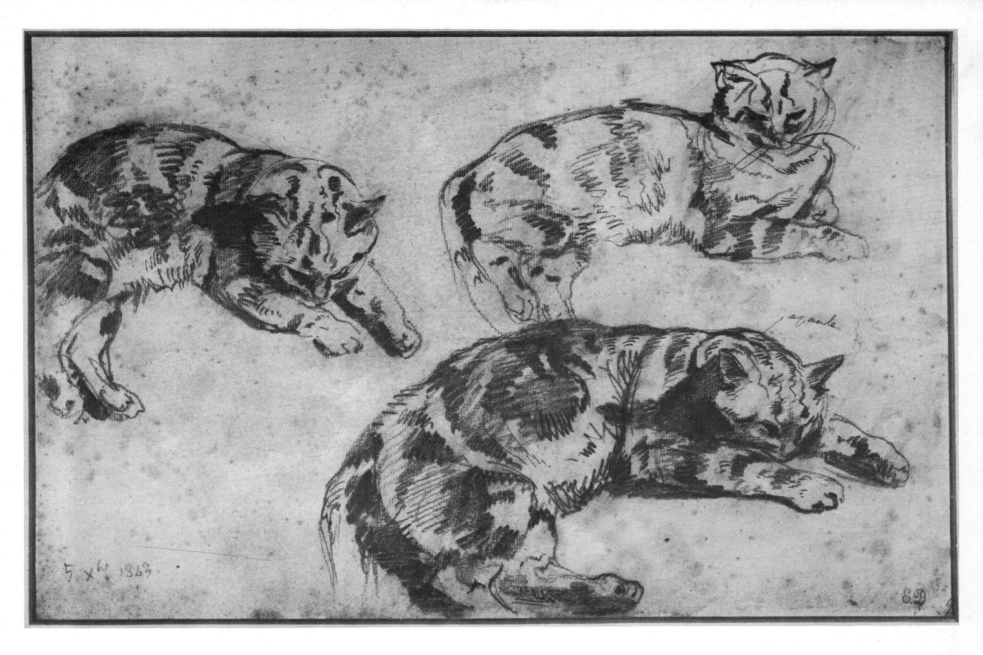

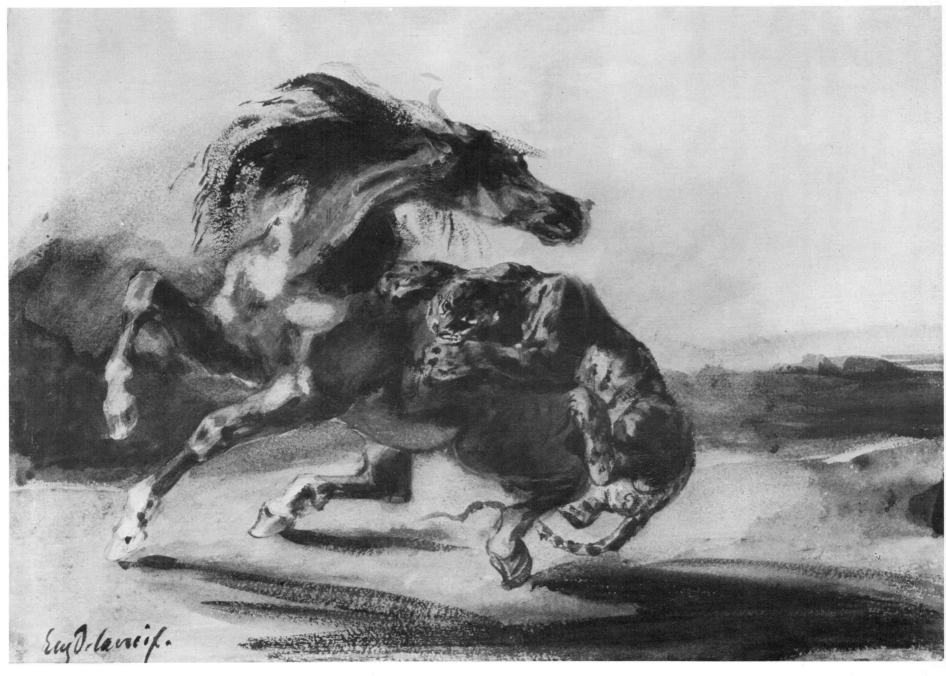

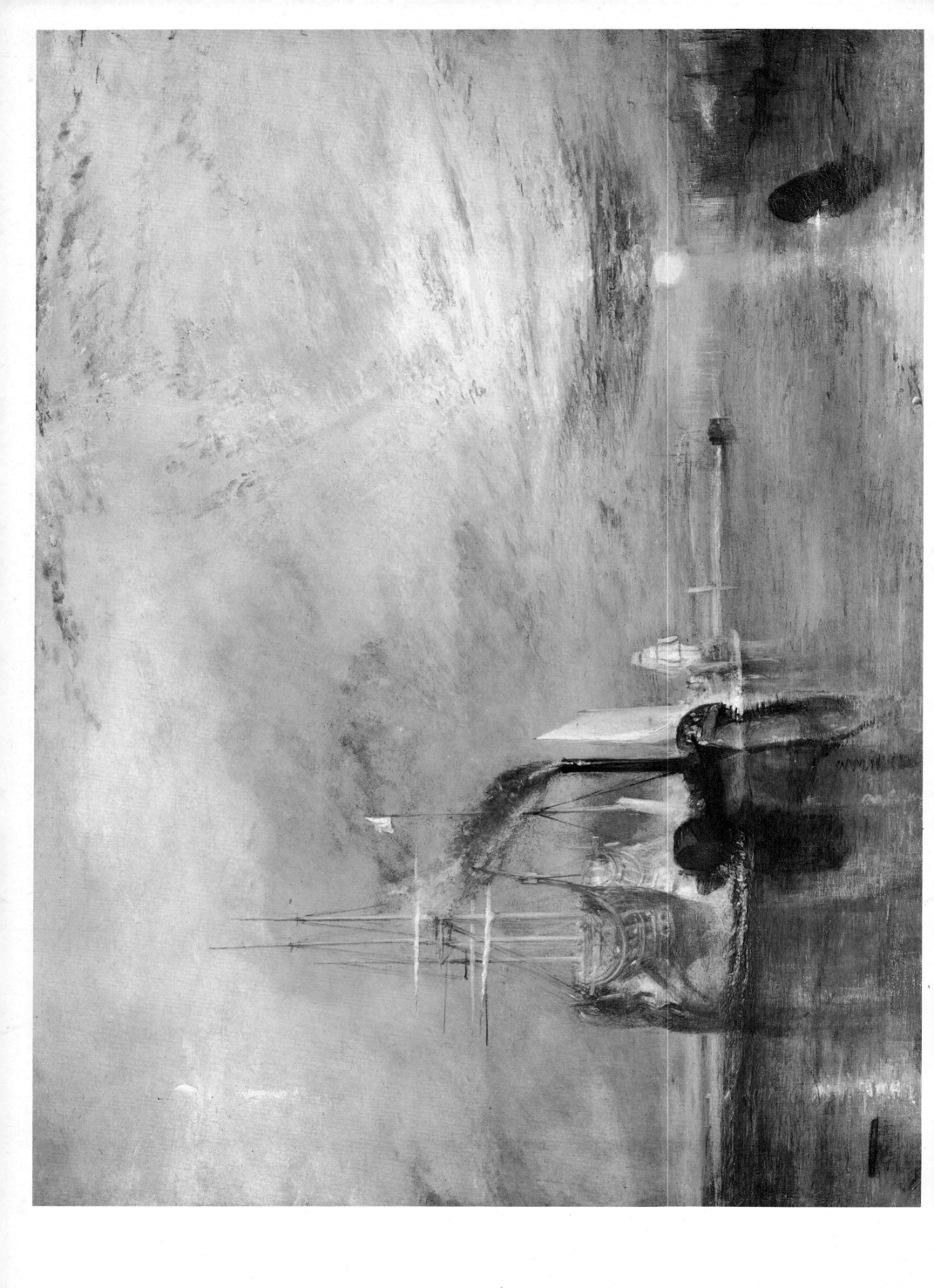

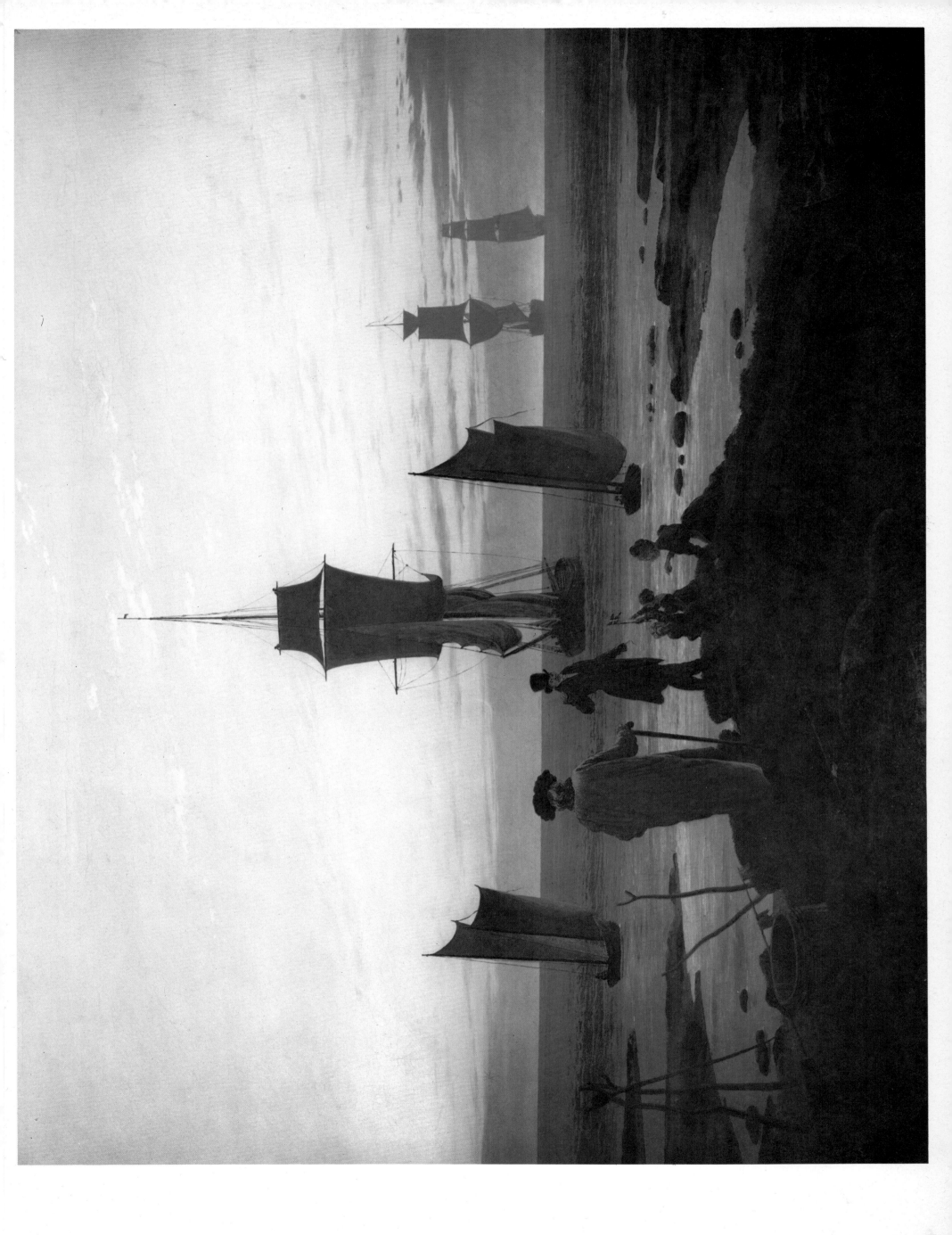

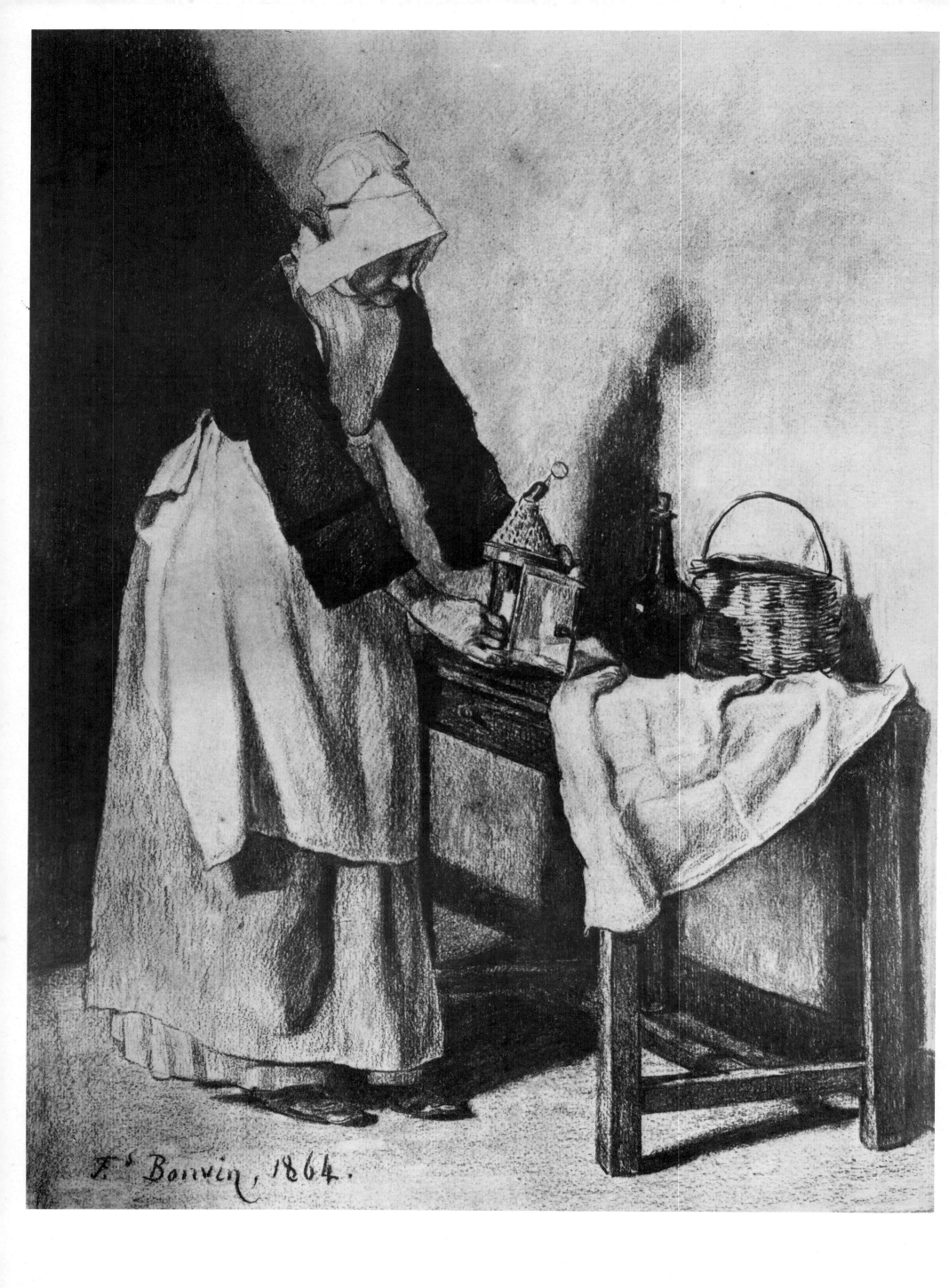

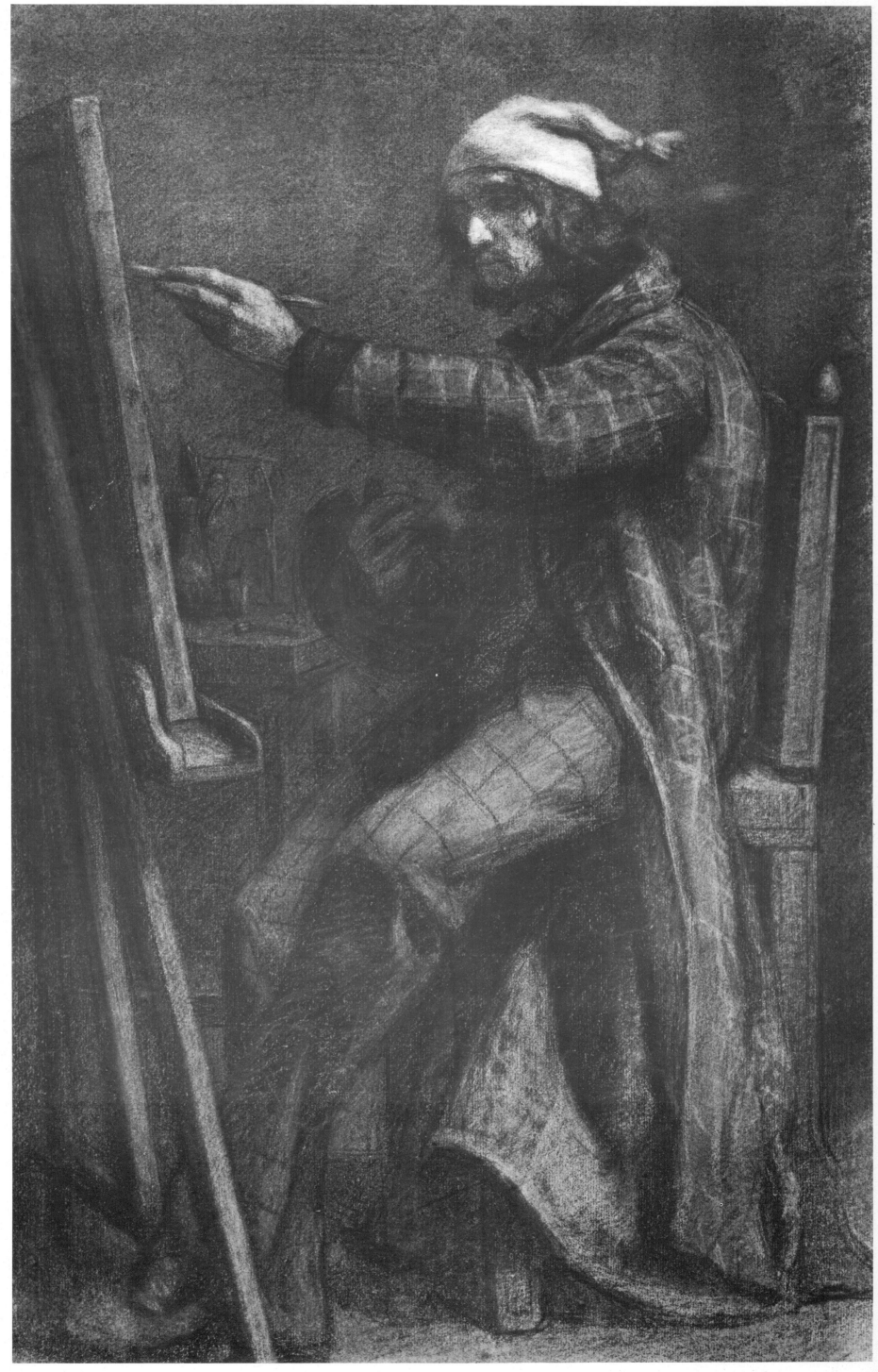

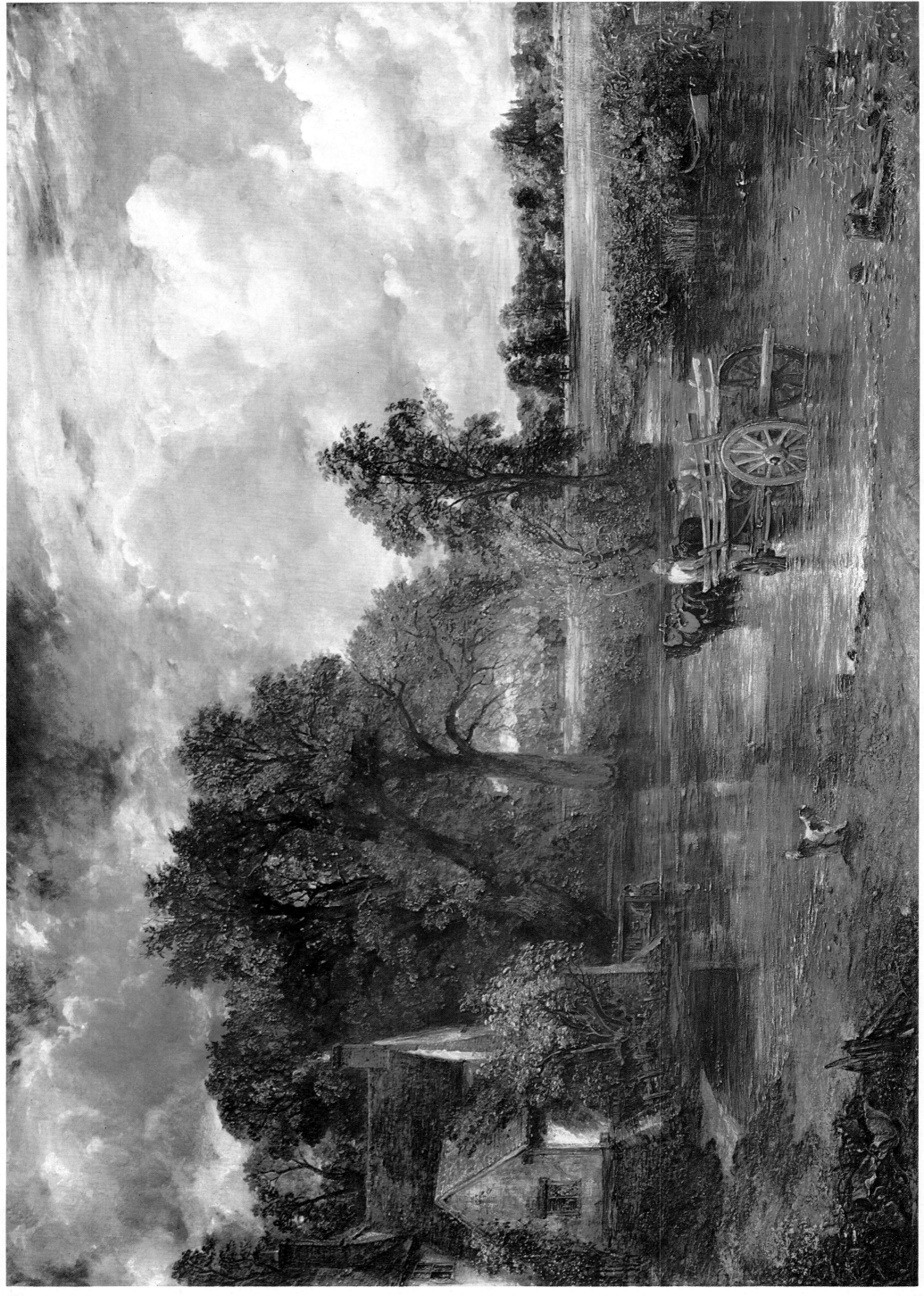

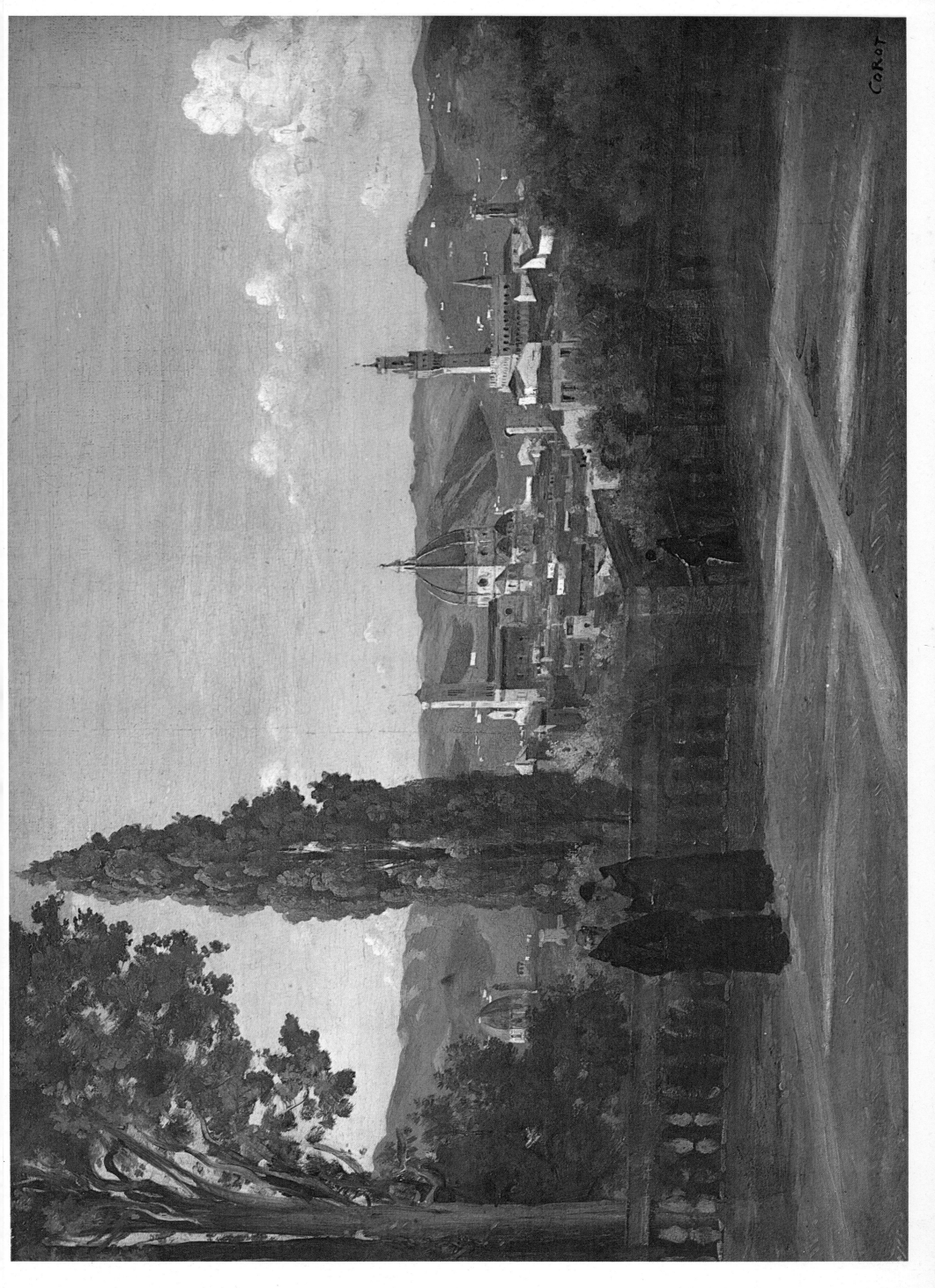

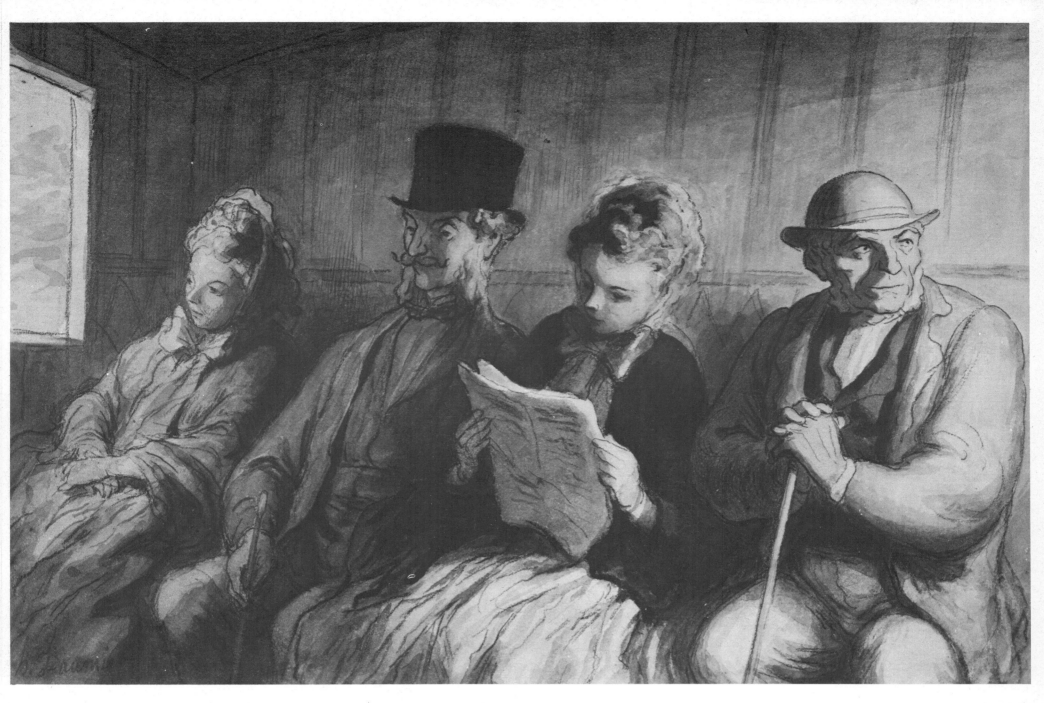

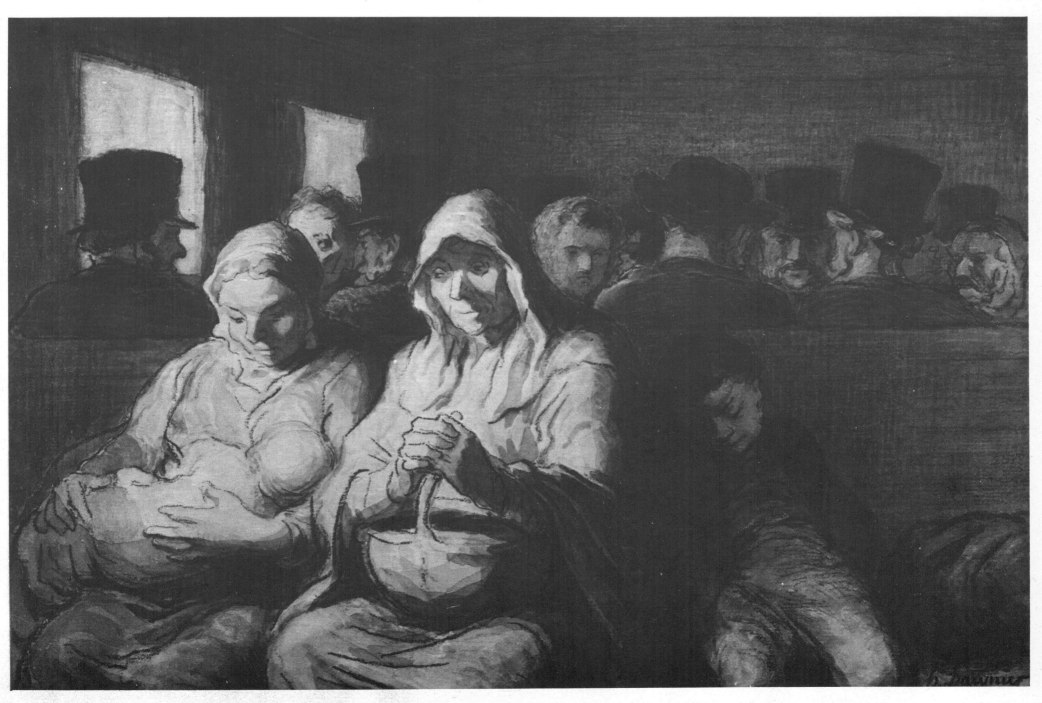

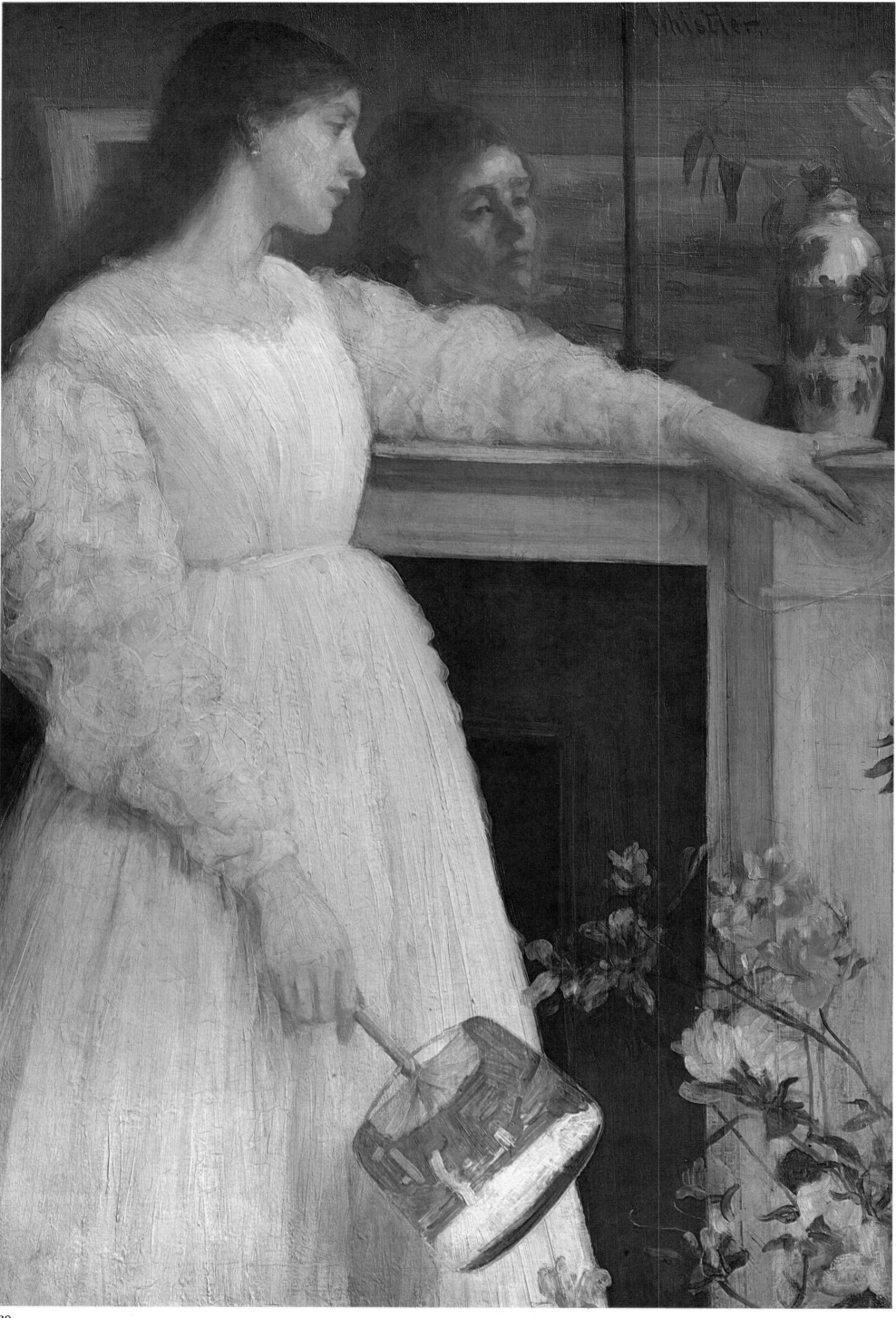

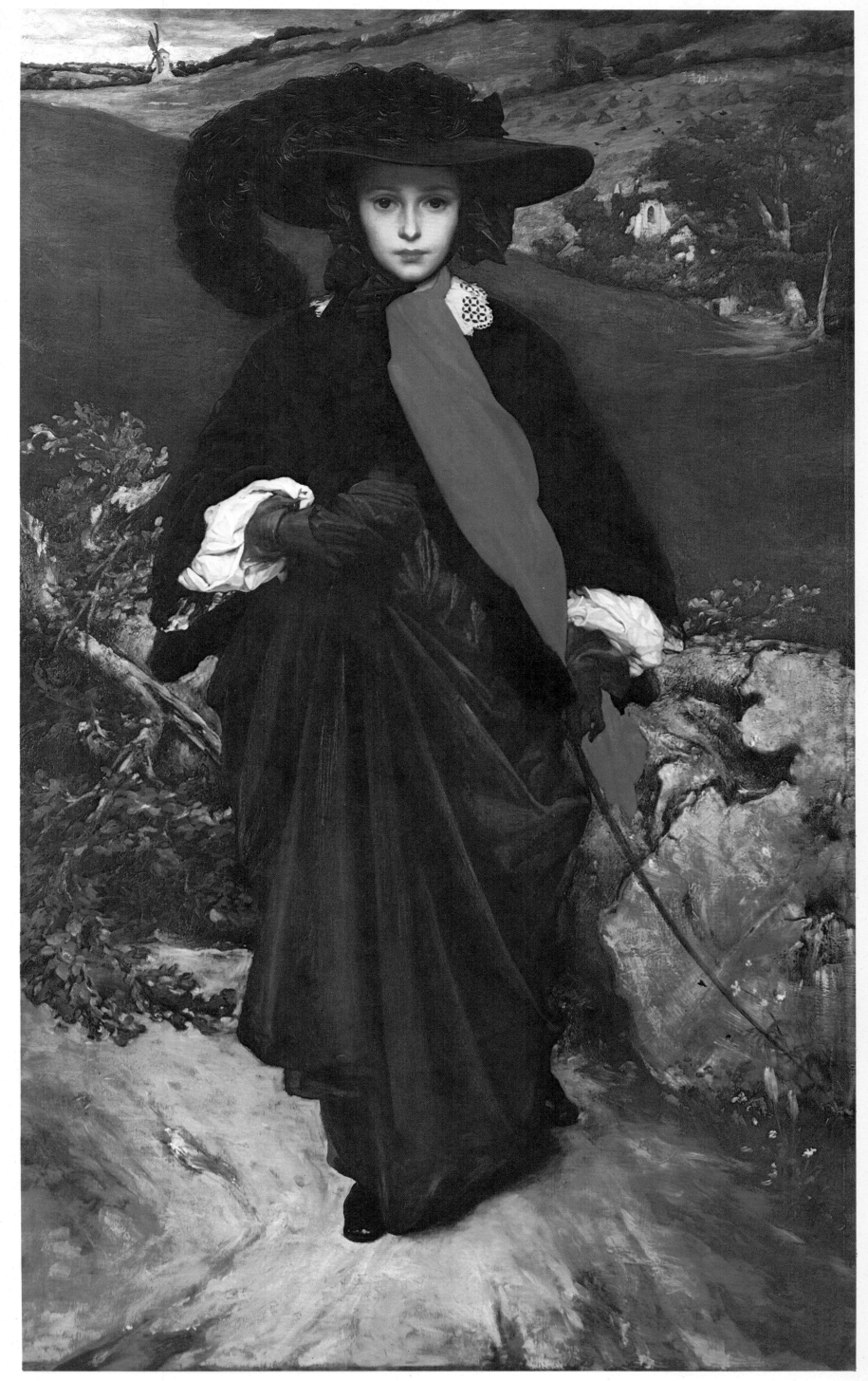

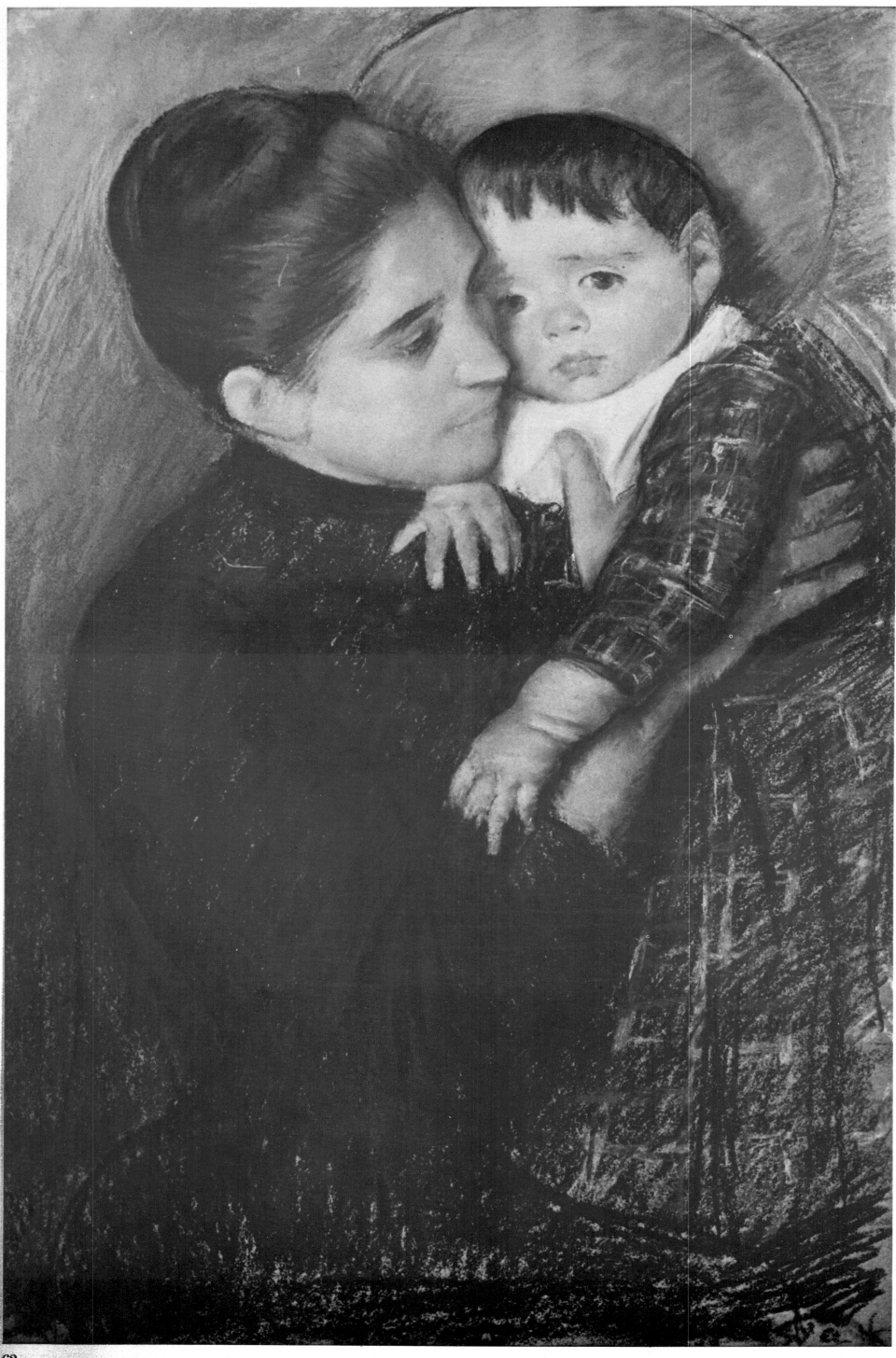

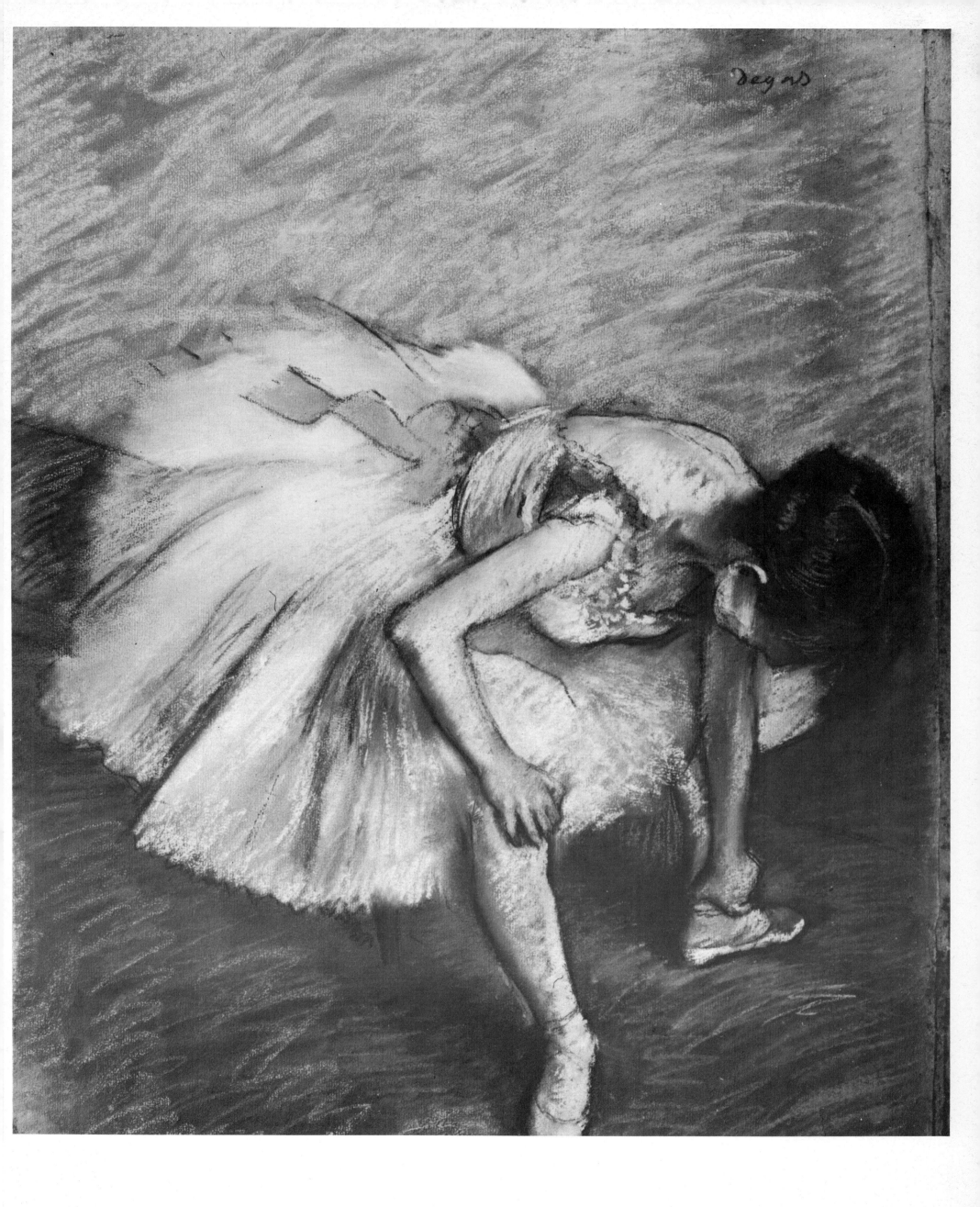

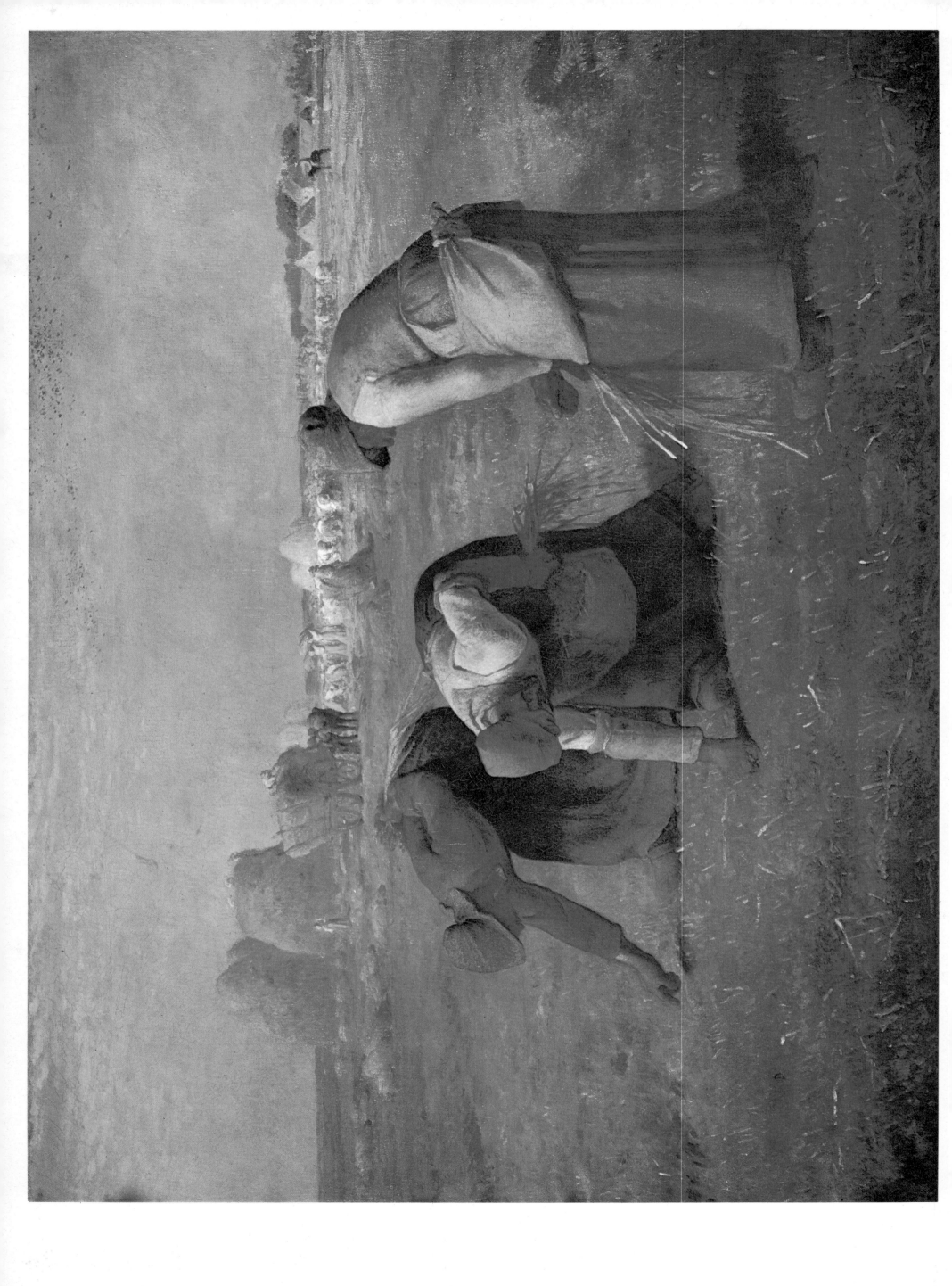

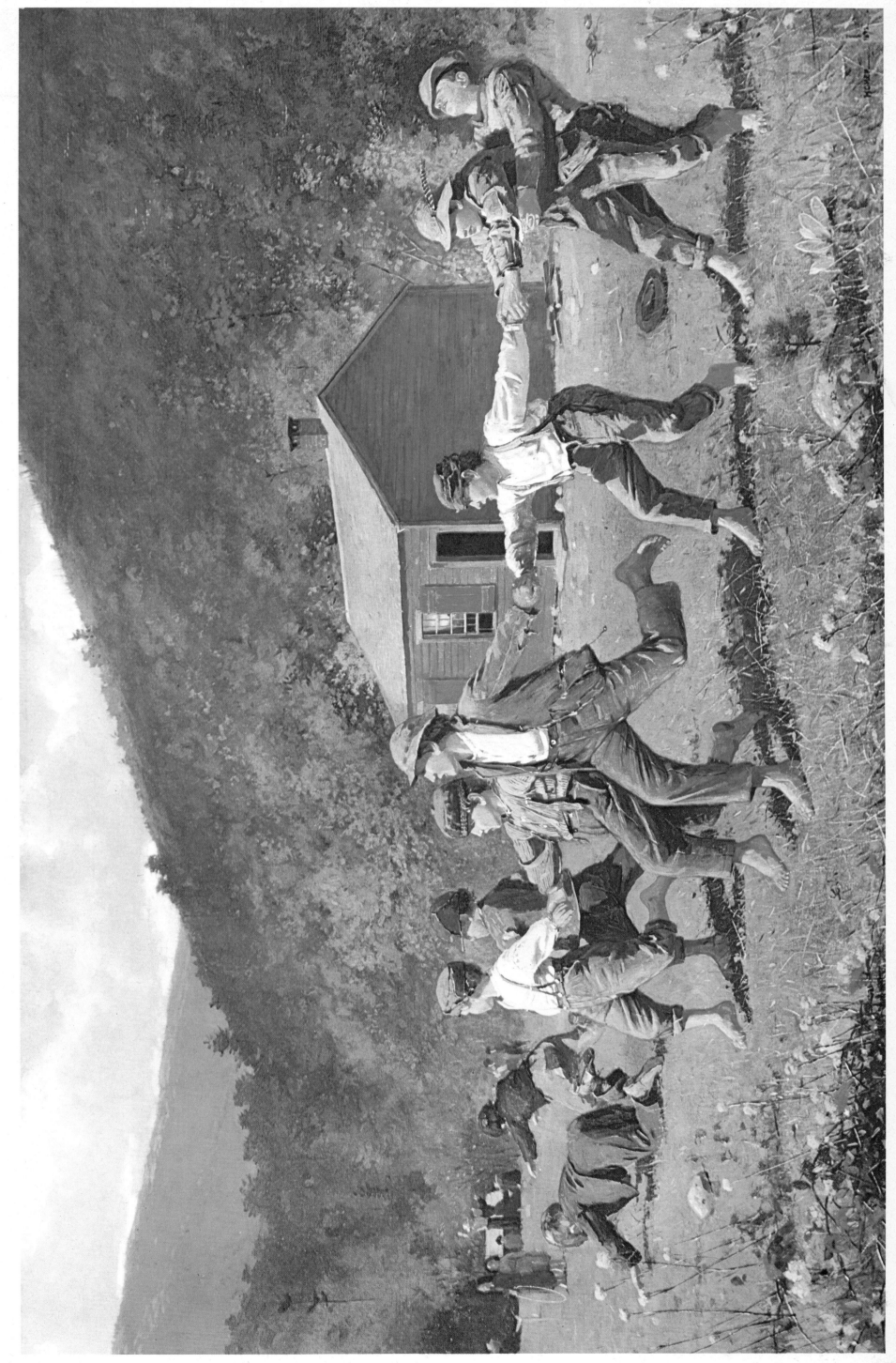

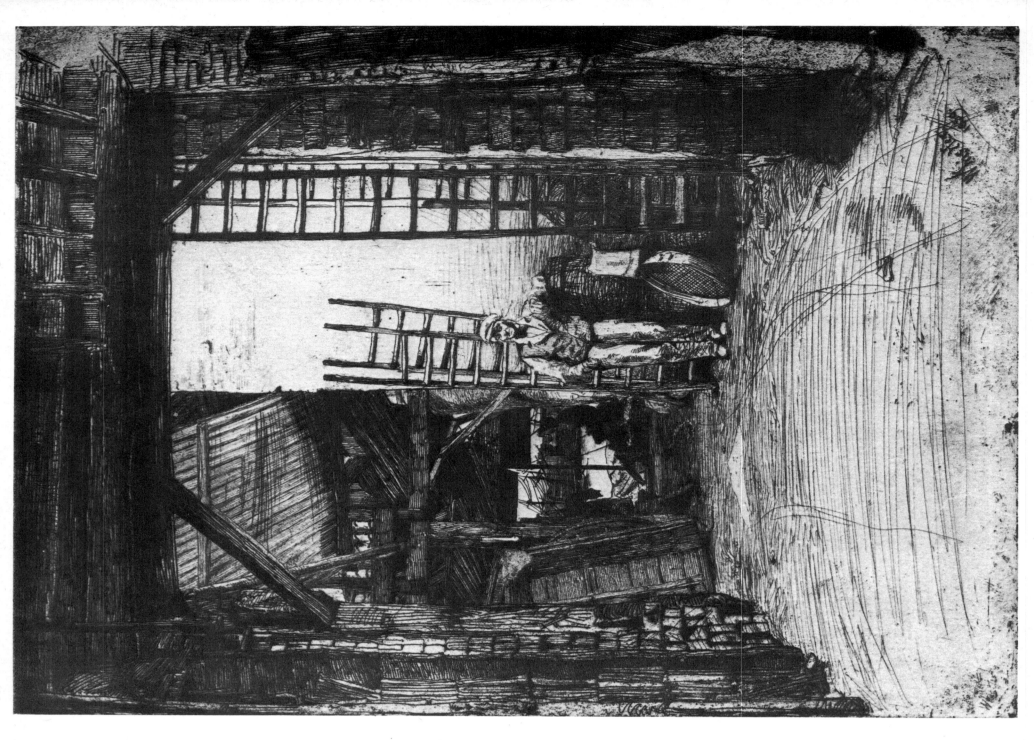

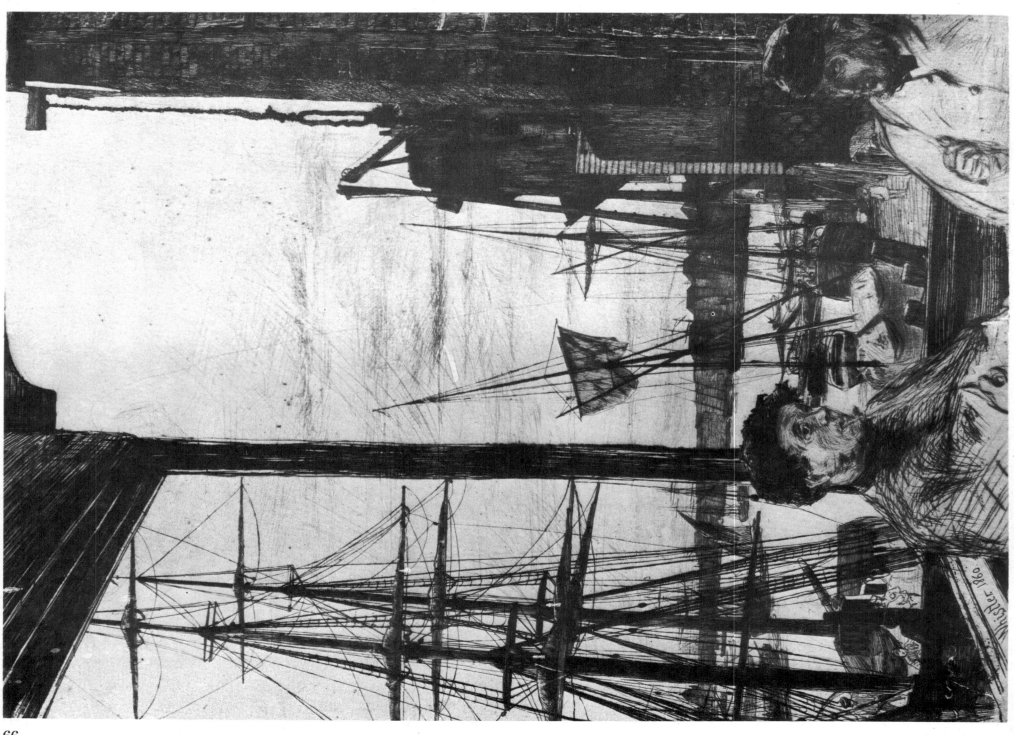

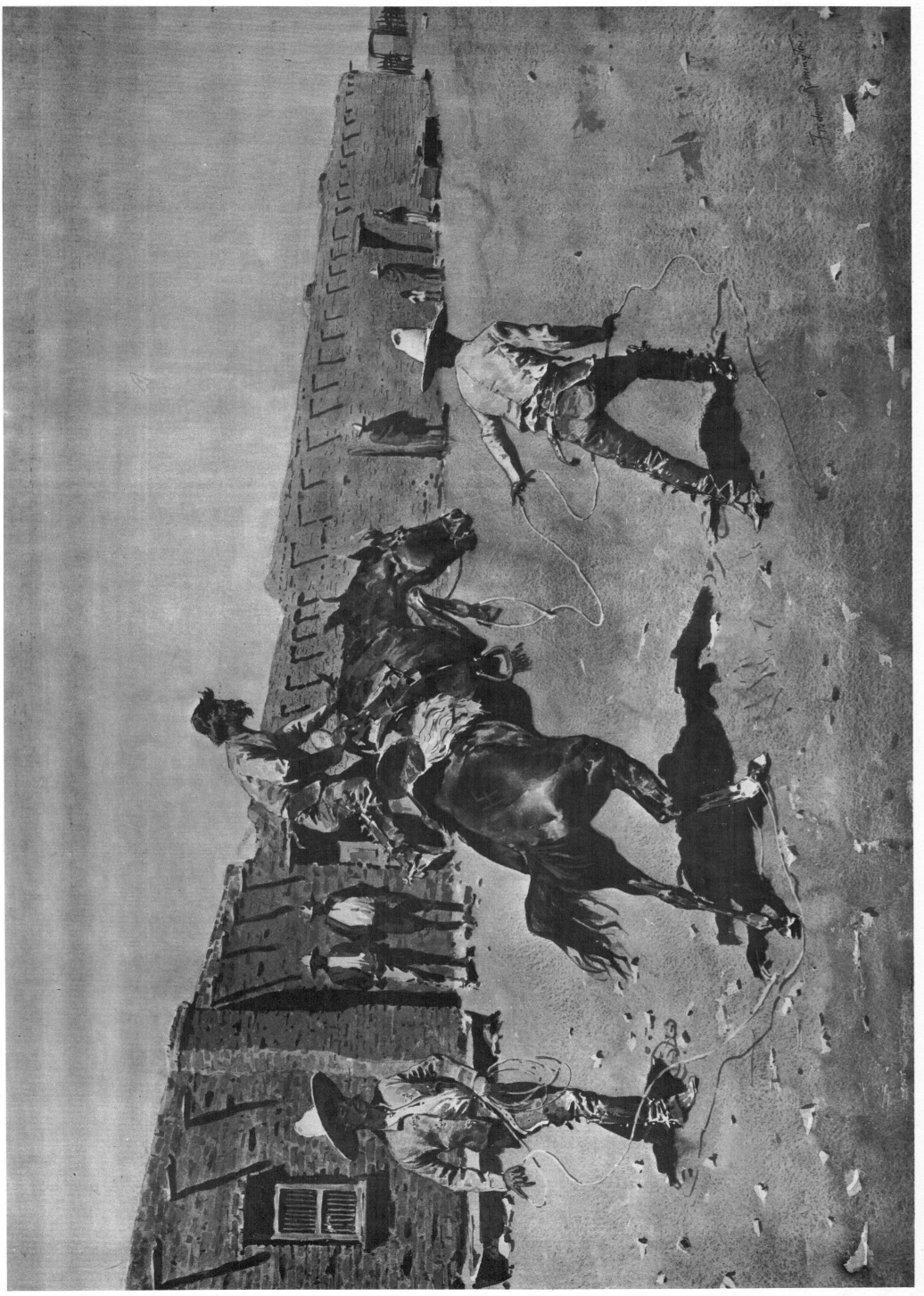

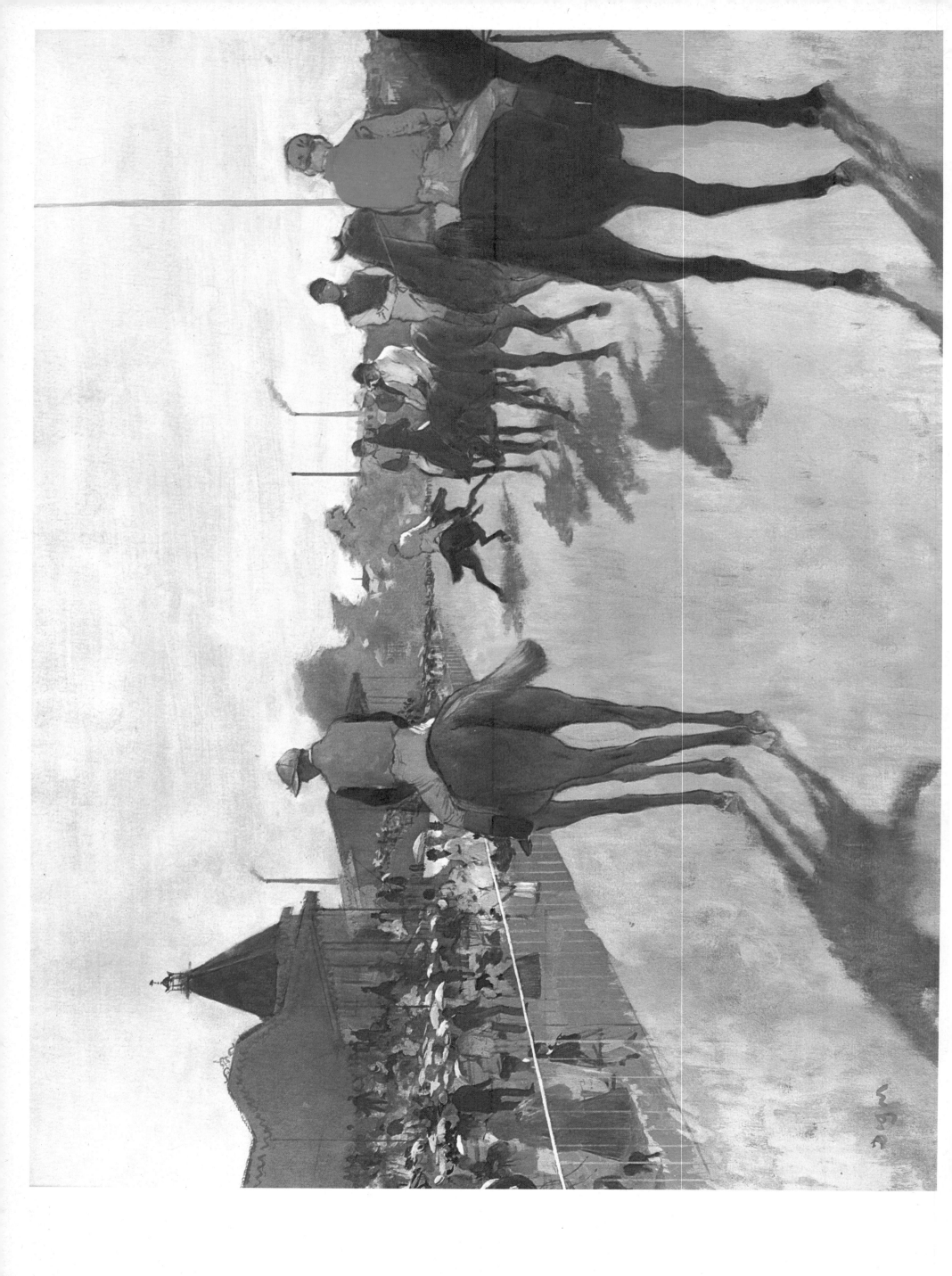

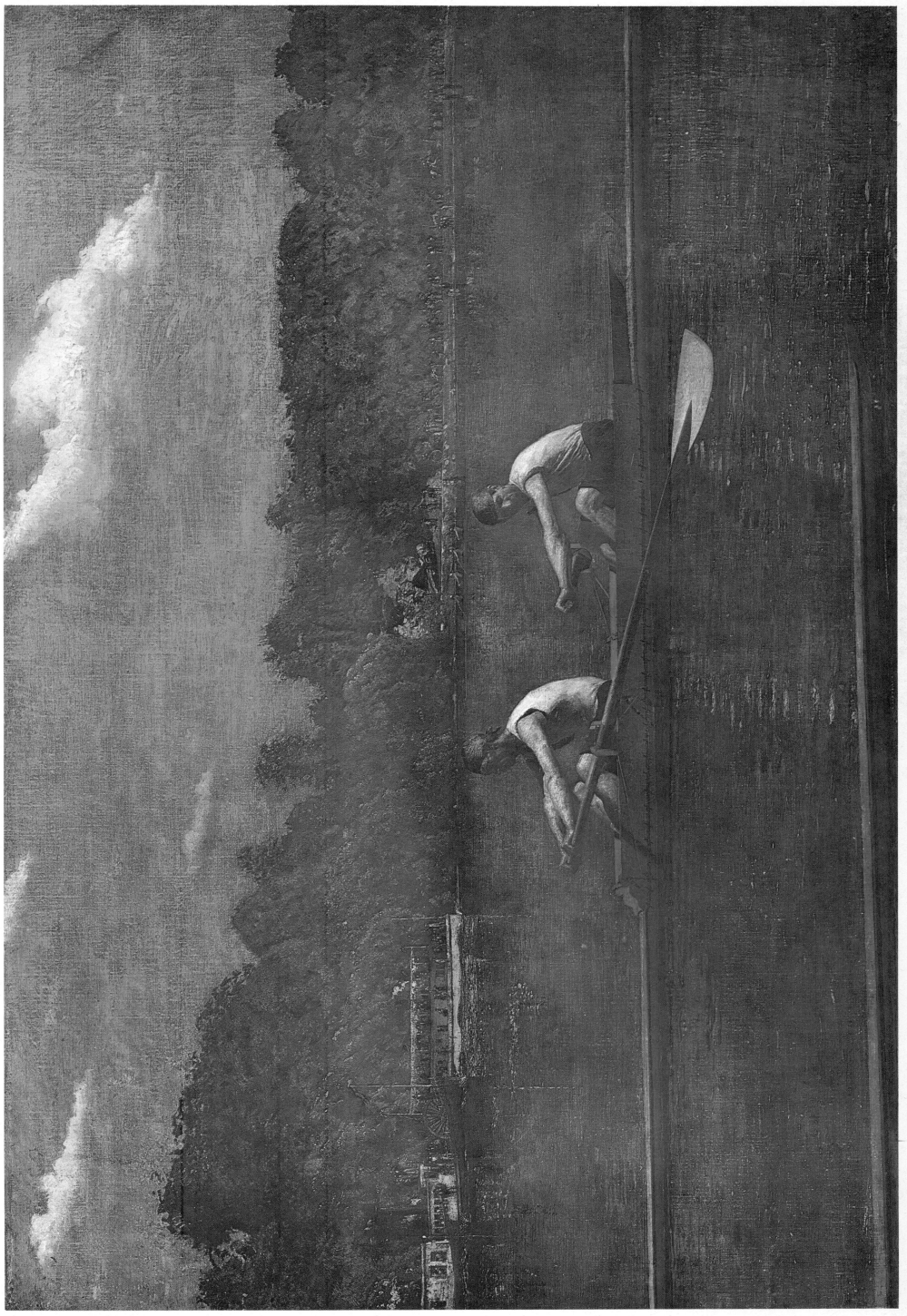

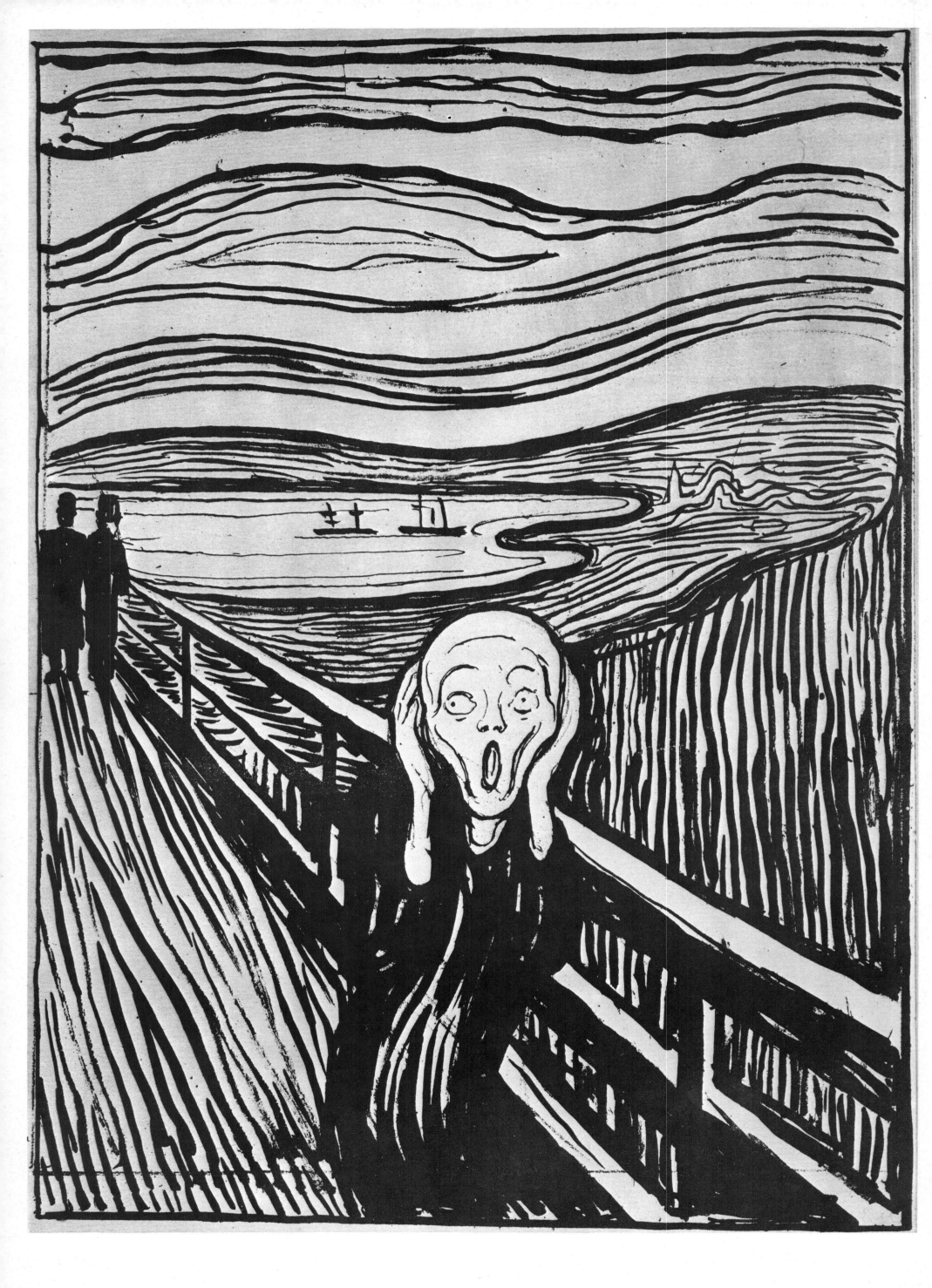

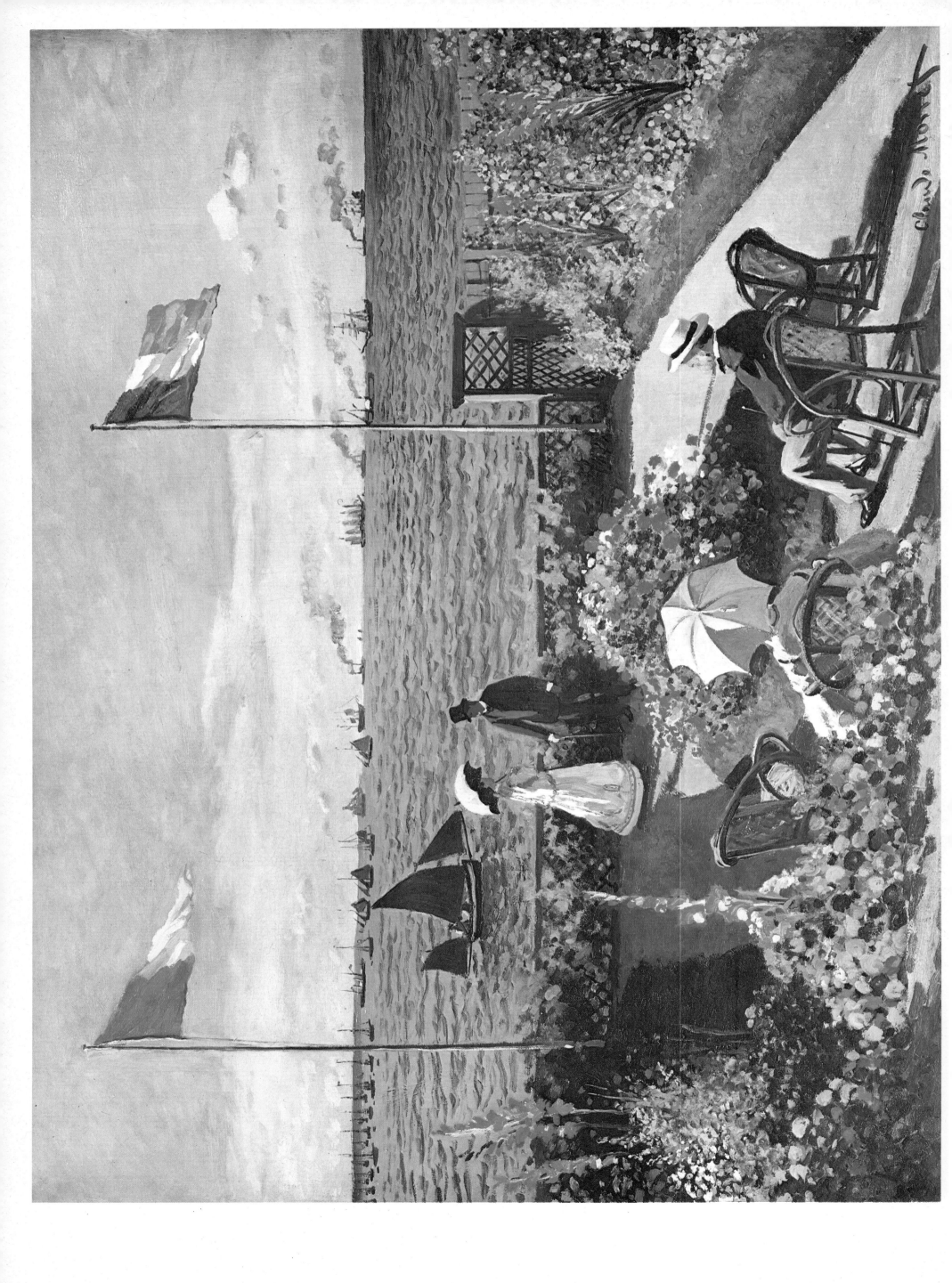

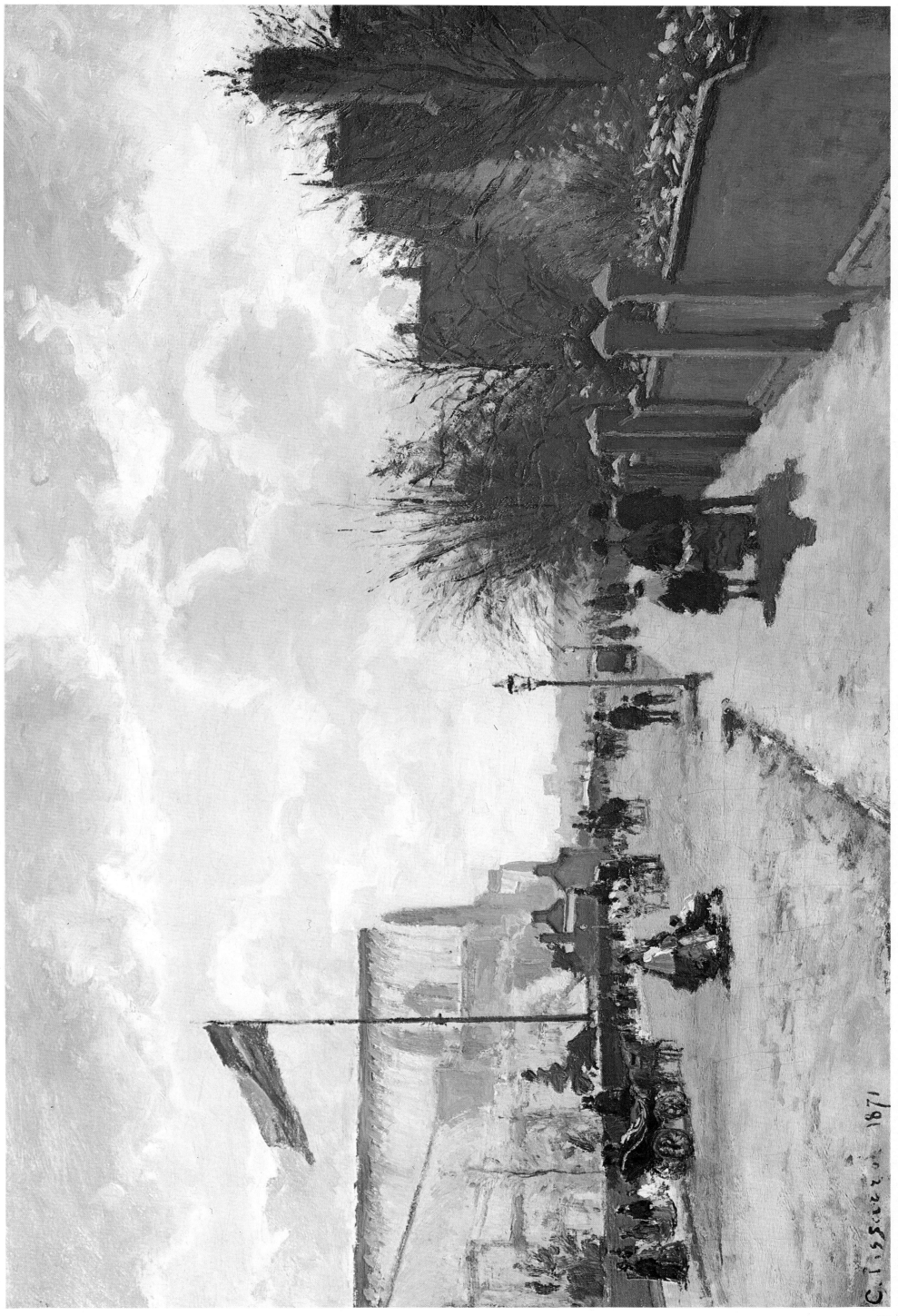

74

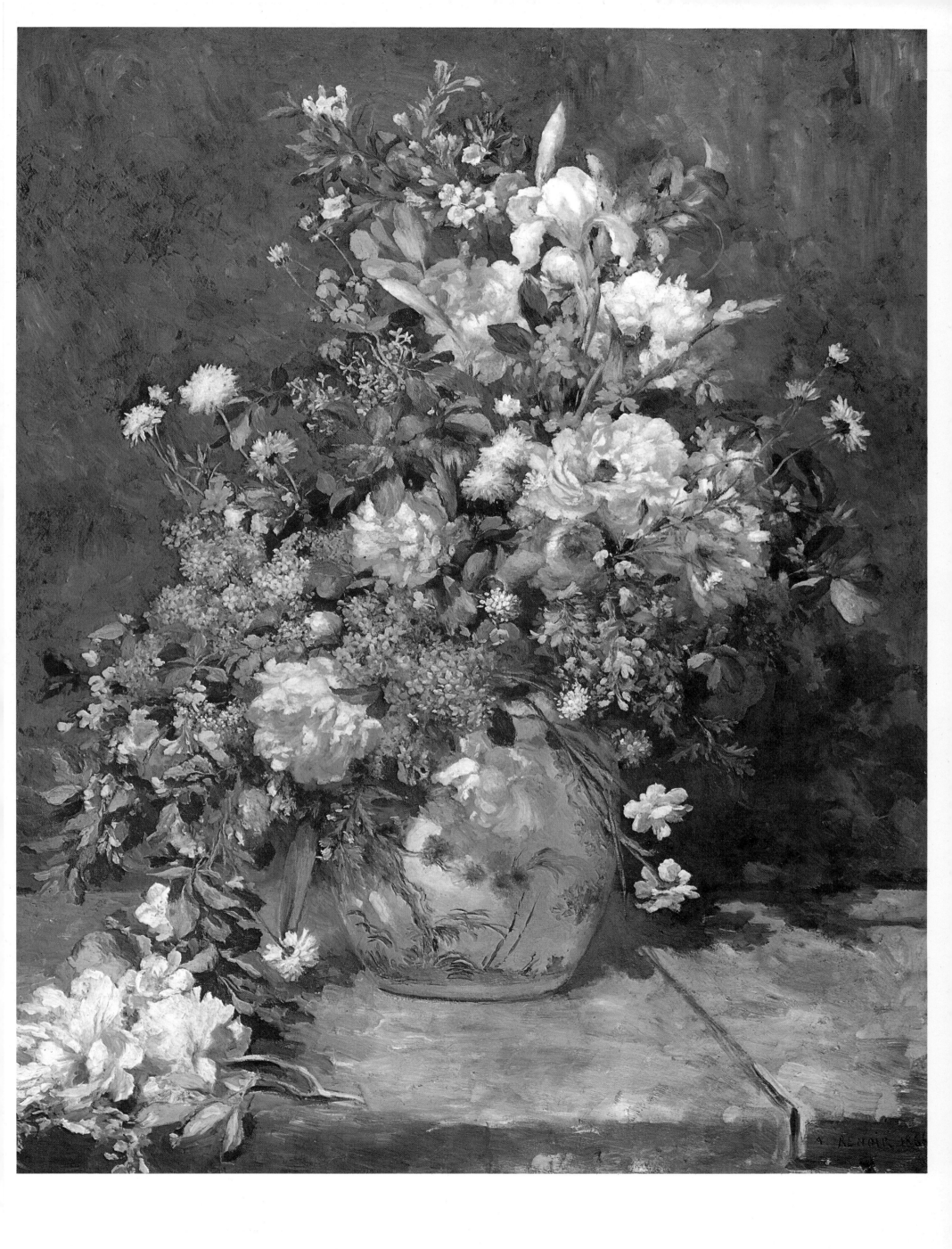

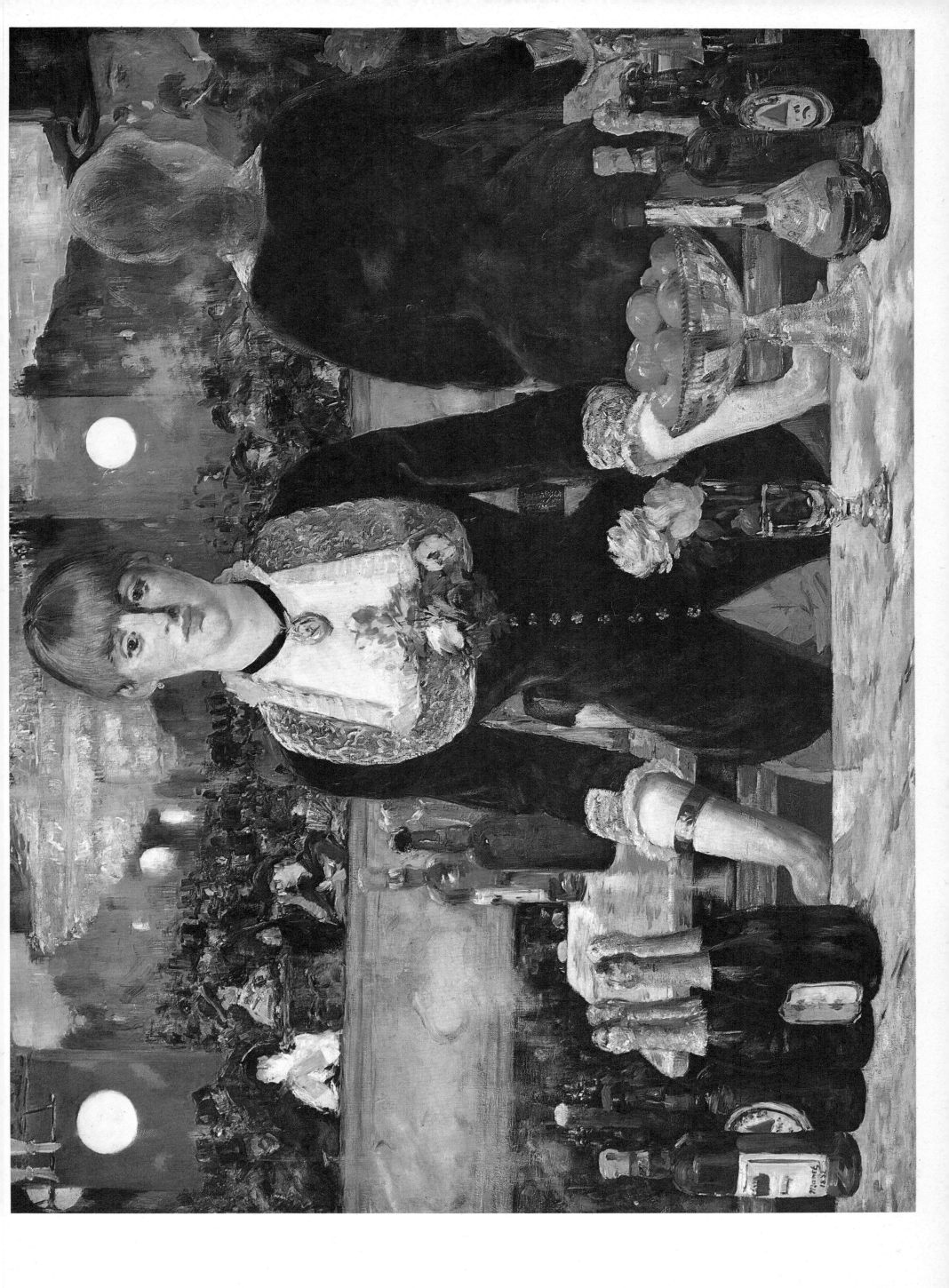

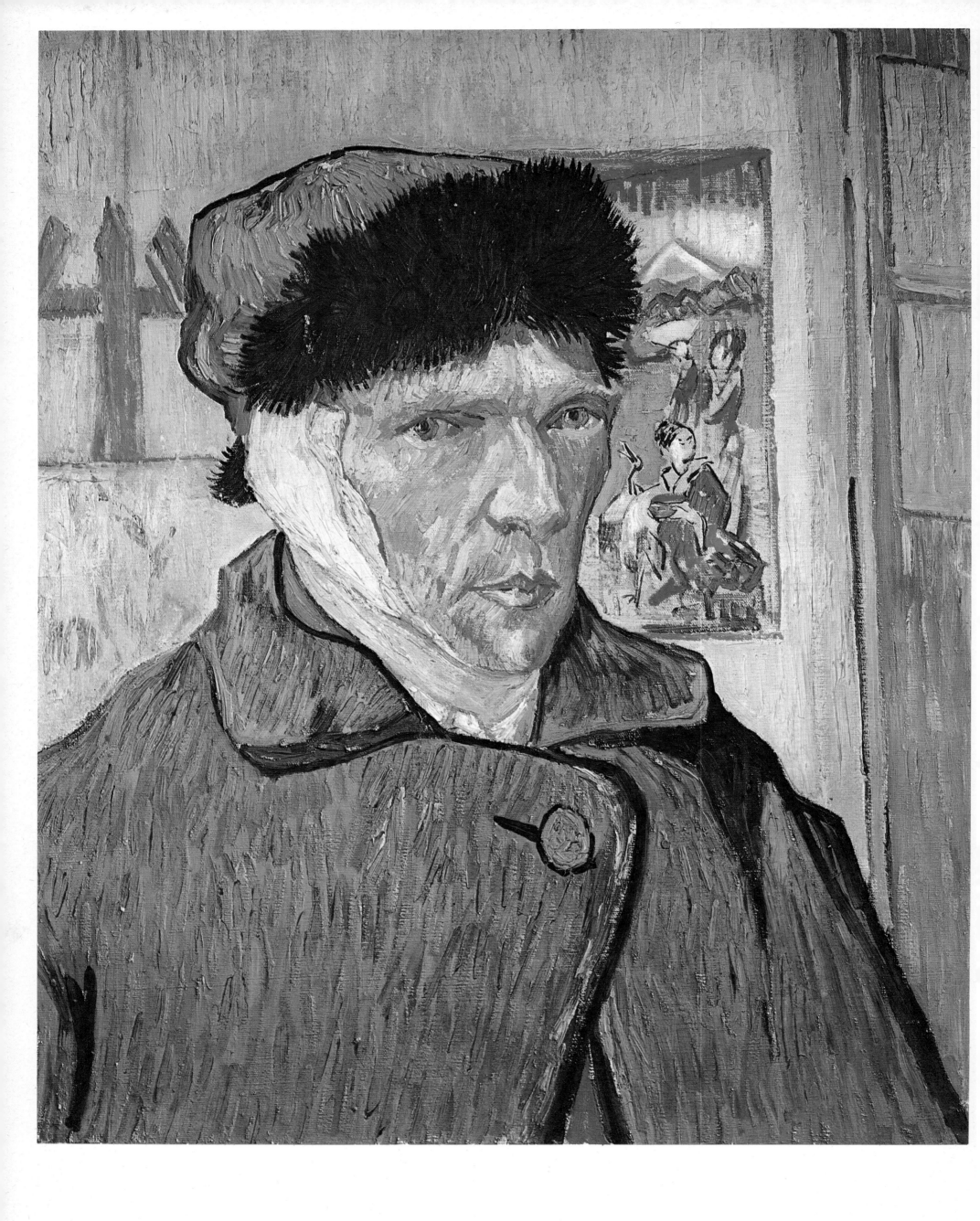

84

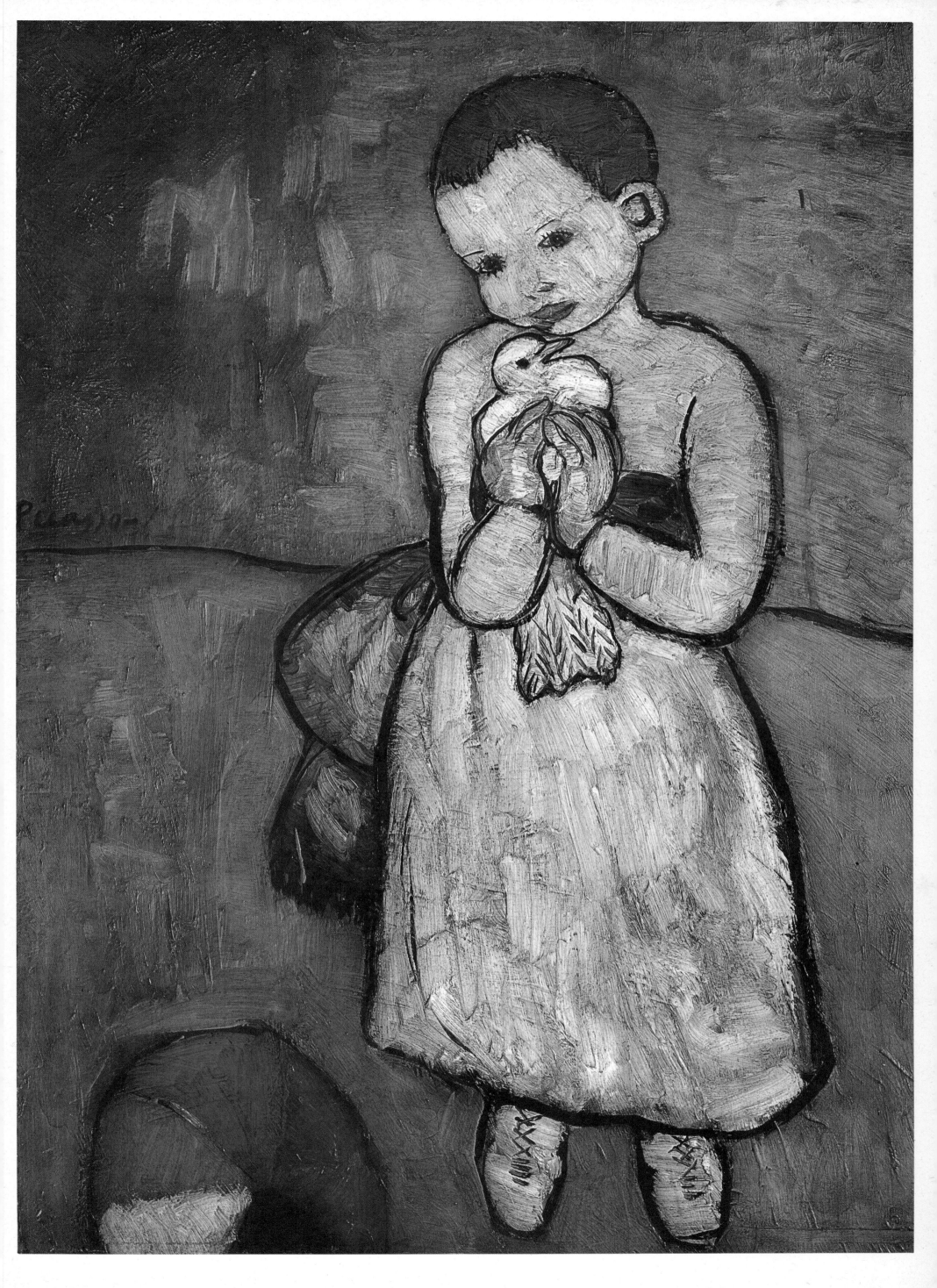

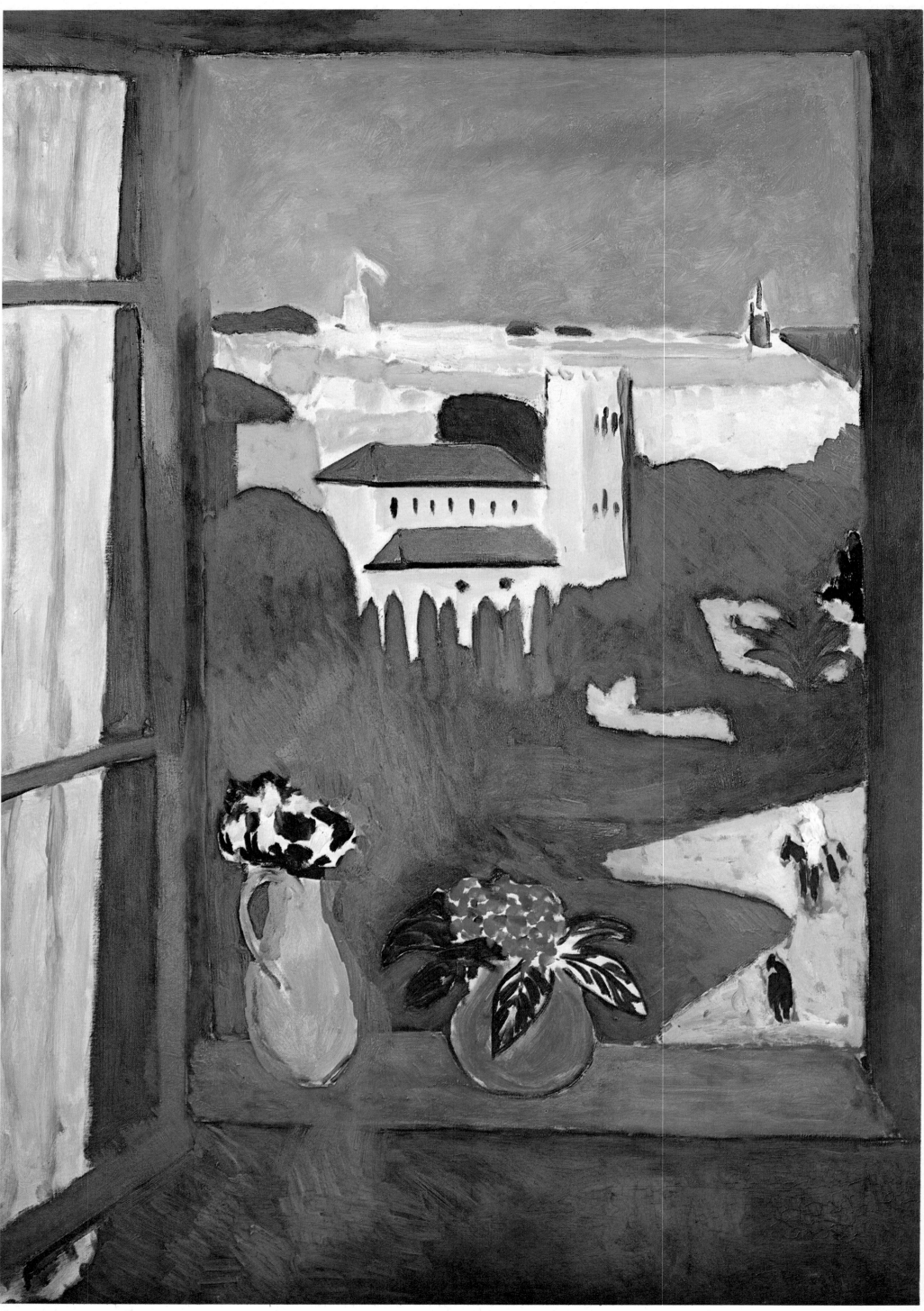

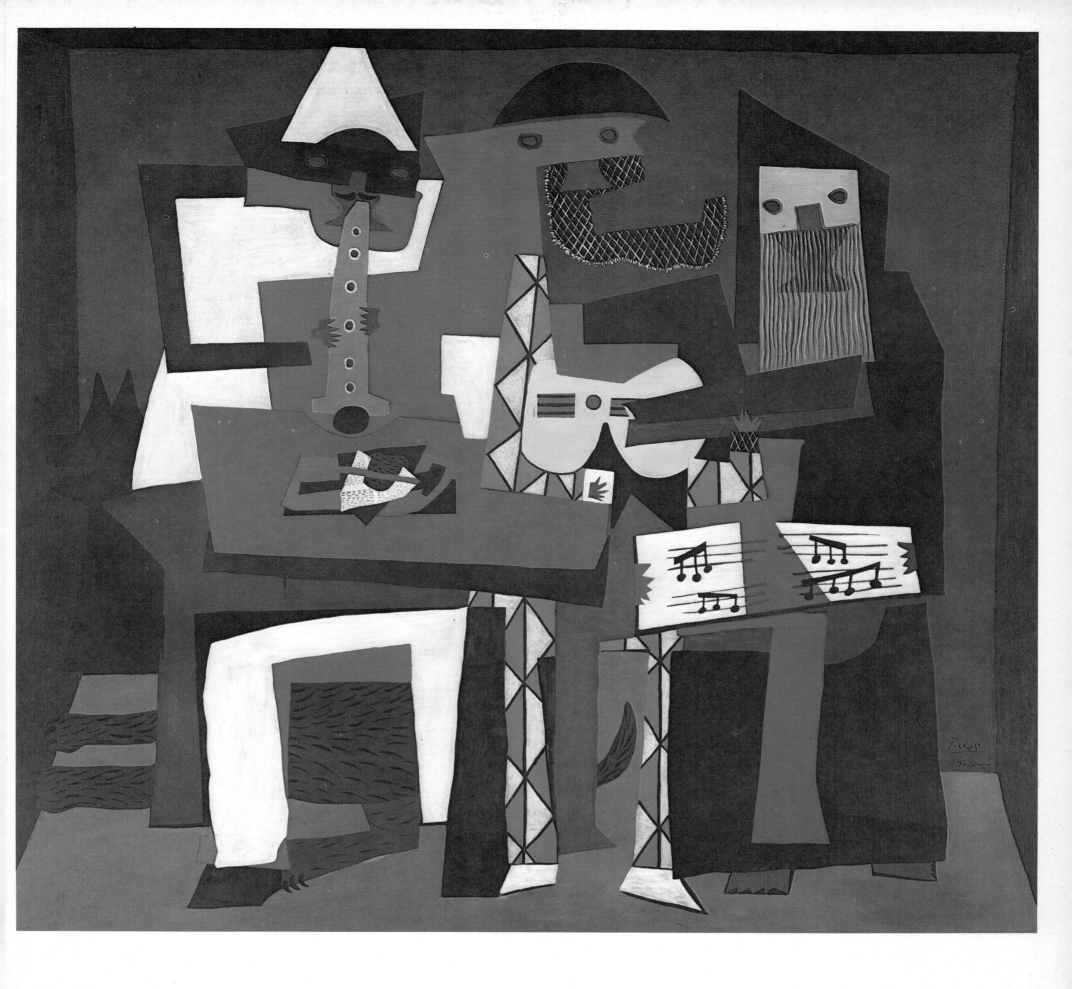

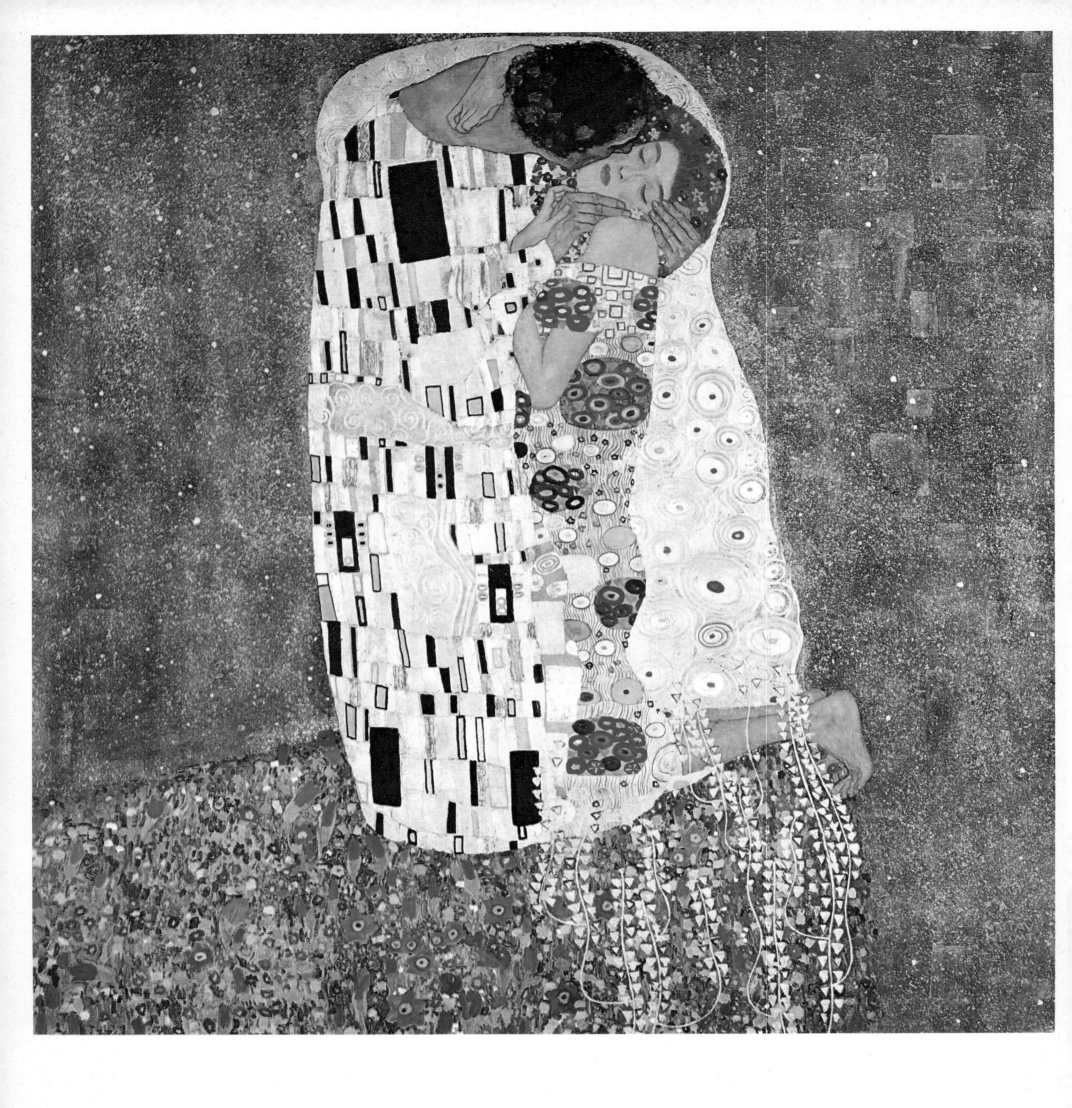

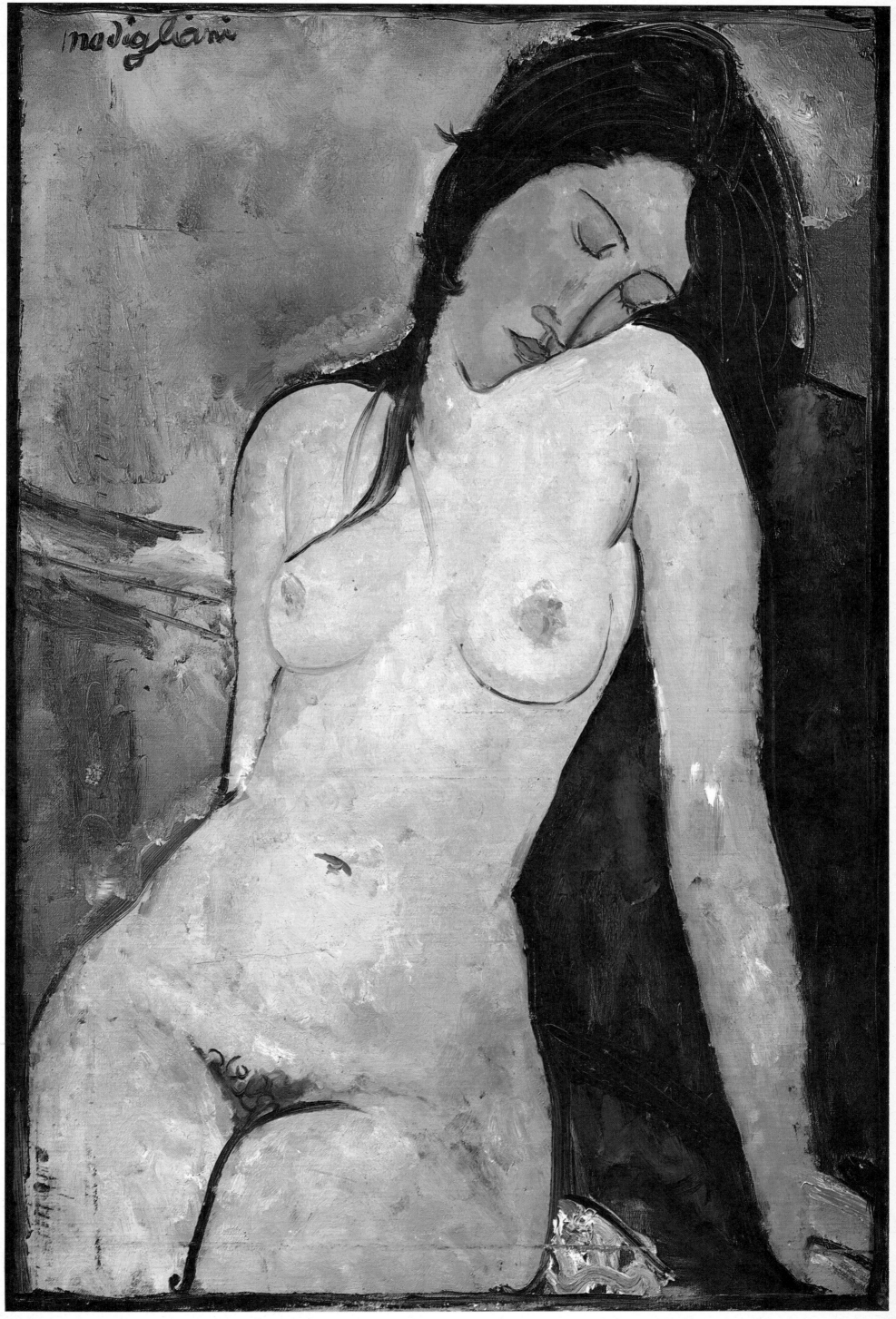

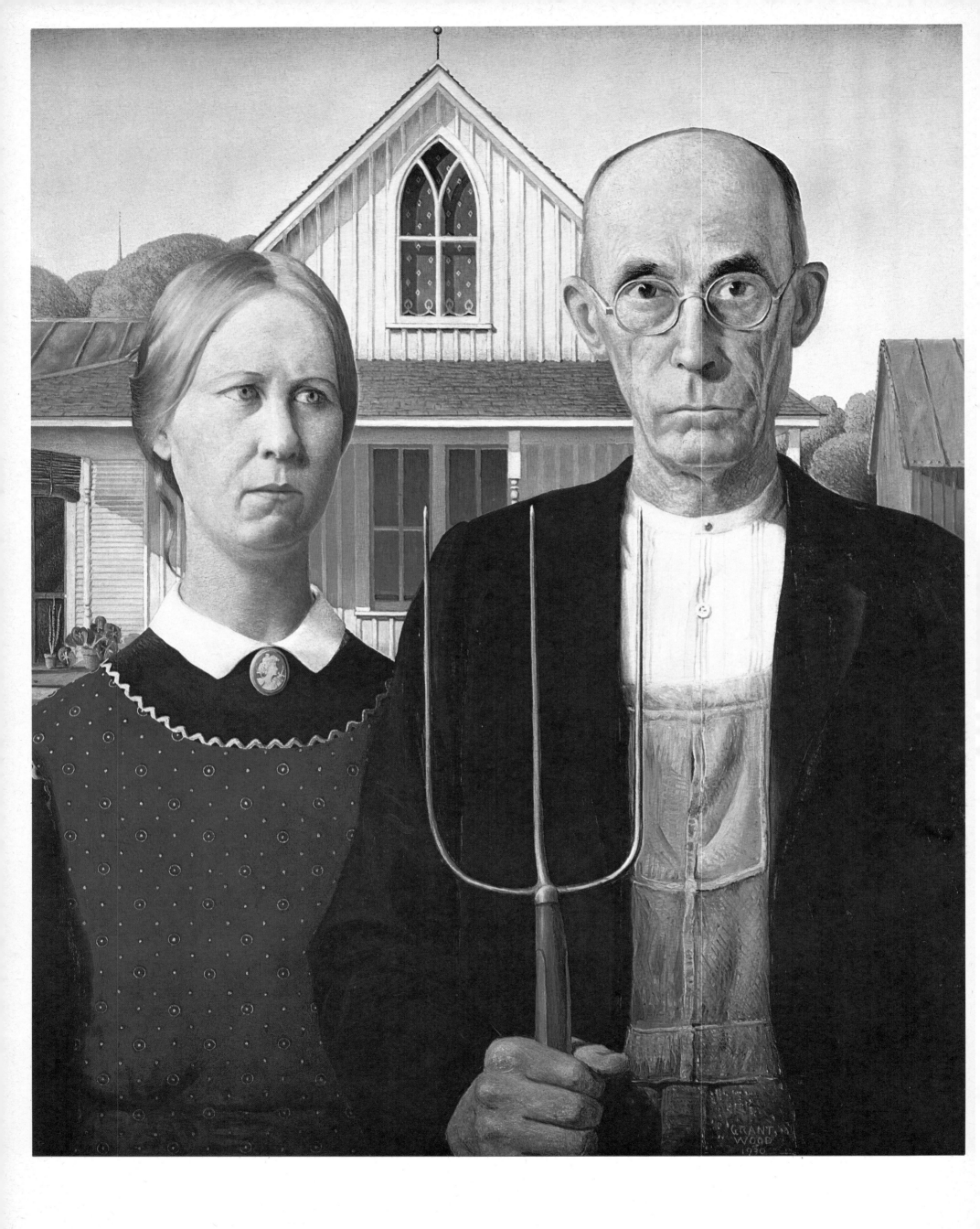

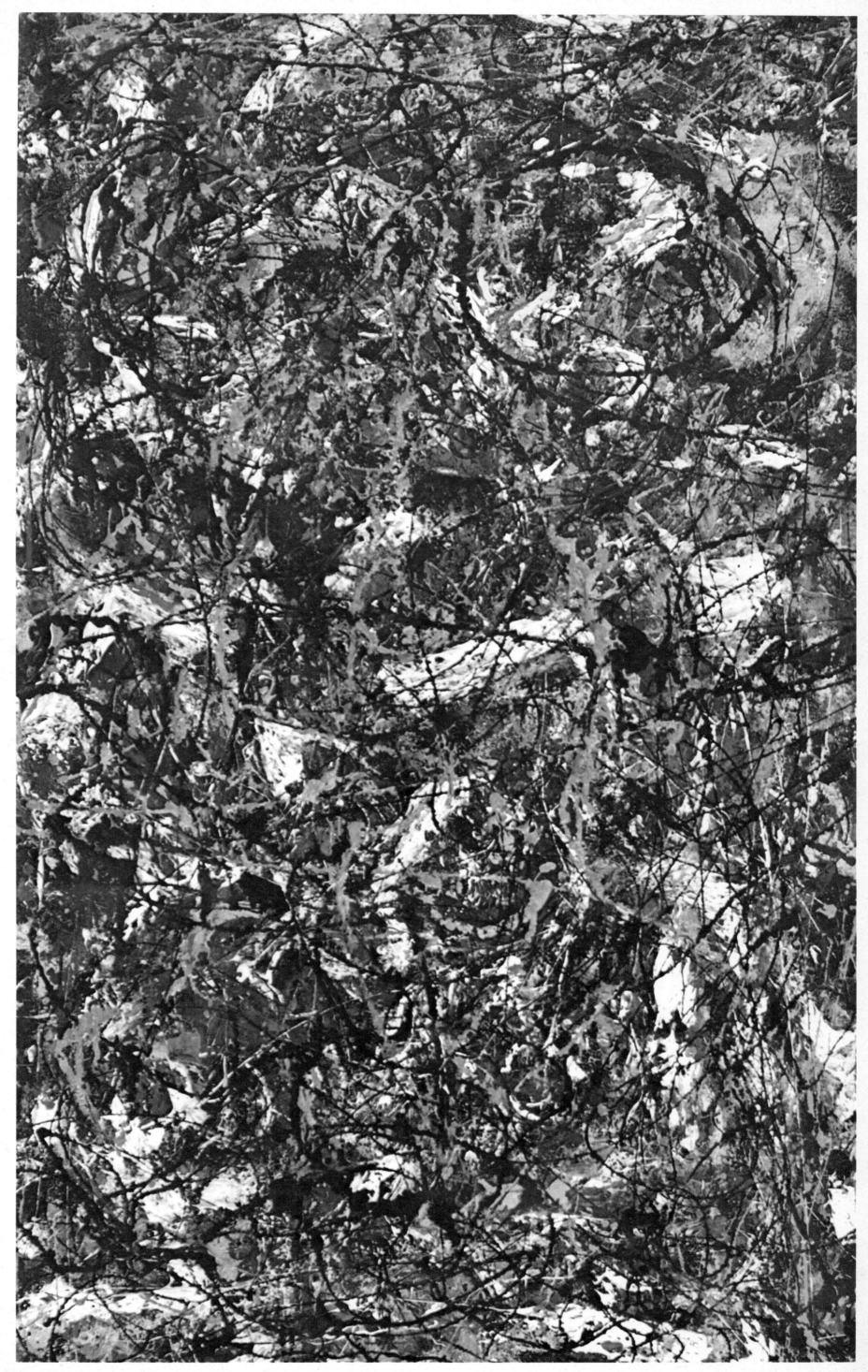

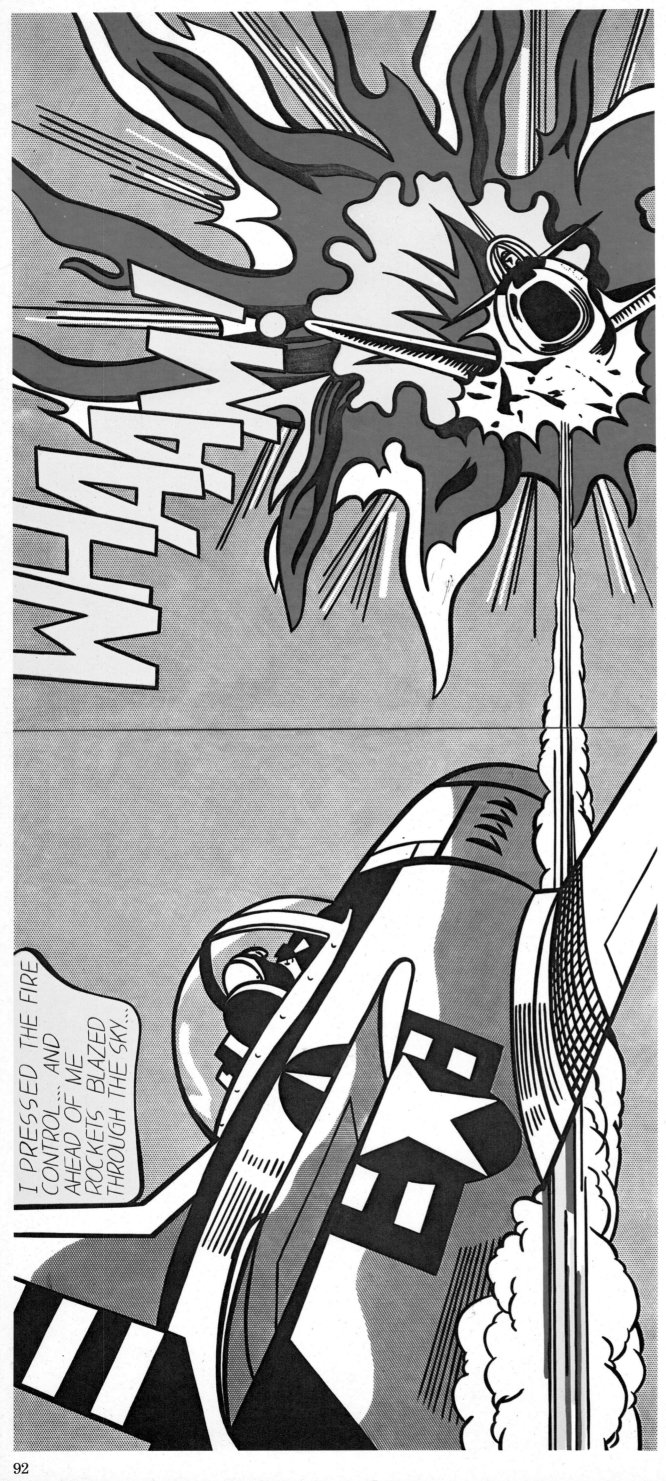

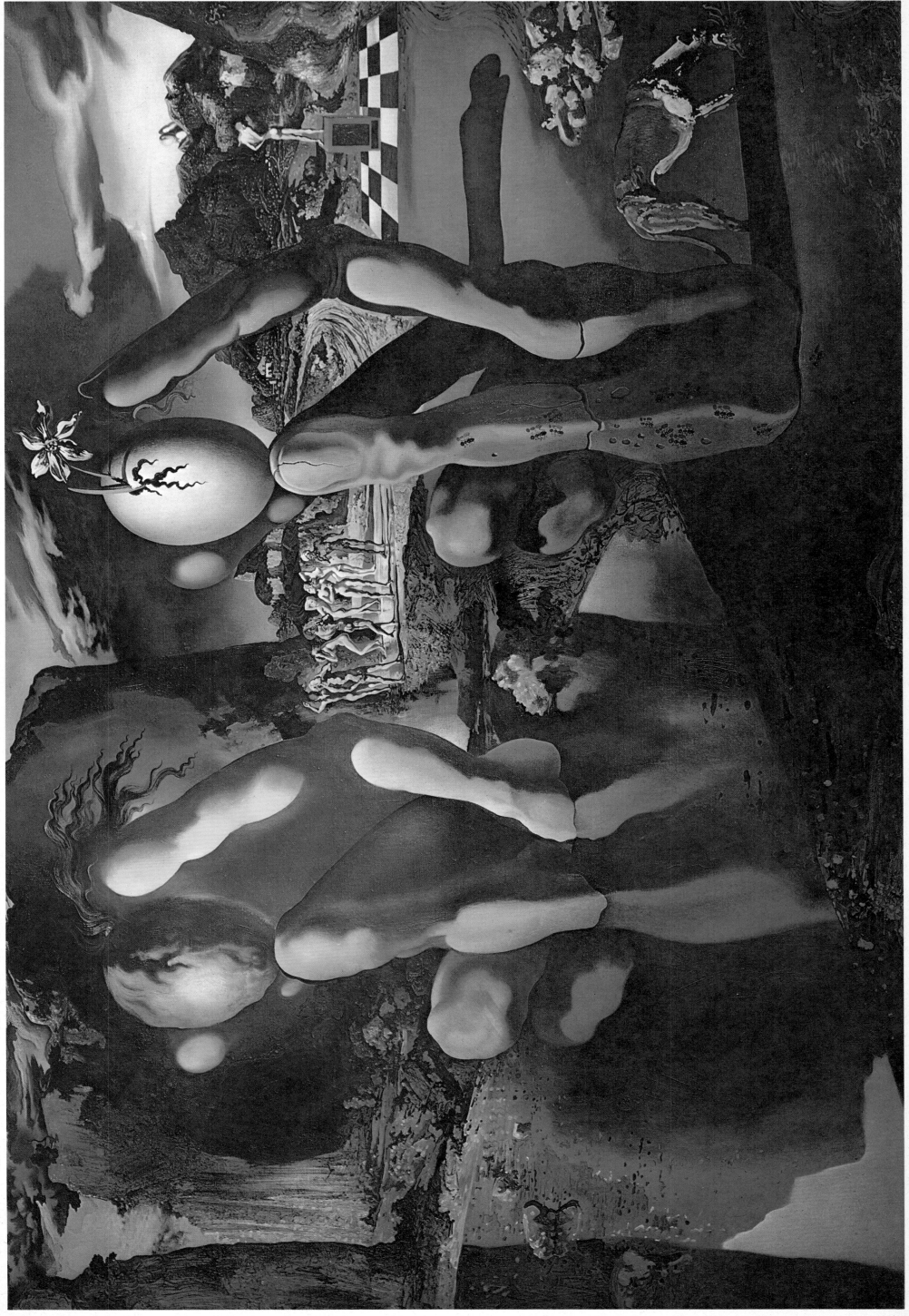

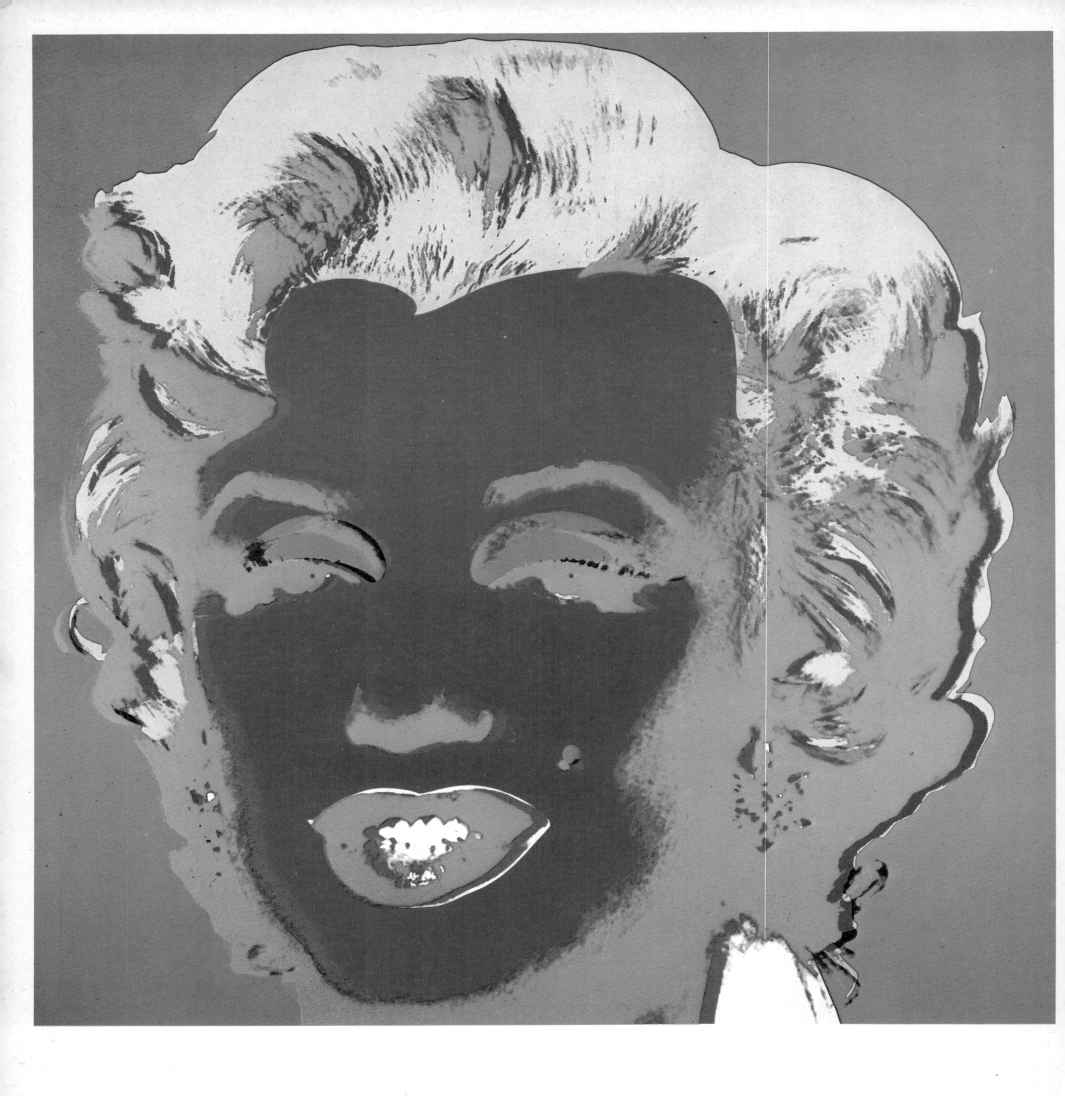